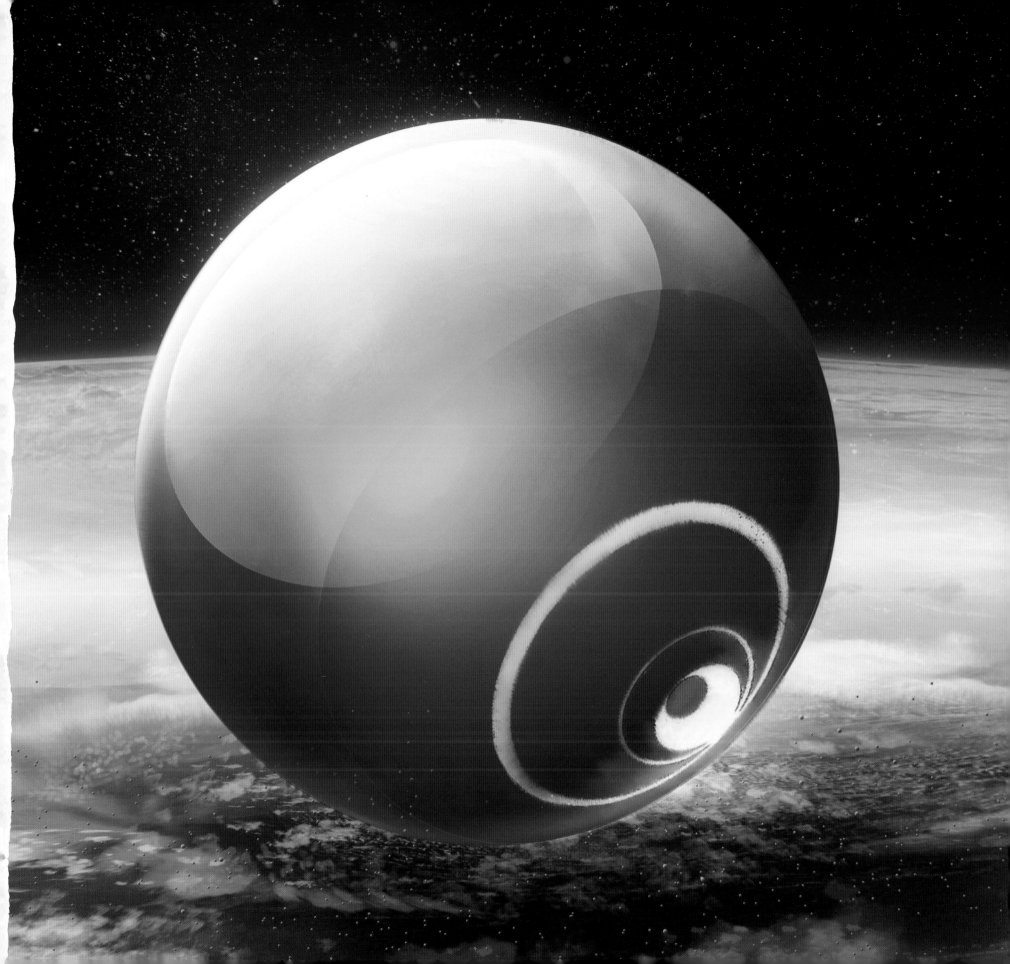

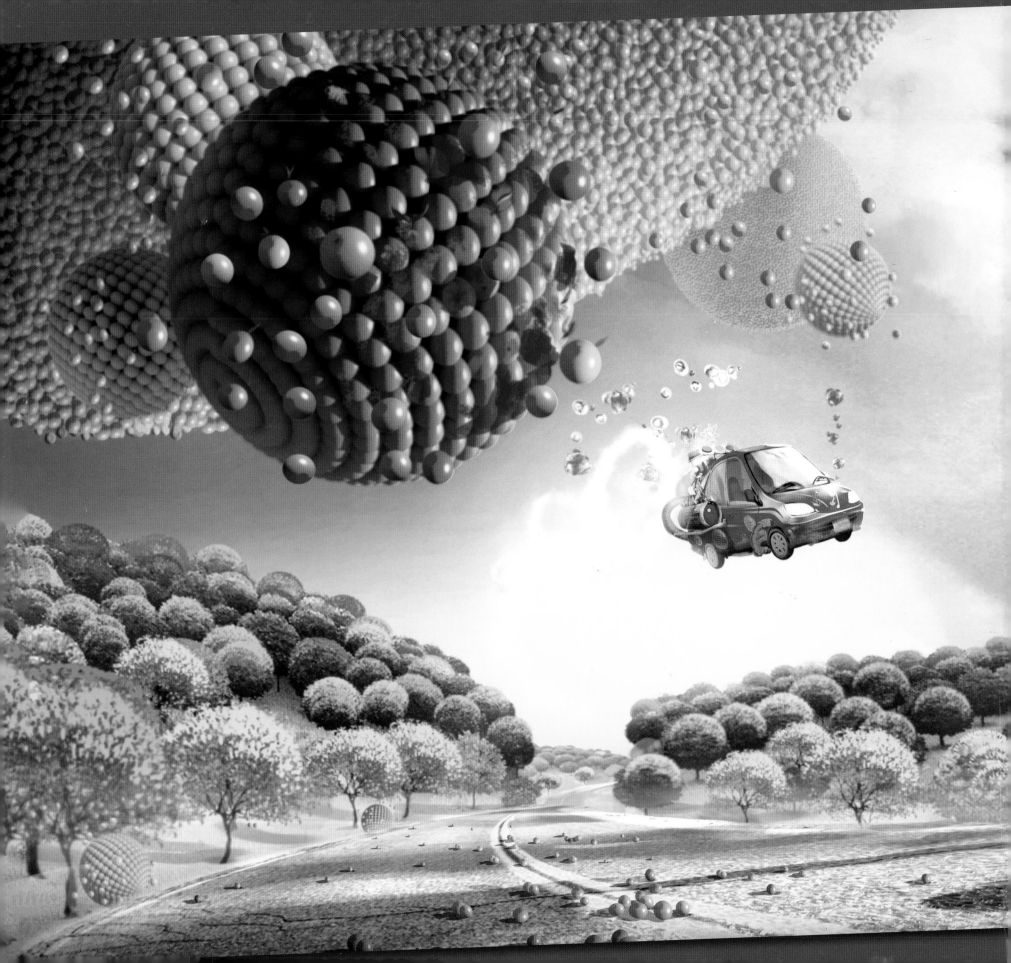

DREAMWORKS

THE ART OF HOME

Written by **RAMIN ZAHED**

Foreword by **JIM PARSONS**

Preface by **TIM JOHNSON**

Afterword by **ADAM REX**

INSIGHT EDITIONS

San Rafael, California

CONTENTS

THE BOOV

THE HUMANS AND THEIR WORLD

THE GORG

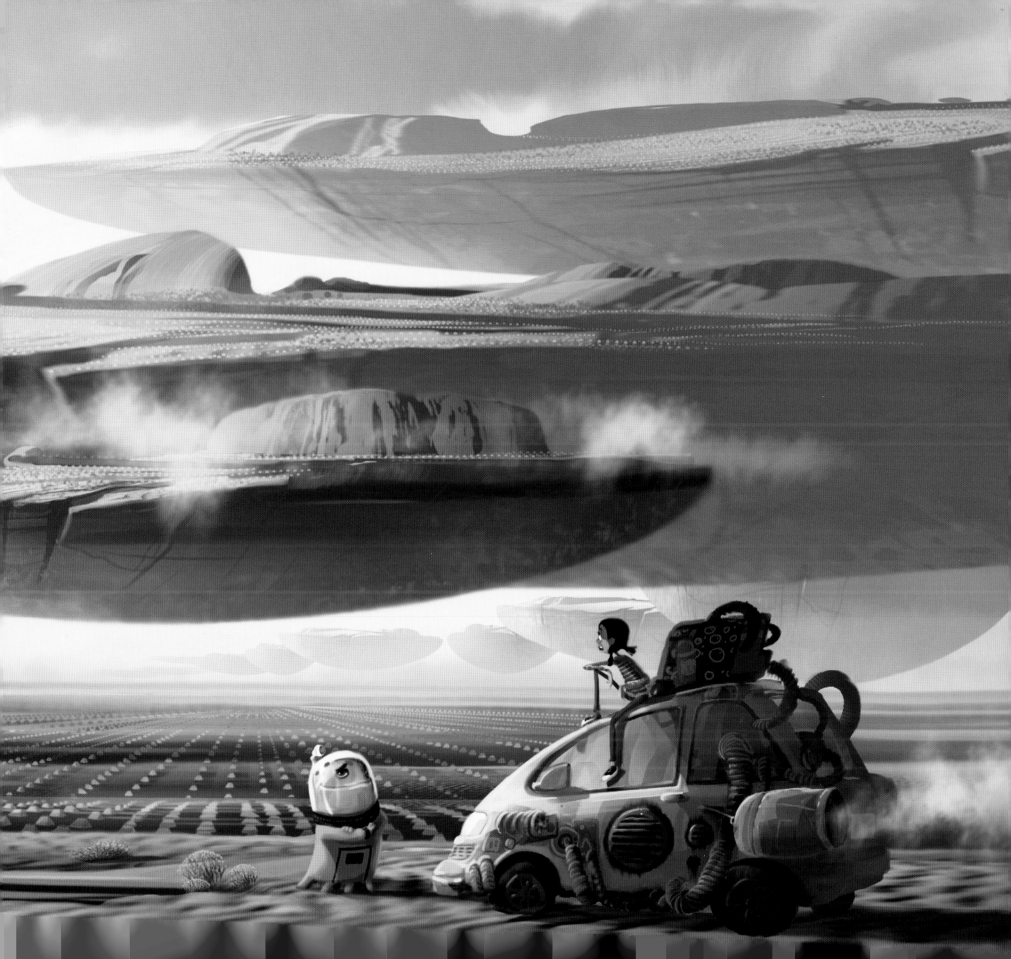

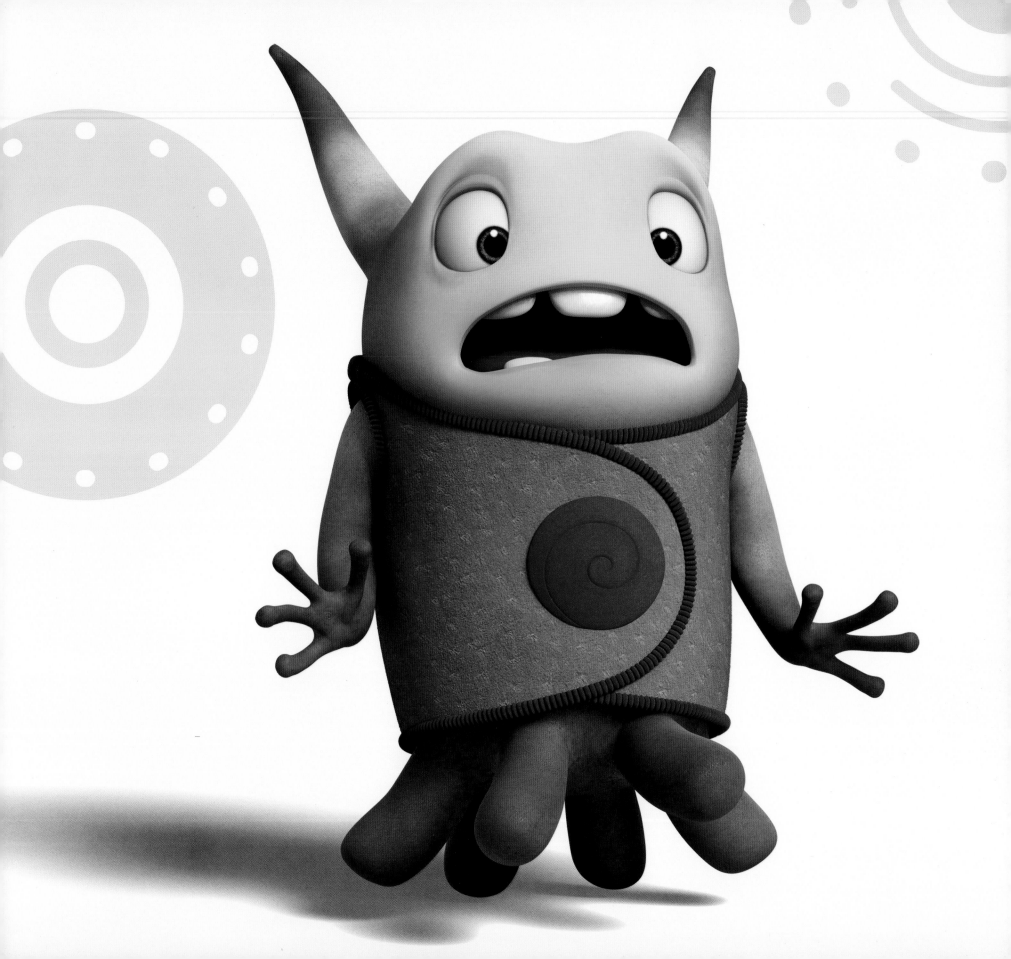

FOREWORD

BY JIM PARSONS

WHAT FUN IT IS TO WATCH a well-made animated movie. What a joy it is to listen to an actor play with words, with tones, with otherworldly sounds that are utterly unique but completely belong to that character on the screen (I'm looking at you, Robin Williams, Mike Myers, Jack Black, and, in our very own film, Steve Martin). What a pleasure it is to watch, again and again, some of the sweet tales of morality and stories about humanity that animated movies manage to tell in a way that touches not just the heart but the soul, in a way no other medium can.

And for all the happiness that watching an animated movie can bring, I must tell you that, having been fortunate enough to experience it, actually *working* on an animated film is even better. I hope this book provides you with a glimpse of what it is like to be surrounded by the intensely creative minds behind the animated movies you love. I hope you can kind of understand, by looking at some of the images, what I mean when I tell you that I traveled from abject horror upon first hearing my voice come out of a little purple alien to sheer joy as I realized that the animators made all the weird sounds and noises and emotions that came out of my mouth make sense! How many times I shouted, while viewing scenes from the movie, "You make my questionable choices look and sound like the right ones!" I cannot count, but I consider these guys and gals my artistic saviors, at least on this project.

I hope, when you see renderings of Tip, you can imagine the delighted surprise I felt the first time I heard Rihanna's voice played alongside that sweet animated face and realized we were listening to a side of Rihanna a lot of people have never had

the chance to hear. I hope when you see the images of Captain Smek in this book, you can sort of envision what it was like to hear very early playback of what Steve Martin had recorded, and experience the excitement I felt listening to the freedom and energy he infused into all his lines, knowing he was already creating an indelible character that, eventually, everyone would know and love.

Most amazing to me, though, was witnessing the ever-evolving images for the movie. I still pinch myself when I think about how I had a front row seat to watch as scenes in this film evolved from scratchy black-and-white sketches to the colorful life you see on the screen in the theater. I know that I would be very impressed with the way *Home* looks even if I were not a voice in the film, but I hope this book gives you a sense of what it was like to watch a scene for a fourth or fifth time when each viewing provided a new revelation: The characters' mouths are moving! There are beautiful buildings in the background! My god, there are shadows! Toward the end of production, as I screened segments of the film we'd recorded perhaps a year and a half earlier, the scenes began to take on an essence I couldn't even explain but that added a depth that made me exclaim, "It looks like life. Or, rather, it looks like it has the *feeling* of life." (See, I told you I couldn't explain it.)

I won't prattle on, because I think *Home* speaks for itself, and, in that vein, my greatest hope of all is that this book serves as a memento of a story that you will watch again and again for many years and with many people you love. More than anything, I hope the images in this book remind you that everyone (or every creature) wants to be heard and understood, that lasting friendships can occur with the most unlikely of pairs, and that, whenever and wherever that happens, you have found a home.

(page 1) Jason Scheier
(page 2-3) Emil Mitev
(page 4-5) Emil Mitev
(above) Takao Noguchi

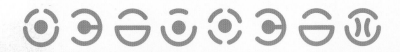

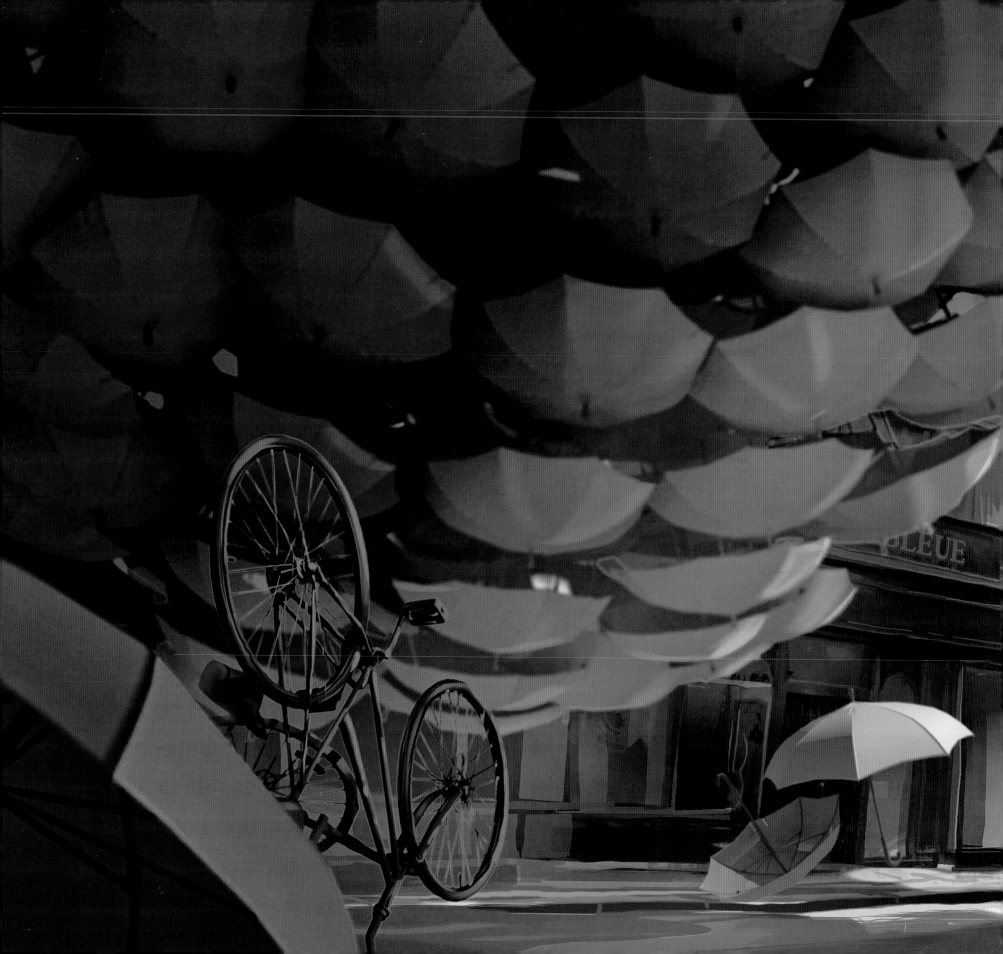

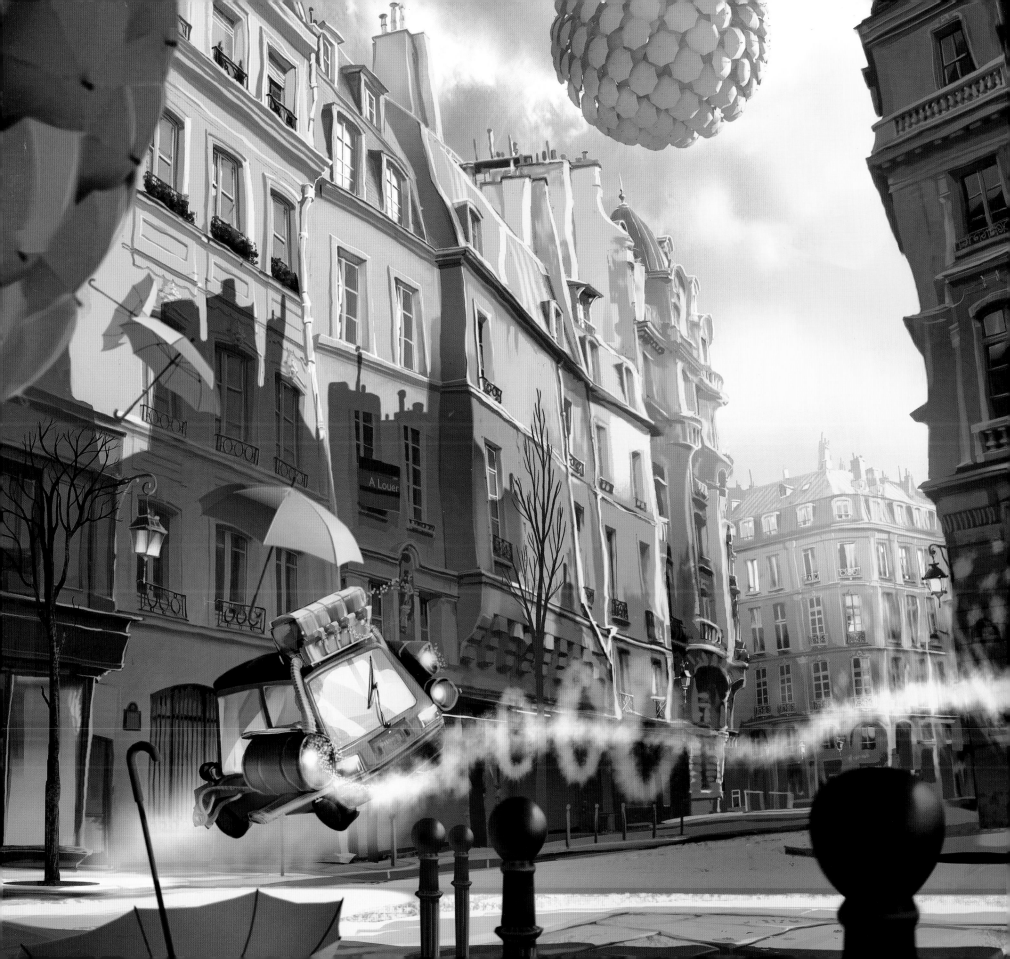

PREFACE

BY TIM JOHNSON

"The Journey Home, A Poem"

When asked to construct my
own short introduction
To a book about *Home*'s
artistic construction,
I said, "I don't want to be rude or contrary,
But who reads the director's
dull commentary?
Why would somebody give up precious seconds
Reading this, when a whole book of art design beckons?"

I was told it's a thing all directors must do
And not wanting to create a hullaballoo
I've written in rhyme (to be more entertaining)
In the hopes of keeping your interest from waning.

In 2007, toward the end of November
My two boys and I all sat down together.
Sharing a book before they hit the hay,
I started to read Adam Rex's *Smekday*.

The three of us giggled, gasped, and guffawed!
Tip was so smart! The Boov were so odd!
After several chapters, my boys went to bed.
And I tried to stop reading the book, but instead
I kept on reading and reading, my love undiminished—
I stayed up past midnight 'til *Smekday* was finished.

It was clear to me as I set down Adam's book
That DreamWorks might want to give *Smekday* a look.
This story of alien colonization
Just might make a blockbuster in animation!

LOOK!

This journey where Tip and Oh become good friends
Spoke strongly of family and making amends.
A tale that begins with an alien landing
And one poor Boov's comic misunderstanding
Becomes an amazing around-the-world trip
And concludes in a powerful, loving friendship.

What made Adam's book so fresh, fun, and unique
Would inspire us to come up with whole new techniques.
We wanted to reinvent film, science fiction
So we decided on some simple restrictions:
No laser beams, hyperdrives, teleportation—
Only bubbles and gravity manipulation!
So began our process of art exploration
The amazing task of creating an alien civilization.

I fear I might sound just a bit overzealous
When I brag that directing would make a king jealous.
But imagine a room of the best and the smartest
Painters, designers, and visual artists
Gathered to show you for evaluation
The work of their wildest imagination.

This book shows our journey, from sketches to screen
And all the discoveries we made in between.
So start turning pages; give the artwork a look
In this book on a film that was based on a book!

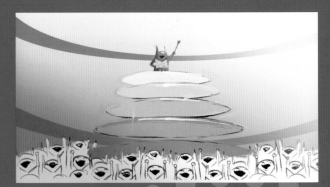

(pages 8-9) Emil Mitev, (top) Takao Noguchi, (center) Le Tang, (above) Michael Lester, (opposite) Emil Mitev

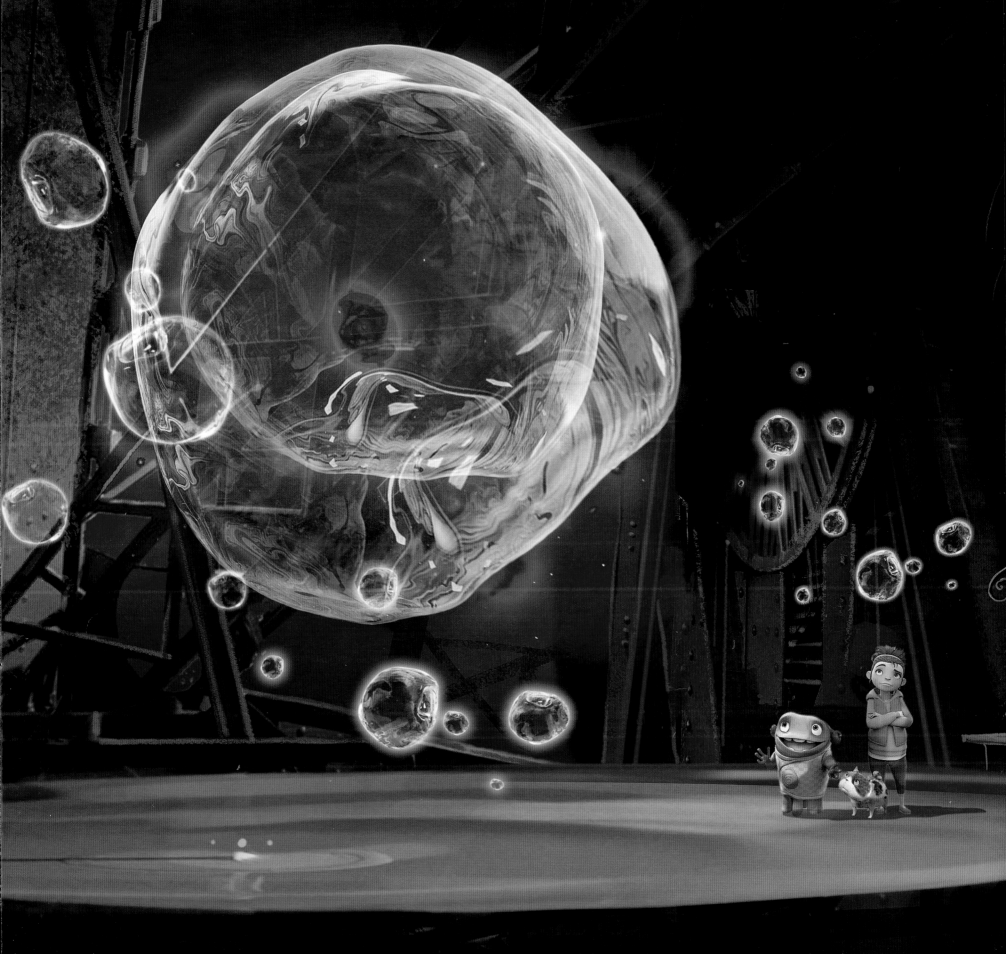

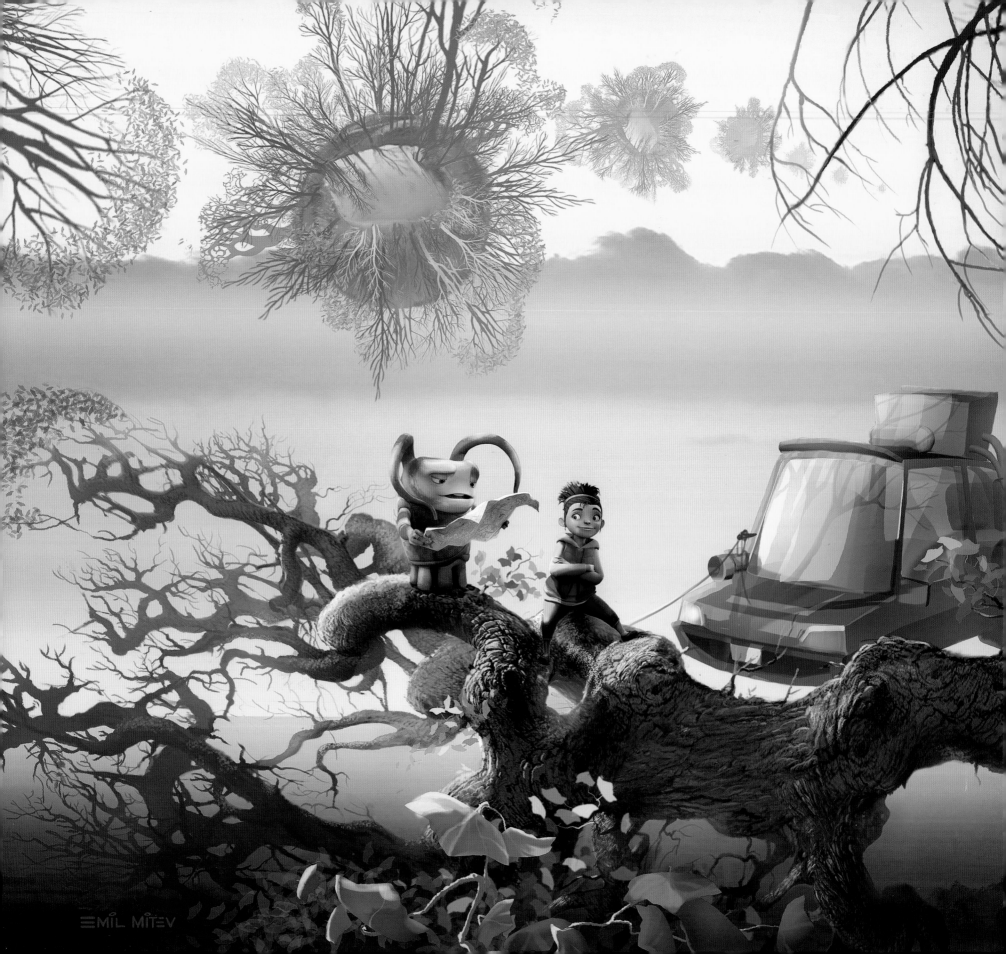

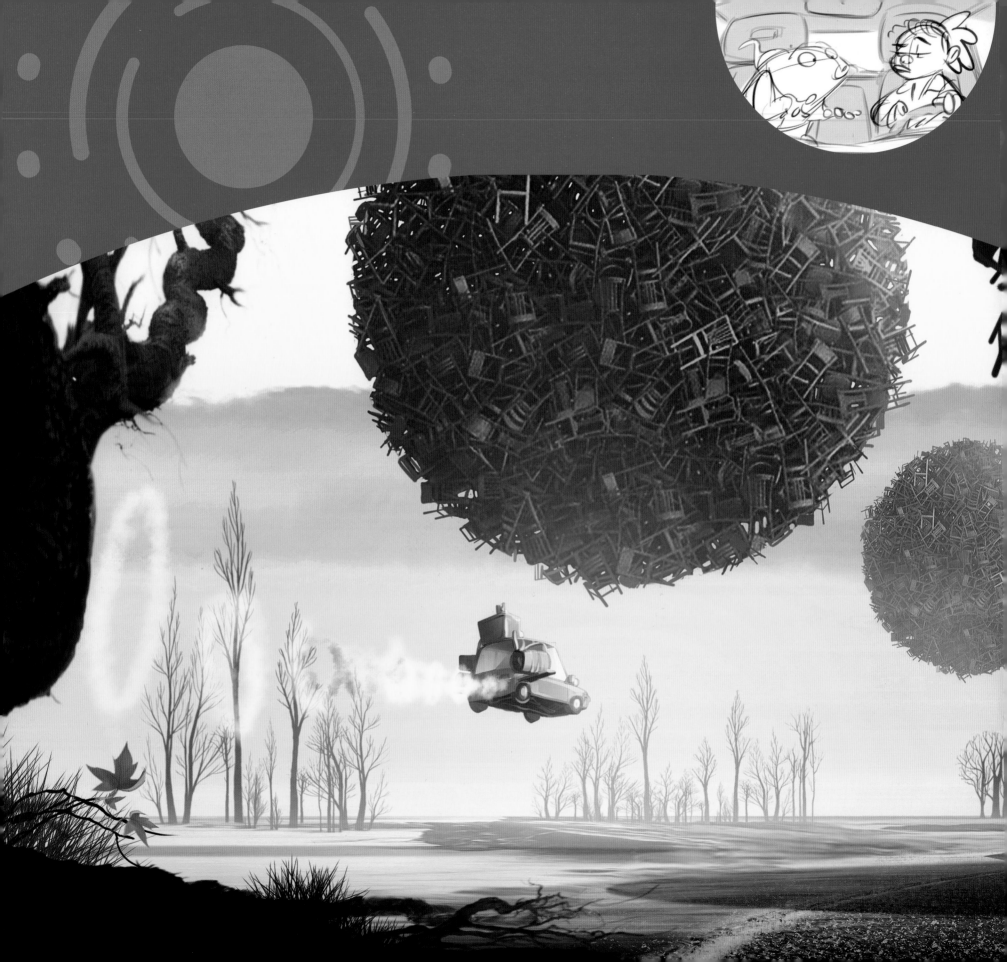

INTRODUCTION

EARTHLINGS MUST DELETE all preconceived notions about alien invasion movies before embarking on the *Home* experience. Nine out of ten aliens agree: DreamWorks Animation's thirty-first full-length theatrical release rewrites the rules of the traditional sci-fi interplanetary conflict genre while exploring new grounds in terms of both plot and rich visual content. Based on the acclaimed book by Adam Rex, *The True Meaning of Smekday*, this whimsical road trip movie delivers a gentle satire on human nature and cultural imperialism as it chronicles the friendship between Tip, a resourceful twelve-year-old girl, and a clueless Boov alien named Oh.

Home director Tim Johnson first discovered the book when he was searching for a book to read out loud to his six- and eight-year-old sons before bedtime. Johnson, who also directed *Antz*, *Sinbad: Legend of the Seven Seas*, and *Over the Hedge* for DreamWorks, came upon Rex's book after doing an Internet search for the best books to read to children. "I found a glowing review of the book in the *New York Times*, so I ordered it immediately," he recalls. "As soon as it arrived, I read a few chapters to my kids and tucked them in bed. Then I cheated on them and stayed up until two in the morning to finish it myself!"

(pages 12-13) Emil Mitev
(opposite top) Jeff Snow
(top left) Todd Wilderman
(top right) Emil Mitev
(left) Emil Mitev

The next day Johnson sent out an email to the development team at DreamWorks, informing them that they should act quickly and get the rights to adapt *The True Meaning of Smekday*. To his delight, he found out that the development team had coincidentally discovered the book and had already secured the rights to adapt it! Before long, DreamWorks embarked on the journey to bring a very different kind of an alien invasion movie to animated life.

One of the reasons Johnson immediately gravitated to the material was the instant appeal of its lead characters. "I thought they were smart and funny," he explains. "I saw both myself and the world in them. I also thought they explored themes that were very powerful and relevant to our experiences today. As a huge science fiction fan, I was also delighted with the fact that [the story] defied so many of the tropes of the genre. I really loved its fresh approach toward the notion of an alien invasion. Everything about it seemed vibrant and full of possibilities."

Johnson and the film's art director, Emil Mitev, had long chats about how to make this space invasion tale different from others that audiences had seen before on the big screen. "Emil had a really fresh take on how these aliens had changed our planet to fit their needs," says Johnson. "He immediately began to paint this world with these floating balls of discarded elements. Along with our character designer Takao Noguchi, they came up with a wonderfully surreal, original, and funny visual universe, and I just knew we had really hit on something great."

Noguchi, who is regarded as one of the top artists working in Hollywood today, was also the man behind some of the memorable characters seen in *How to Train Your Dragon*, *Puss in Boots*, and *Rise of the Guardians*. "When I first heard the premise, I was a bit unsure about how we could make an alien invasion of Earth look charming," he admits. "But as I found out more about the Boov and their culture and technology, I got more and more excited about the possibilities of what we could do with these characters."

Noguchi followed an important rule as he set out to create the original sketches for the film's characters: They had to be simple enough for a kid to be able to draw them. "I started out by doodling them, using the illustrations in Adam Rex's book as a point of departure," he says. "Then I thought about the creatures we encounter in the ocean, like squids or octopi. I thought it would be fun to put tentacles on their heads, and these aliens could express some emotions through them, as well as [through their] big eyes and mouths, just like cats and dogs."

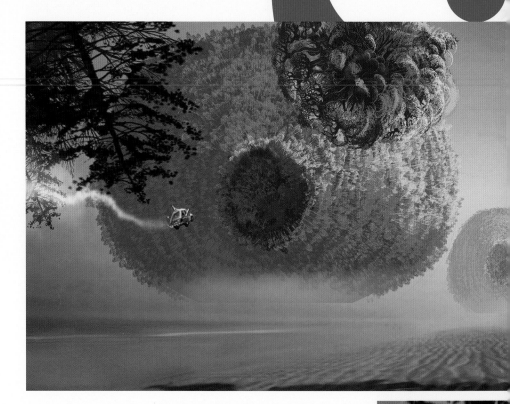

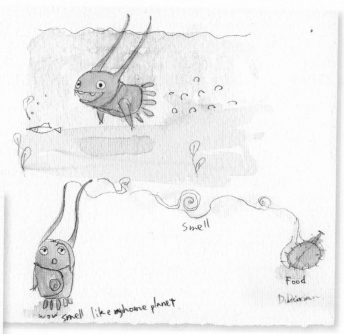

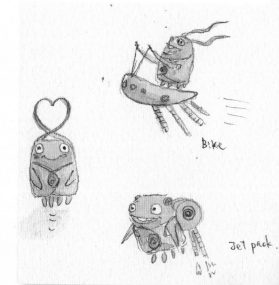

(above & right) Takao Noguchi

(top & above) Emil Mitev

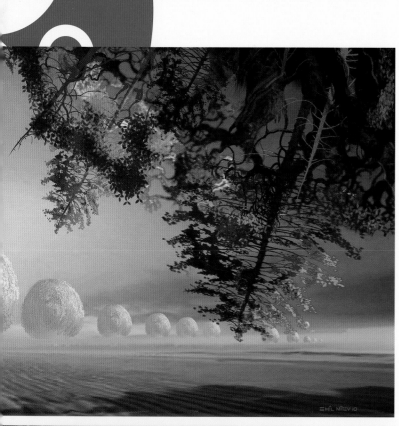

"One of our key challenges for the layout department was keeping the shots interesting during the long drive in the car. We wanted to avoid just going back and forth between the two characters and keep them moving around so that the same camera angle isn't used over and over again. Another important task was making the cities all look lived in, and bringing character to these locations.

"The movie gave us the chance to really explore the possibilities of the 3-D technology. We have some great sets that help us draw the viewers into the rich 3-D environments. There is some lush foliage, similar to Avatar's Na'vi planet. We shoot through trees and some stunning foreground elements, which add to creating a rich, animated experience. There's also this remarkable crash landing in China—one of our artists built an amazing cathedral out of bamboo, which leads to the Gorg, which is pretty incredible.

"I think what makes this movie stand out is the very original tone. It's a buddy, friendship tale, but it's also a science fiction movie to a large extent. It's also a great comedy. One thing that makes our movies at DreamWorks really special is the fact that they're all different from each other. Each time we explore an entirely new imagined world. There's nothing conventional about them."

— Mike Trull, Head of Final Layout

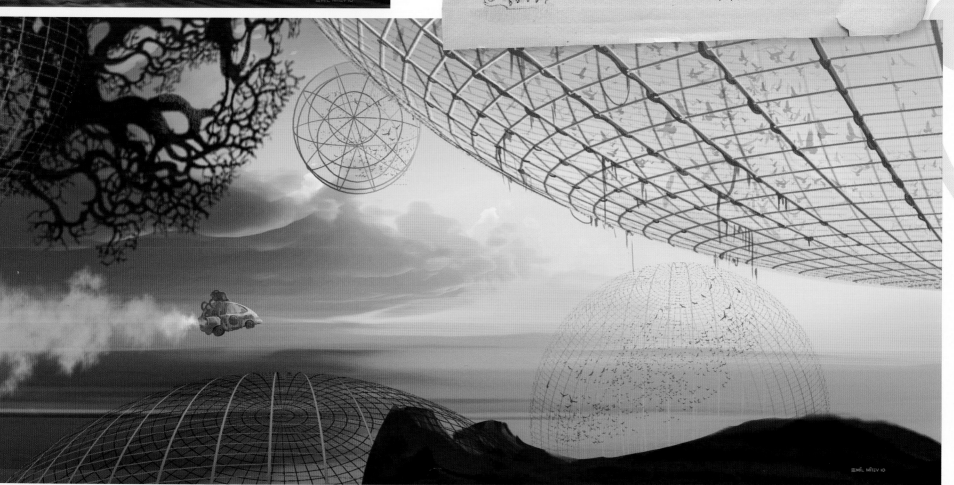

BOOV

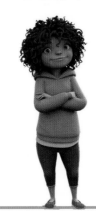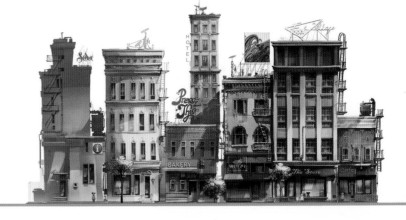

HUMAN WORLD

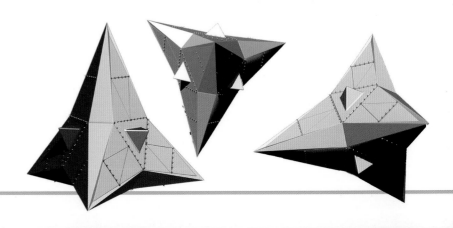

GORG

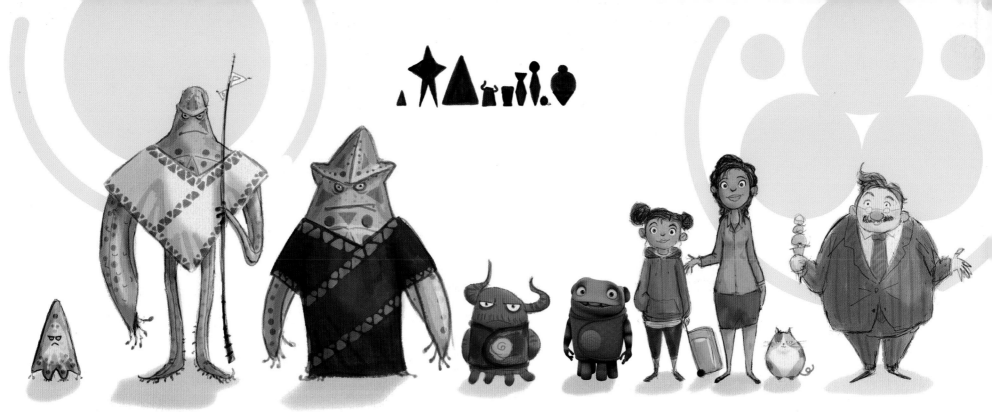

Takao Noguchi

THREE SHAPES TO RULE THEM ALL

To create a distinct visual language for each of the cultures featured in the film, the team opted for specific geometric shapes to unify their worlds. The humans were assigned a linear, square-like world. "When you think about it, as humans, we surround ourselves with boxes," says Johnson. "We live in cubes and pack our belongings in boxes—everything has a linear edge. So our human world has a very distinctive square shape. Conversely, the Boov live in a very round universe. They ride in bubbles and have this desire to make everything smooth and round to satisfy their particular creative aesthetic. Lastly, we have the Gorg, the true antagonists and threat to our main characters in the film. We decided to give them these harsh angular shapes to play up the threat they pose to humans."

According to producer Chris Jenkins, the artistic direction of the movie was dictated by the characters. "All of the movies at the studio have a very strong, stylized feel," he explains. "But what I love about Tim's direction is that it really comes from the characters first and flows into all other areas. We have those areas of shapes and design, based on the simple basic geometry of the humans, the Boov, and the Gorg. Beyond that, there is also a beautiful, unified environmental style. You can see it in the way the paint is applied, the way our artists are delivering the light and shadow like the Post-Impressionists. The interplay between the lit and shaded areas makes the visuals really leap off the screen and right into the audience's lap."

Jenkins, who began his career as a visual effects artist on features such as *Who Framed Roger Rabbit*, *The Little Mermaid*, *The Lion King*, and *Pocahontas*, believes that *Home* really succeeds at capturing some of the best aspects of being human.

"The film really provides us with insights into what's best about us and also cleverly shows us what might be wrong at times with the way we treat others," he says.

The universal appeal of the story's main characters and fresh storyline is one of the key selling points of the project. Jenkins compares the film's humor to Douglas Adams's *The Hitchhiker's Guide to the Galaxy*. He adds, "The tongue-in-cheek satire really draws you to the material. Plus, you have this incredibly arrogant little alien that you want to cuddle and smack at the same time. Oh's contrary character has reeked of charm from the very early stages of development."

Another interesting quality of the movie is that, unlike many of today's animated features, it dares to focus on only a handful of characters. As *Home* producer Suzanne Buirgy (*Kung Fu Panda 2*, *How to Train Your Dragon*) points out, "We are telling this unusual story about the friendship between an alien and a young girl, which I think is very cool. And we have a grand total of about five characters, with Oh and Tip having the most lines in the script."

Buirgy is also proud of the fact that the movie embraces positive messages such as the importance of finding a true home and looking beyond first impressions and appearances. "I love the fact that we touch on themes such as belonging and choosing our family and friends," she explains. "Another one of the movie's big themes is not judging a book by its cover—those ideas are in the background of the story in a very subtle way."

Art director Emil Mitev, an award-winning veteran of DreamWorks Animation pictures such as *How to Train Your Dragon*, *Puss in Boots*, and *The Croods*, says one

of the big challenges for the creative team was staying away from the science fiction clichés we have all grown accustomed to throughout the years. "We were always striving to stay original and come up with visuals that were fresh and unique," he says. "That's how we came up with the Boov's reliance on bubble technology in all aspects of their lives. We look at the work of innovative artists such as Christo and Andy Goldsworthy for inspiration, as they both created charming works of art using the natural world as their canvas. That's what we wanted to do with the Boov—they were changing our world, but we didn't want it to come across as menacing. Even though we were dealing with an apocalyptic world, we wanted to make it silly and whimsical so that it would be suitable for children."

Mitev says the premise of the movie inspired him to think deeply about what would happen if aliens from a completely different world were to invade Earth: "When I move to a new place, the first thing I do is change things around and redecorate to express my tastes. That's how we came up with notion that the aliens were going to alter the Earth in ways that would allow us to deliver some whimsical visuals."

GOING FOR THE SWEET SPOT

Production designer Kathy Altieri echoes Mitev's sentiments, adding that she is proud of the fact that the film allows itself to be accessible to younger and female audiences. "I find it really admirable that we have this really sweet spot here," she notes. "We're allowed to be cute and funny, as well as explore deep issues, and still have a visual style that is charming, uplifting, and joyous."

Altieri, whose remarkable career at DreamWorks goes all the way back to *Prince of Egypt*, has worked on epics such as *Spirit: Stallion of the Cimarron* and *How to Train Your Dragon*. She points out that the look of *Home* evolved from being a bit sober-looking to a world that was rich and buoyant, full of saturated colors and striking

imagery: "Part of this change was taken on because of the sense of playfulness and humor that our voice actors Steve Martin and Jim Parsons brought to the table. They are so funny and added such playfulness to their roles that we also allowed ourselves to be silly and not wall ourselves into this serious, dark, sci-fi universe."

So how does this futuristic tale about a somewhat hostile, oddly goofy takeover of our planet fit with the rest of the other movies in the twenty-year DreamWorks Animation repertoire? Johnson believes it continues in the tradition of offering visually arresting movies with smart stories for viewers of all ages to enjoy. "As we saw with *Over the Hedge*, animation can provide a great social satire for families to enjoy together," he says. "We can all celebrate and lampoon everything about the human experience. Of course, we now have amazing state-of-the-art tools that let us dream even bigger than we've ever done before. Along the way, we also love making audiences laugh and share some genuine emotions about our lives here on our *Home* planet."

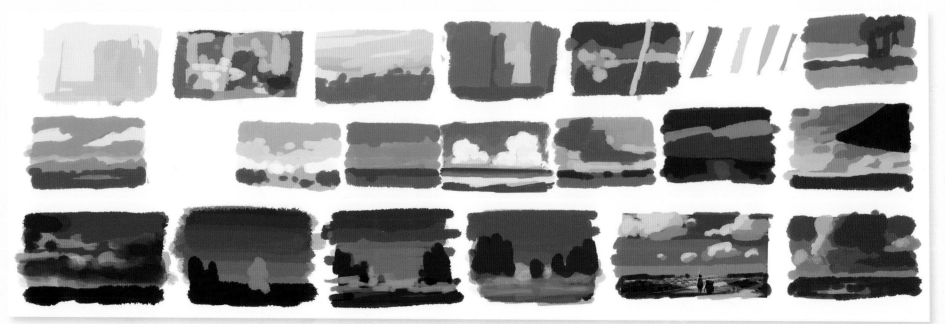

(top) Ron Lukas, (above) Kathy Altieri

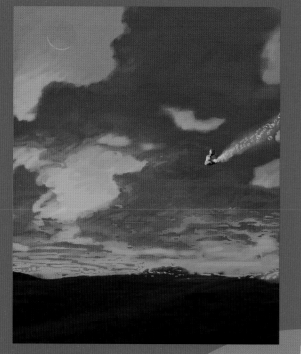

"When Tim Johnson first told me about the project, what appealed to me most about it was its simplicity. This was a simple story about two very memorable characters. It also had some stunning artwork. I knew we could really explore and elaborate on this further.

"Some of the sequences demand such enormous sets that we had to simplify them greatly so that all the other departments could work on them. Rough layout is the global term for pre-vis, and final layout is the final confirmation of shots for animation and visual effects.

"One of the most challenging scenes was the one set in Paris, where we see what the Boov have done to the Eiffel Tower. This is the first contact we have with the enemy. We had to revise our plans once we put the initial images in the computer and began to build the sets. It takes a lot of planning and communication.

"What I love best about the movie is that it has a big heart. It's not too sentimental, but it's a real buddy movie with these two characters. Although we do travel the world and have lots of impressive effects, crowds of aliens, and an enormous spaceship, it's really about telling this heartfelt story."

— Mark Mulgrew, Head of Rough Layout

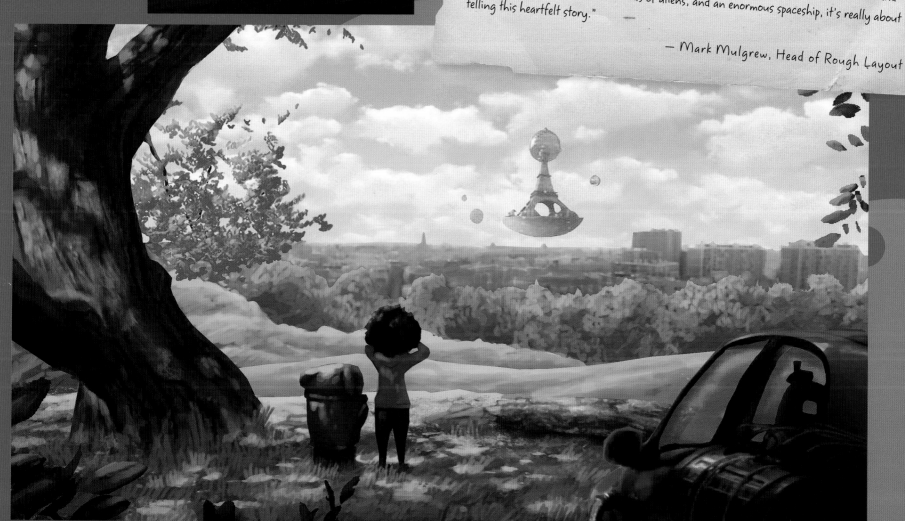

(top & above) Bill Kaufmann

HOME
THE COLOR SCRIPT

50 Finding Smekland

80 Happy Humanstown

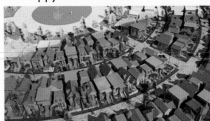

125 Oh on the Street

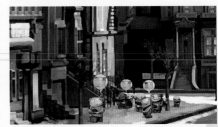

500 Two Fugitives

600 The Mo-Po

675 Bring Him to Me

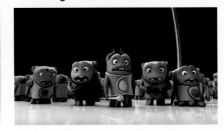

700 Slushious

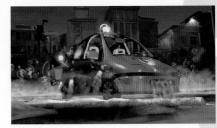

1500 Over the Atlantic

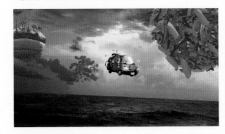

1600 Sad Mad

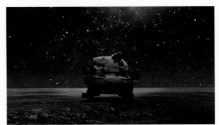

1660 Find that Password

815 Knock Knock

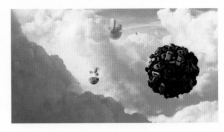

1900 Running

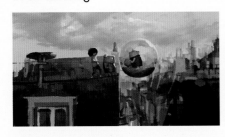

2000 Oh's Apology

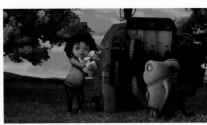

2010 Oh Drives

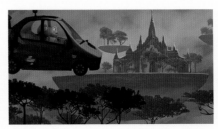

2050 Dogfight

2800 Reunions

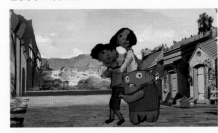

3100 Returning the Shusher

3150 The Gorg

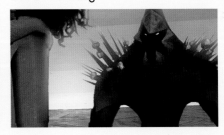

3200 Coda (Credits)

150 Oh Moves In
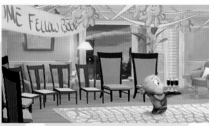

300 Gratuity's Apartment

375 Party is Over

400 Uh Oh
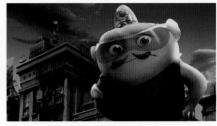

800 On the Road
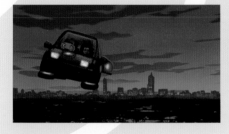

803 Hiding
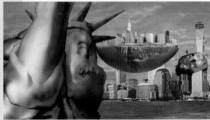

807 Rest Stop

1400 Kyle Reports
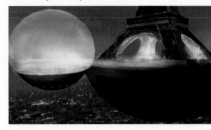

1700 Makeover

1800 Great Antenna
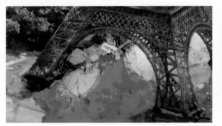

1850 Computer Room

1880 Trapped
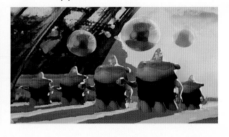

2200 Stealing the Superchip
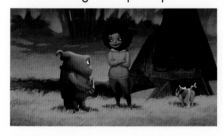

2400 Oh Abandons Tip
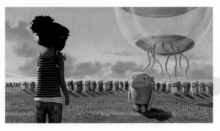

2500 Confronting Captain Smek

2600 Starry Starry Night

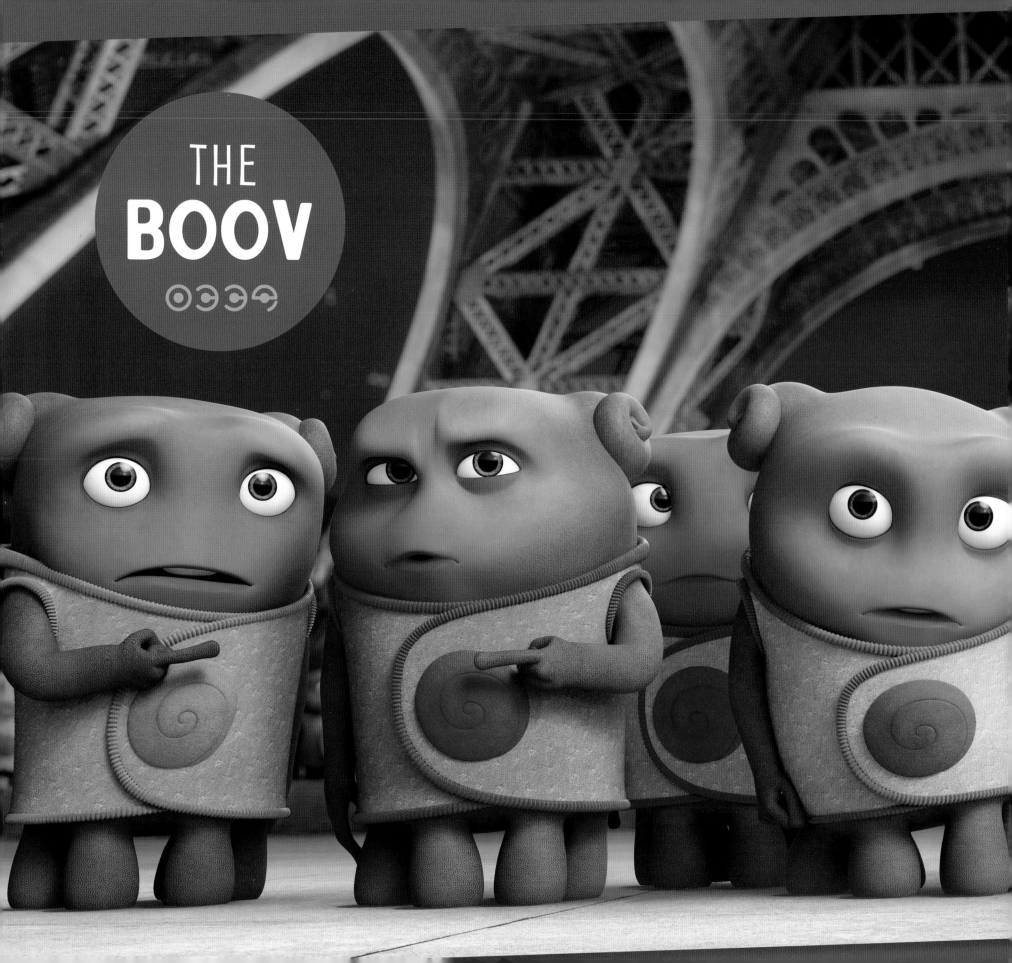

THE
BOOV

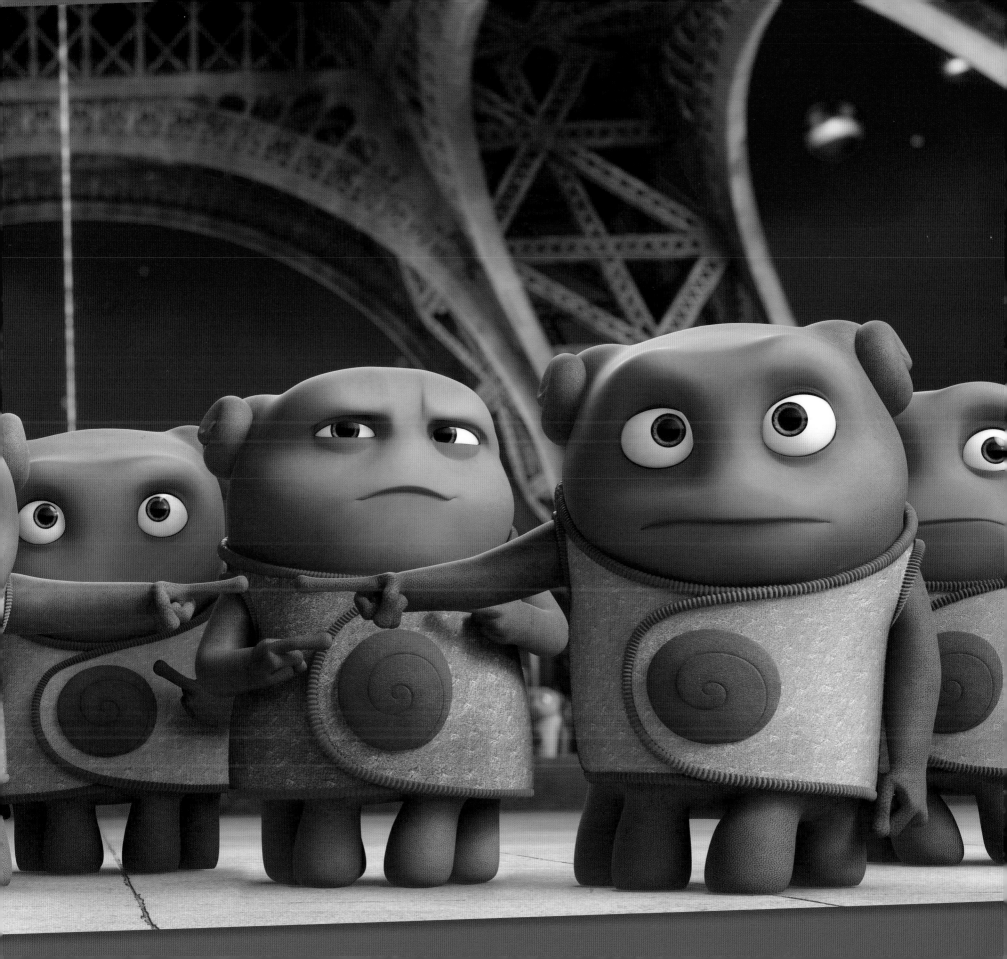

OH

CHARACTER DESIGNER TAKAO NOGUCHI used the original illustrations in Adam Rex's book, *The True Meaning of Smekday*, as a launchpad for the look of Oh, the lovable Boov alien who anchors the movie. Noguchi, who greatly values simplicity of design, believes that children should be able to draw the main characters in the movie. "I love to doodle, so I began to explore how to express this alien in the simplest graphic way," he says. "These aliens are square and have multiple arms. I added those tentacles (called 'nostricles') to their heads so that they could use it to express their emotions, just like cats and dogs use their ears."

Noguchi avoided typical sci-fi movie alien tropes in order to make the Boov more relatable, especially for young audiences. "Once we figured the aliens could be any shape, really, that gave us a lot of freedom, so I tried to push a simple shape so that kids could easily draw Oh at home with crayons."

The way director Tim Johnson sees it, Oh is the central alien character in this post-apocalyptic alien invasion buddy/road trip movie. "He is really trying very hard to be a good Boov because he believes all the propaganda and the spin that the Boov and Captain Smek have fed him through the years. His journey takes him from being a misfit who desperately wants to be a good Boov to someone who—thanks to his friendship with Tip—gradually realizes that he has been sold a bunch of lies. He finally realizes that it has nothing to do with how beautiful, vibrant, and emotional humans can be."

Roy Santua

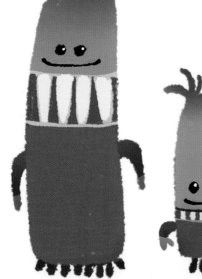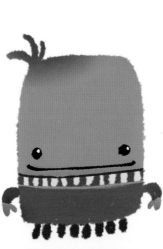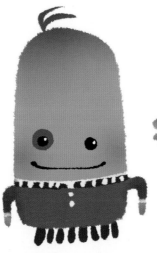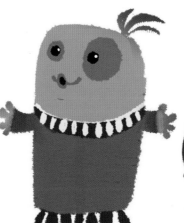

(top) Takao Noguchi, (above) Griselda Sastrawinata

26

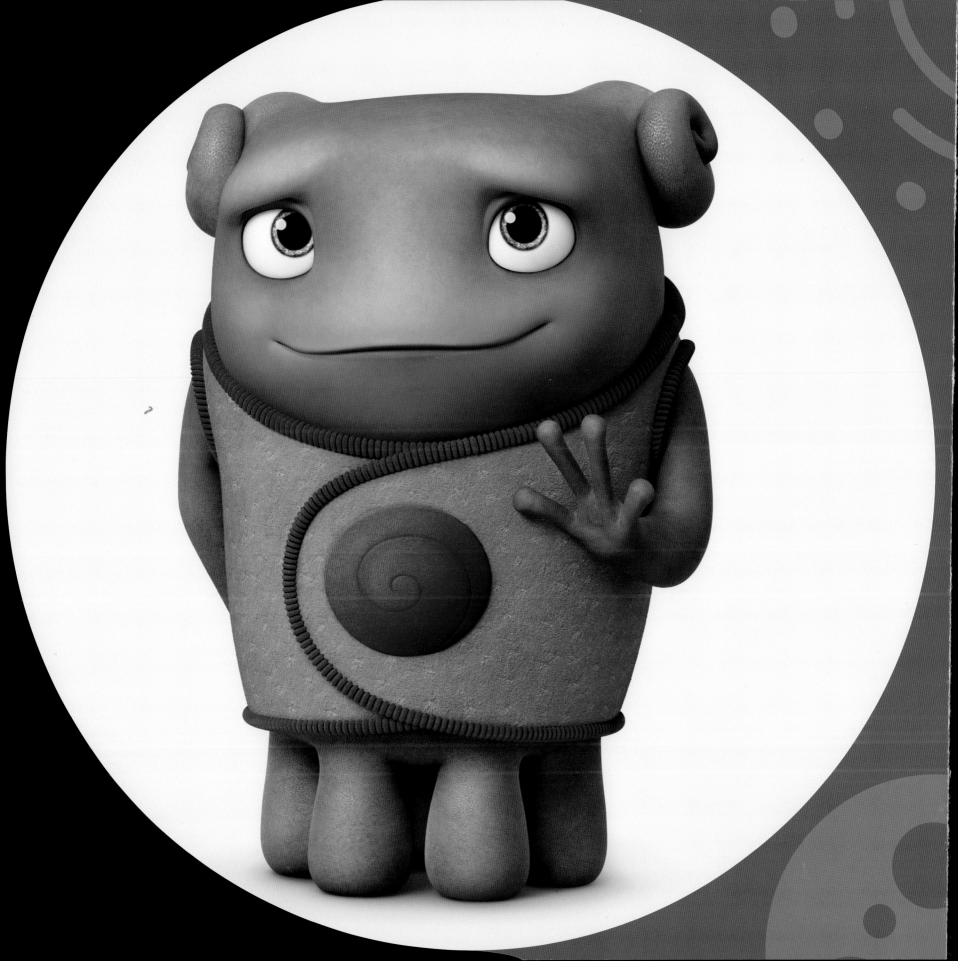

"Oh's journey throughout the film is about becoming human—both what it means and how it feels," adds producer Mireille Soria. "What's unique about our movie is the visual language we have in place to tell this story: We track Oh's emotions by seeing his color change and use these cues as benchmarks throughout the film."

According to Jason Reisig, head of character animation, the team spent a good amount of time exploring the possibilities of how a barrel-chested alien with six legs would actually move around. They observed footage of sea creatures such as octopus, jellyfish, and squids to define his movements. The color-changing characteristics of cuttlefish also helped them come up with ideas on how to animate a character whose skin color changed with his emotions.

"You are working with this cute, color-changing, squishy character with six legs, two opposable thumbs on each hand, and ears that look like elephant trunks," says Reisig. "Rigging a character like that is certainly a challenge. We did lots of animation tests to experiment with how Oh would get around, since his arms are more like tentacles," says Reisig. But however alien he is on the outside, Oh had to be a believable character who, through his journey with Tip, takes on very human traits. For inspiration, the team looked at acclaimed road trip movies and classic comedies such as *It Happened One Night* and *Planes, Trains and Automobiles*. Reisig explains, "We really explored works that begin with characters who are at odds with each other and struggle for understanding, and then finally reach something profound and find love, respect, and admiration for each other."

Producer Suzanne Buirgy adds, "One of the great themes of *Home* is how both our main characters learn that their preconceived ideas about others are wrong. Oh learns that his ideas about humans are wrong, and Tip learns that once you get to know someone, they are more than just a one-dimensional thing to hate—they become full and realized."

Johnson also saw the relationship between Oh and Tip as vital to their character development and worked hard to strike a balance between unrealistically friendly and overly antagonistic. "We were constantly trying to fine-tune their journey so that they progressed believably from their initial animosity to this powerful friendship," he says. "We wanted there to be a convincing emotional pitch so that the audience would root for these two charming characters every step of the way."

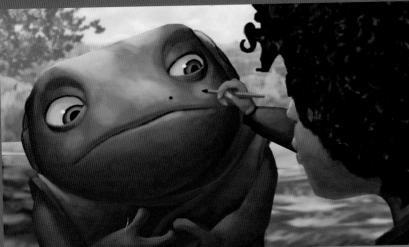

(top) Takao Noguchi, (center) Ron Lukas, (above) Bill Kaufmann

(above & right) Andrew Erekson

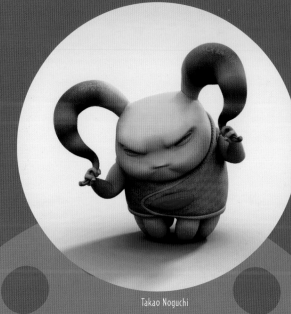

Takao Noguchi

Oh is a character who literally can't help but show his true colors. It's not only a theme of the movie but a concept inherent in the design.
—MIREILLE SORIA, PRODUCER

(top) Michael Lester, (center) Jeff Snow, (above) Takao Noguchi

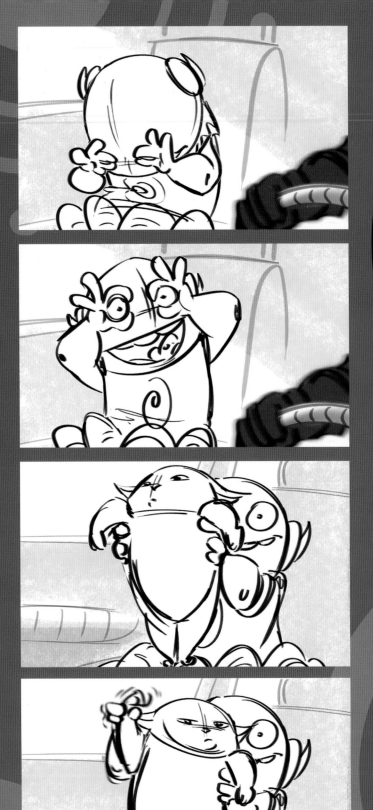

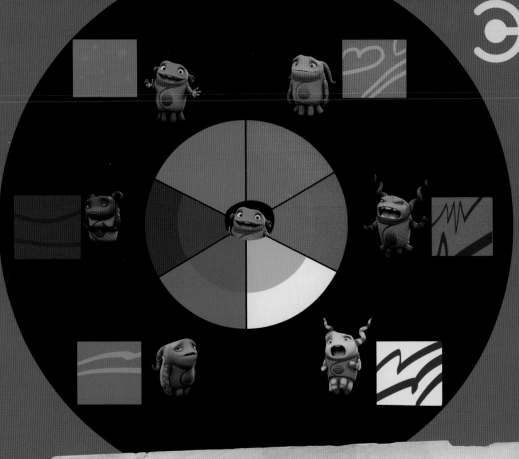

"I love the fact that our movie starts out telling the invasion story from the alien point of view. I enjoyed learning about the aliens and how they misinterpreted the human race. The Boov have a very simplified view of what make us tick, which allows us to make fun of ourselves a bit. More important, it allows us to hold up a mirror to humanity and reflect on what makes us special. I love how Oh gets to learn about art, music, dancing, hope, family, and friendship. He learns that humans are much more complicated than he originally was taught.

"One of my favorite moments in the movie is when Oh apologizes to Tip on behalf of the Boov, because he finally realizes what Captain Smek and the rest of the aliens are doing. It's an apology that is very heartfelt, and it sums up the growth that Oh had gone through. Tip, in turn, also gives him the keys to the car and tells Oh that he can call her Tip. It's the first time that we see that the two are friends. It's a wonderful moment, and it was great to see it come together.

"It's been amazing to see how our characters have evolved over the course of making the movie. With each step—from the script, to the story artist, to the voice actors, to the animation—the characters took huge leaps forward."

— Todd Wilderman, Head of Story

(above) Aimee Marsh, (top right) Kathy Altieri

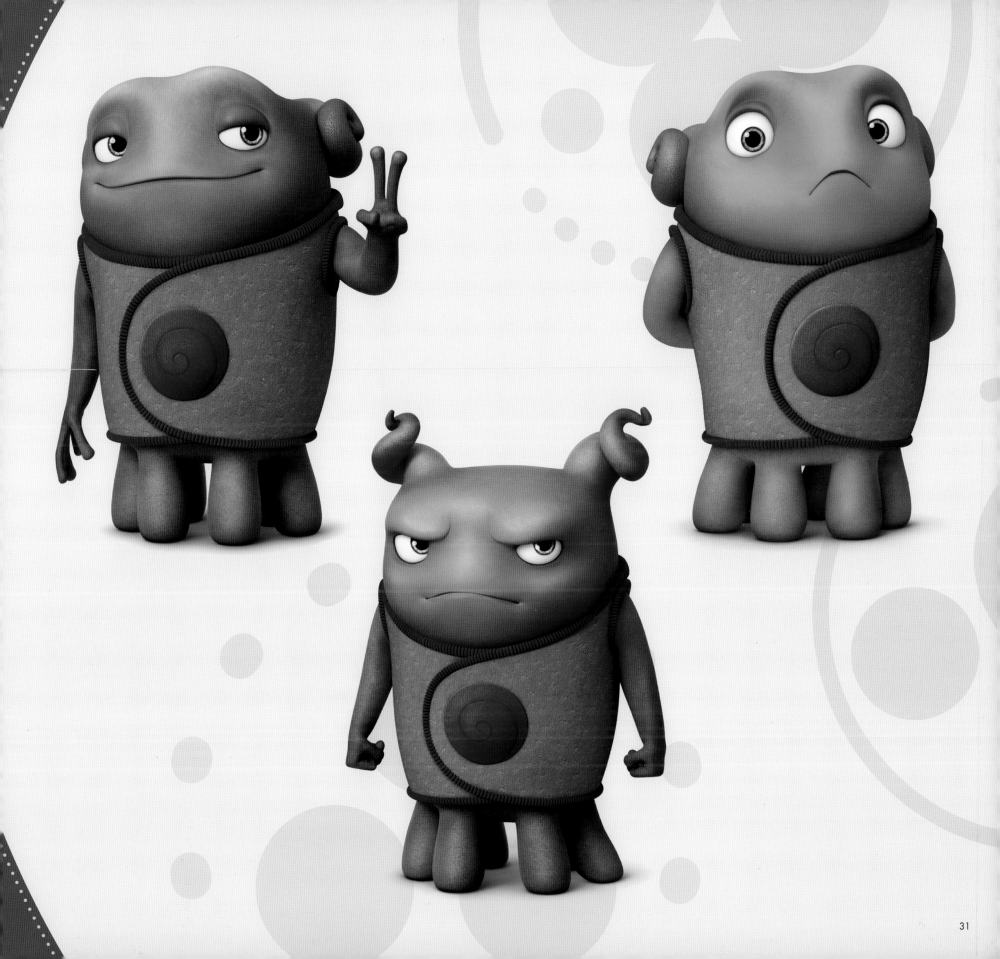

CAPTAIN SMEK

SINCE THE BOOV ARE A SUPERCILIOUS RACE, their great leader had to be a real piece of work. Haughty and self-deluded, Captain Smek is the classic self-important authority figure used as a comic foil. In the words of director Tim Johnson, "Captain Smek embodies the comedic worst aspects of his race. He is so arrogant that he is convinced the Boov have this entitled right to take over any planet they come across. He captures the swaggering arrogance of the Boov, but also their utter cowardice. He follows this philosophy that it's never too late to run away."

The filmmakers were fortunate to have the amazingly gifted comic actor, writer, and performer Steve Martin voice the captain. "It was a phenomenal, once-in-a-lifetime experience to direct Steve Martin." Johnson says. "He's one of the most brilliant artists I've worked with in my career. As soon as he came in and stood behind the mike, he brought a whole new dimension to the character and the movie. He understood the comic foibles of Captain Smek right from the start but also brought genuine vulnerability to the character, so you relate to him even as you laugh at his absurdity."

Character animator Jason Reisig agrees: "Having Steve Martin voice the character was such a huge coup for us. He really put all of his personality and general sense of fun and humor into the character. We were really able to use his poses and gestures to animate the character."

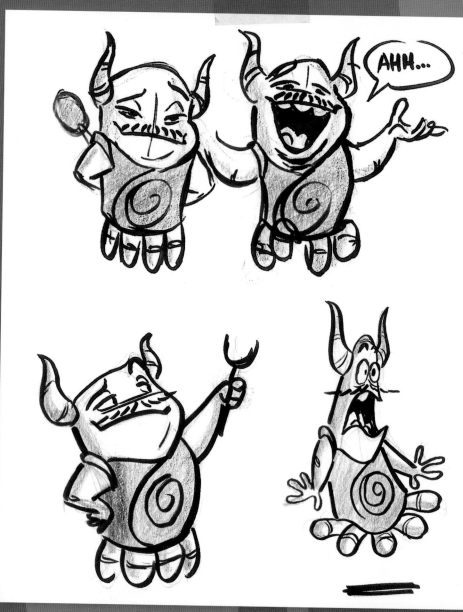

Andrew Erekson

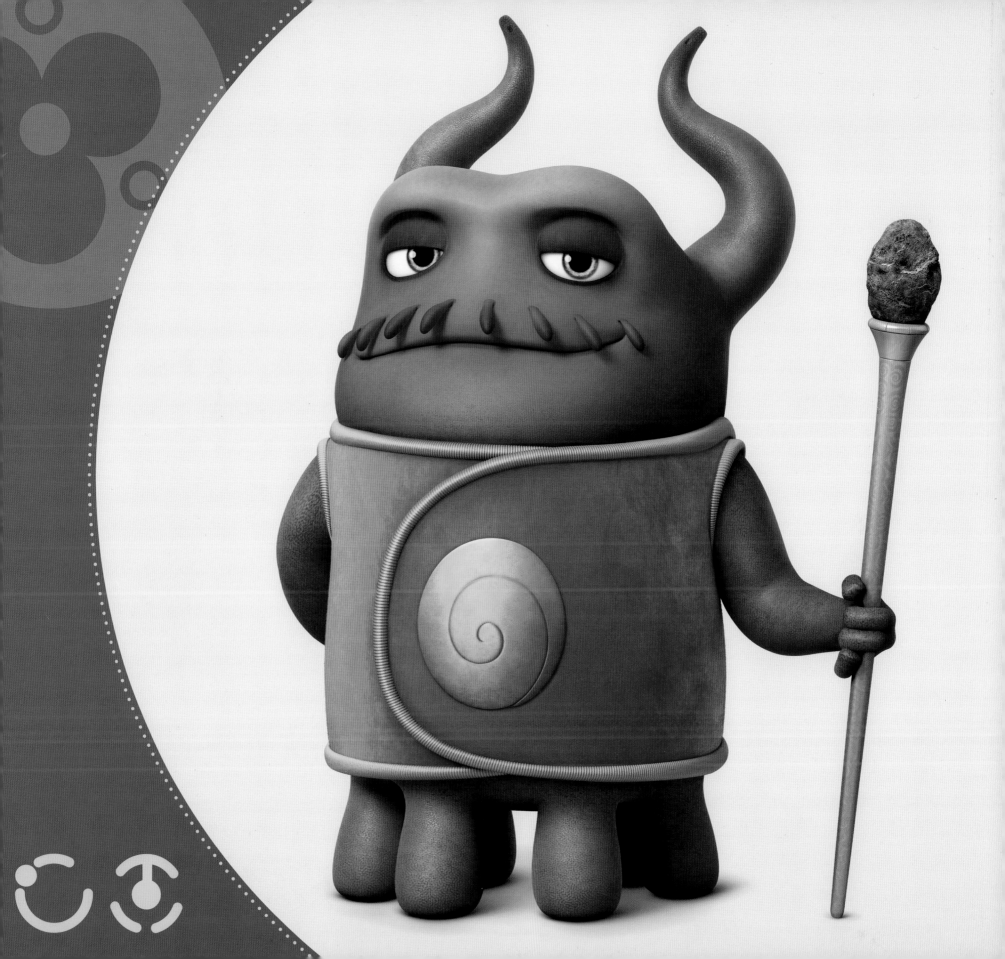

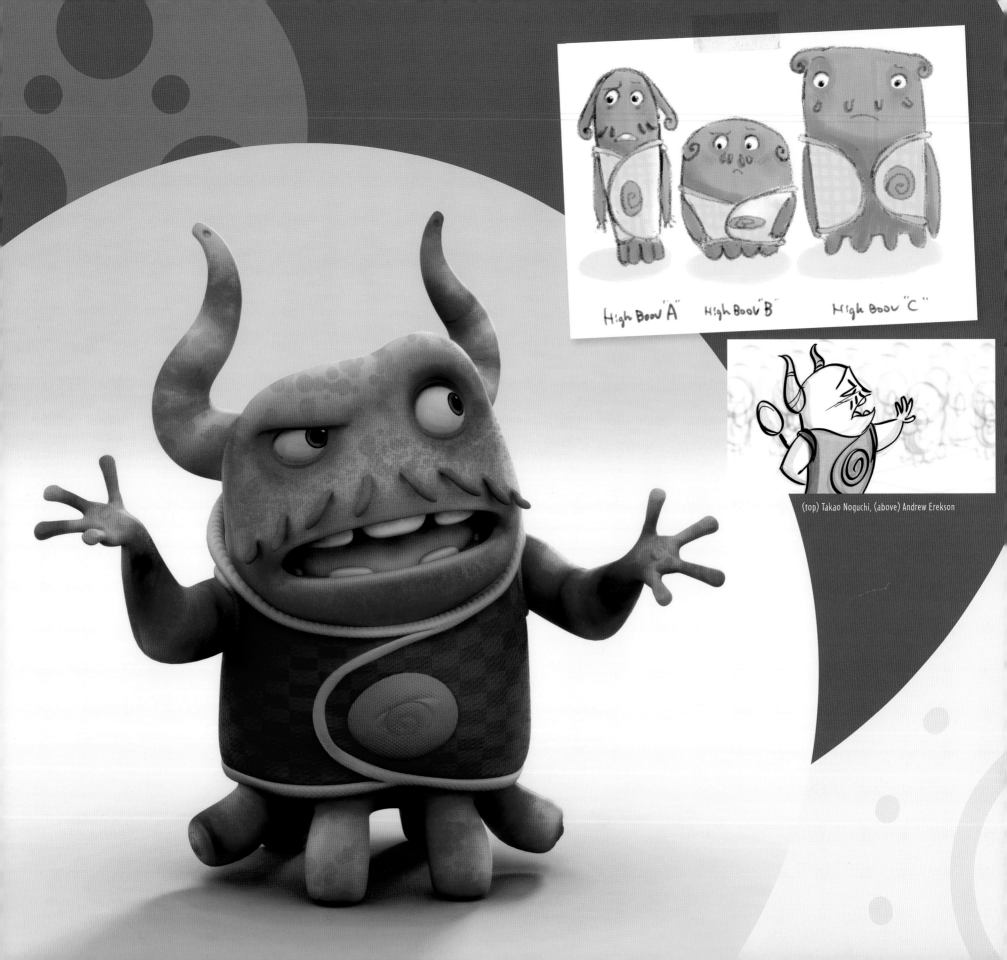

High Boov "A" High Boov "B" High Boov "C"

(top) Takao Noguchi, (above) Andrew Erekson

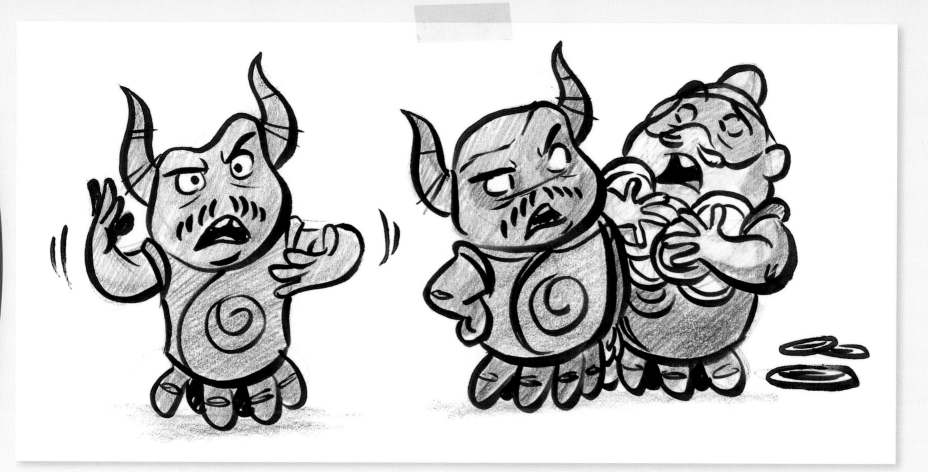

"For the Boov, we researched octopi, jellyfish, and squids. We had to figure out exactly how this alien moves—like an ant with suction cups. He doesn't have to move forward—he can move sideways or just slide in any direction. With six legs, he can turn around easily, and his movements are a lot more fluid than those of humans.

"What my team does is make CG puppets for the animators to use. The design comes to us, and then we add bones, muscles, clothes, wrinkles, etc. and hand these models to animation. We put in as much control in the animators' hands as possible. Our goal is to make it as natural as possible so that they can think of the performance and not about the rigging, which becomes invisible to them."

— Nathan Loofbourrow,
Character Technical Director Supervisor

(top) Andrew Erekson, (above) Michael Lester

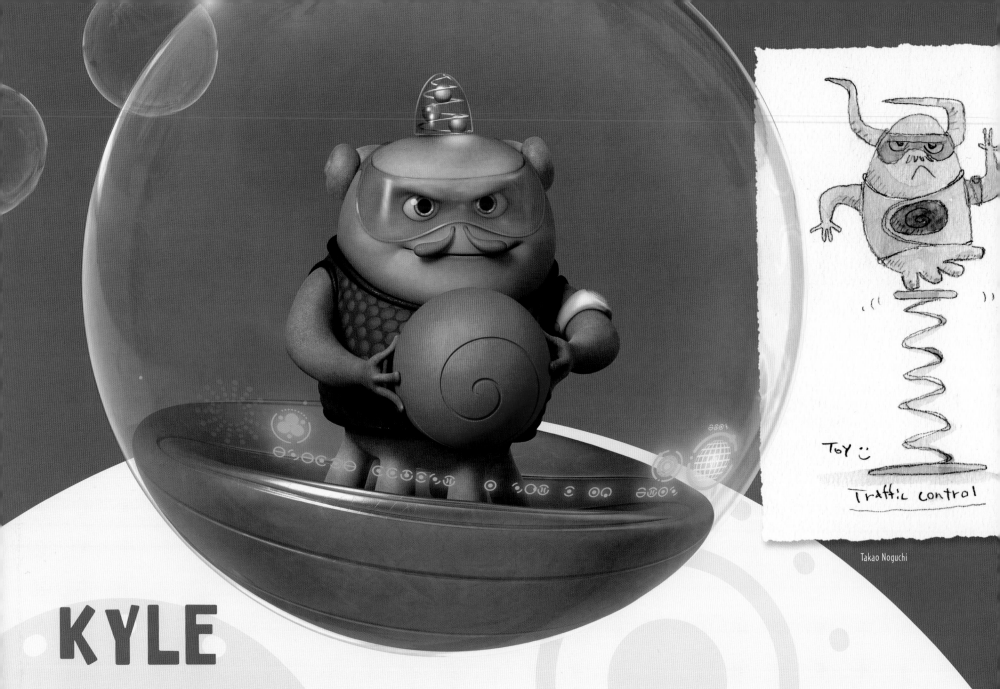

Takao Noguchi

ToY :(
Traffic control

KYLE

IN ADDITION TO OH AND CAPTAIN SMEK, the befuddled Boov police officer named Kyle is another one of *Home*'s great comedic characters. Voiced by Matt Jones (*Breaking Bad, Mom*), Kyle is the official in charge of pursuing Oh when he goes on his globetrotting adventure with Tip. At the beginning of the film, Kyle is an ordinary Boov traffic cop in the city, content to do his job. But everything changes when the outgoing Oh makes his acquaintance during one of Kyle's lunch breaks. Once Oh becomes a wanted fugitive, the poor, beleaguered Kyle is given the task of chasing down Oh, even though he wants nothing more than to go back to his regular life. As head of story Todd Wilderman explains, "Kyle started out being just another Boov who is simply annoyed with Oh. But by the end of the movie, he's been so involved with this chase and has witnessed so much that he gets to evolve as well."

The dynamic between Kyle and Captain Smek also provides the movie with some of its great comedic moments. Kyle is constantly protesting and trying to convince the Captain that he's not qualified for the task at hand. But the unstoppable Captain Smek insists on promoting him to a position that is clearly out of his skill level, for the sole purpose of pursuing Oh.

Kyle's design was inspired in part by the classic frustrated authority figure in comedy movies. "We were thinking along the lines of the old traffic cop in *Smokey and the Bandit*," recalls Jenkins. "He is overweight and only a few years away from retirement. He is rounder than your average Boov and sports a funny moustache. We have no idea what it's made of. He also wears a traffic cop helmet, composed of a pair of glasses and a light that sticks on top of his head like a police car!"

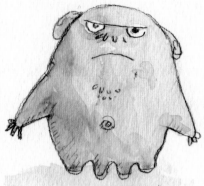
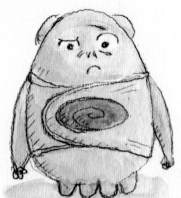

naked

Carl SMEK JLo

stretched

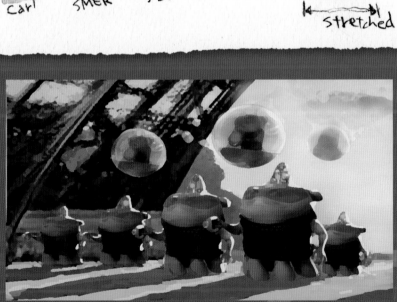

Ron Lukas

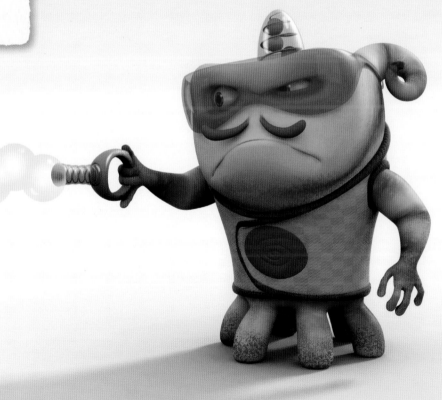

(above & top) Takao Noguchi

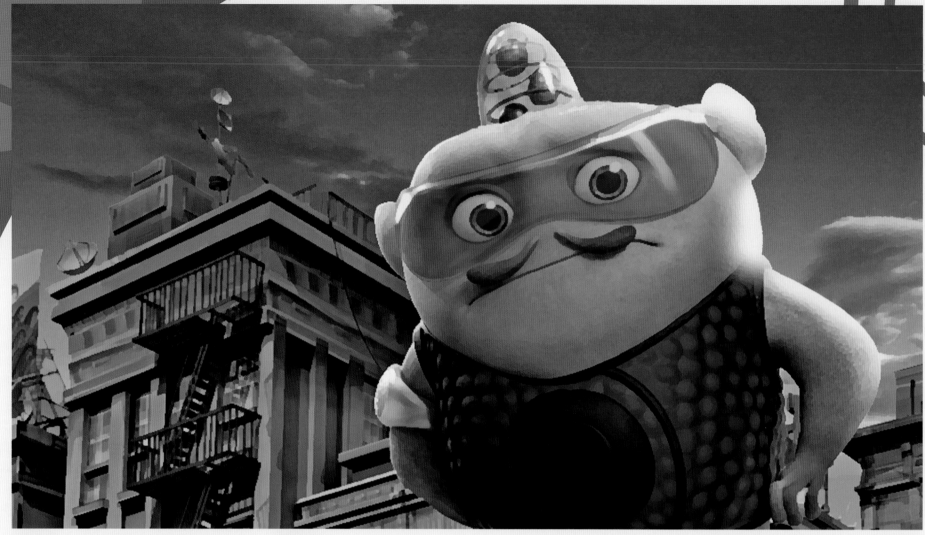

Andrew Erekson

(top) Ron Lukas, (above) Todd Wilderman

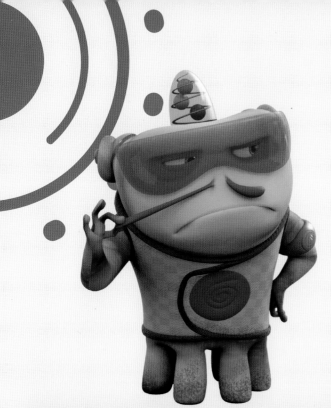

"We had this great chance to really work on the performance of these two characters and a great villain, as compared to some of our previous movies where we had a large cast of characters—projects like *Over the Hedge*, *Shrek*, and *Kung Fu Panda*. We love getting these great acting shots and really exploring the performances.

"It's always fun to explore the idiosyncrasies of these alien characters. They have six legs and two opposable thumbs on each hand, as well as ears that resemble elephant trunks. So we had to figure out how they work with these hands, how they use their nostricles—rigging a character like that is a great challenge. We rigged them with DreamWorks' new software, Primo, which gave us a lot of intuitiveness and speed.

"We looked at weird and wonderful sea creatures to get inspiration for how our aliens behaved. We researched cuttlefish to learn more about color-changing behavior of the skin. We also learned that it was pretty tricky to animate a twelve-year-old girl. It's a very challenging age to depict, because at twelve, Tip is not quite an adult, and she's not a little kid. We looked at a lot of child actors, but a twelve-year-old actor tends to act much older than her age. So we looked at a lot of video references from our animators' kids. Plus, Tip is a tougher character than most twelve-year-olds as she can handle most challenging situations that are thrown at her. She had to be both smart and vulnerable."

— Jason Reisig, Head of Character Animation

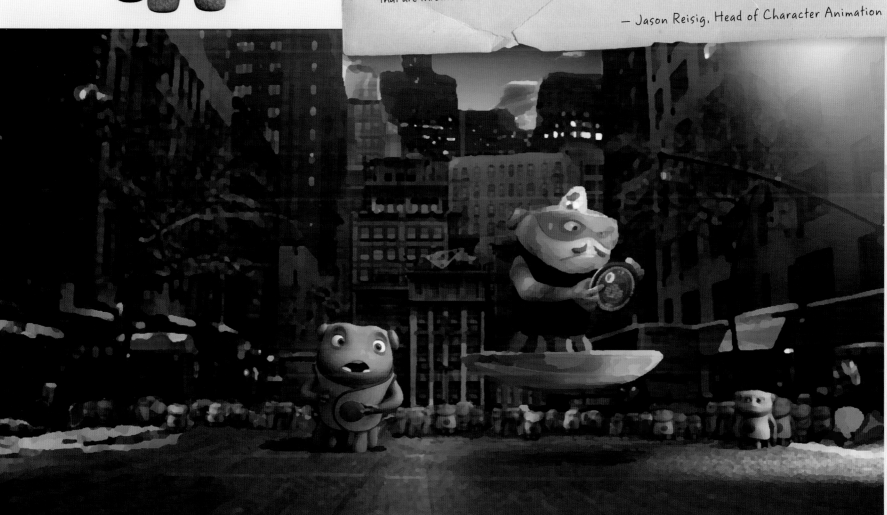

(top) Takao Noguchi, (above) Ron Lukas

ALIENTOLOGY 101

A FEW THINGS YOU NEED TO KNOW ABOUT THE BOOV

◄ The Boov are amphibious creatures that evolved from simpler aquatic life forms. In their early stages of life, they resemble tadpoles, and then eventually they lose their tails, develop ears that turn into nostricles, and begin to walk. The cycle closes in during old age, when they turn into a "gummy glob."

◄ Another special characteristic of the Boov anatomy is that they have two uvulas. We get a close-up shot of Oh's uvulas in the pre-China scene where he and Tip are hanging out, and he ends up snoring.

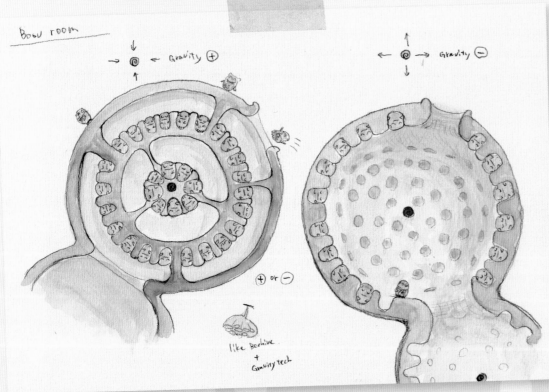

Boov room

Gravity ⊕

Gravity ⊖

⊕ or ⊖

like Beehive + Gravity tech

(top left, right & above) Takao Noguchi, (right) Vy Trinh

The Boov all carry Boov Pads, which are very powerful personal computers mainly used for communication. The Boov like to keep them in the spiral pouch on the front of their tunics. ►

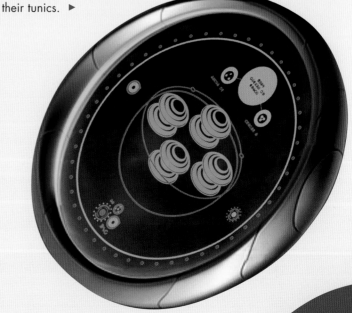

The Boov sleep in cubbyholes in special bubbles especially designed for optimum rest.

40

The Boov's skin changes color as they experience different emotions. In case you run into them in the wild, here is how to figure out their inner emotions: purple (normal), blue (sad), green (lying), pink (in love), yellow (scared), red (angry), and orange (angry).

(above) Bill Kaufmann, (left) Le Tang, (below) Stan Seo

As a way of calming down the population of their invaded planets, the Boov research their favorite music. For Earth, they use the familiar, comforting music of ice cream trucks. (Think "The Mister Softee Jingle" and "The Entertainer.")

In the movie, we see how the Boov use their bubble guns to destroy buildings, but the bubbles are also used for good, as safe modes of transport or as means of carrying belongings, similar to how we use suitcases. ▶

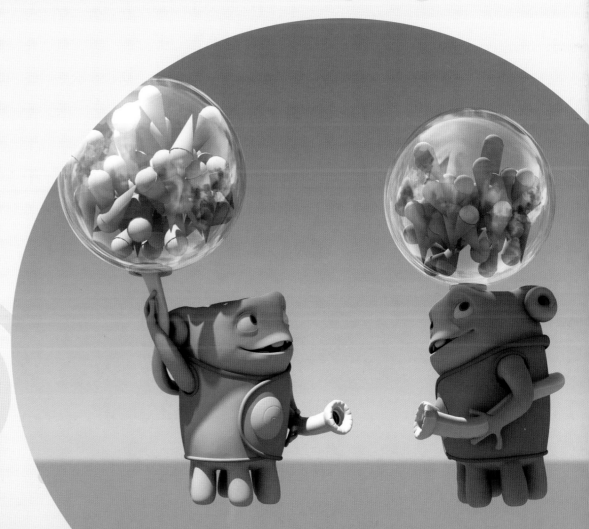

BOOV SHIPS

FOLLOWING THE BOOV'S CIRCULAR ICONOGRAPHY, the Mothership itself is a colossal sphere. Everything the Boov need for interplanetary travel is contained within this planetoid-size spacecraft. The Boov have mastered the use of the most efficient design in the universe, turning their mothership into a massive, bubble-powered billiard ball in space.

Stored within the Mothership are individual bubble-like ships that serve as the Boov's vehicles. The unique design of these ships lends itself especially well to animation. "Because the Boov have great control over gravity and their ships are based on floating bubbles, we were able to really explore our 3-D stereoscopic abilities," says director Tim Johnson. "The ships leave these beautiful gossamer trails, and we were able to float things off the screen gently or forcefully and even have them fly right in front of the viewer's nose."

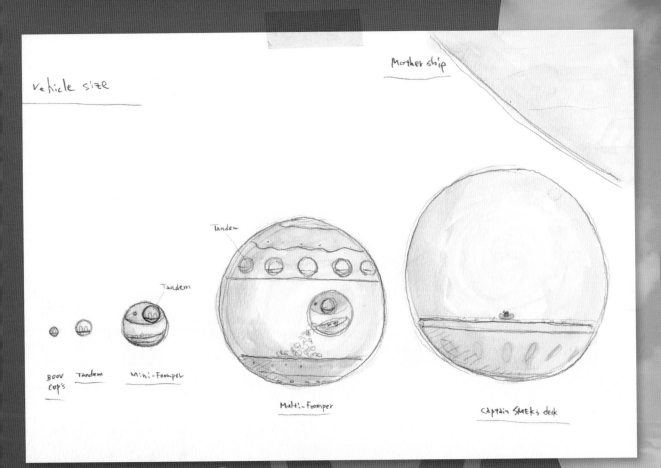

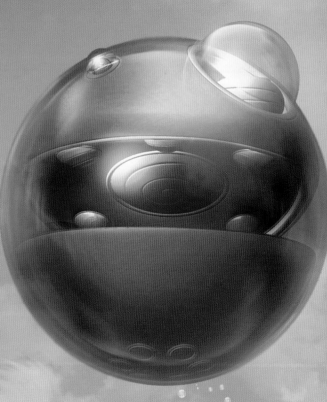

(above) Takao Noguchi, (right) Jason Scheier

42

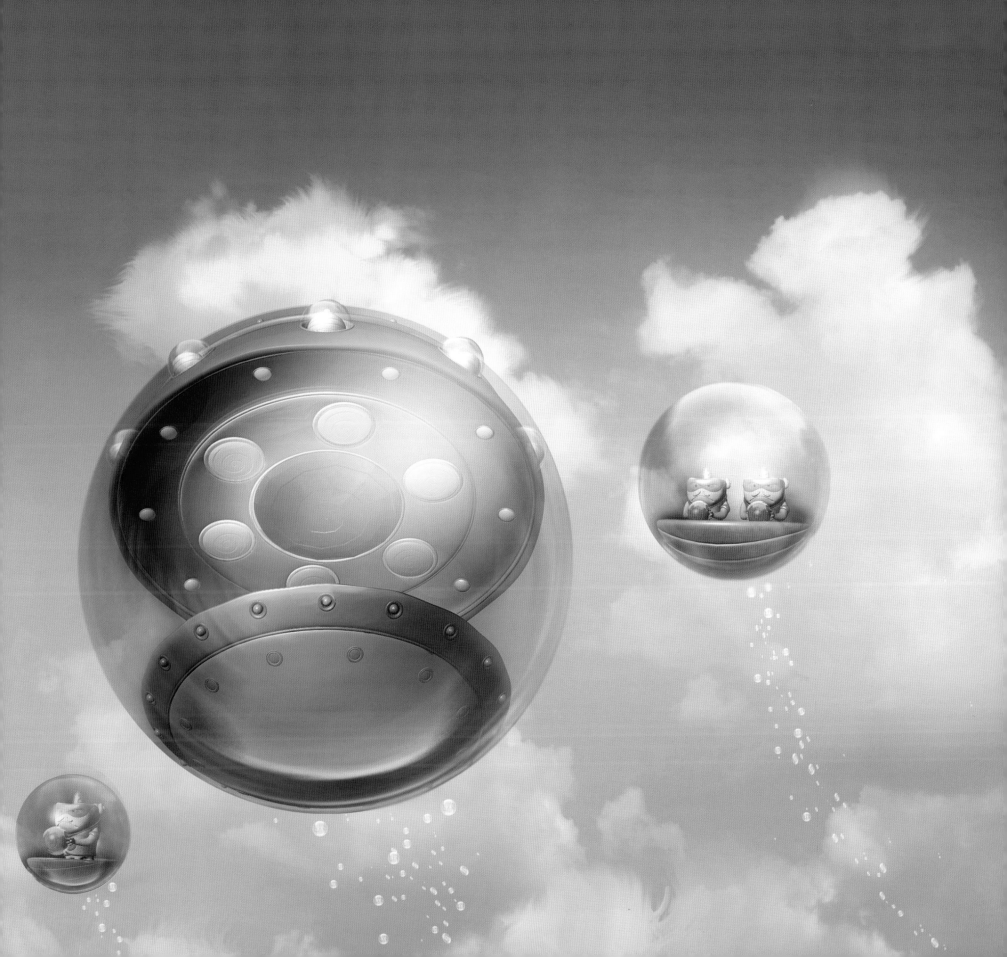

Inside of mothership

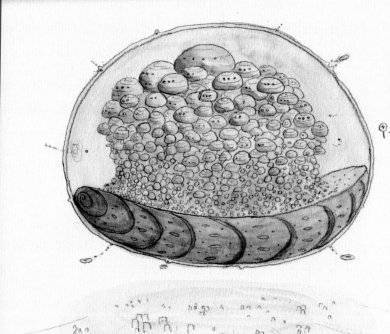

bedroom

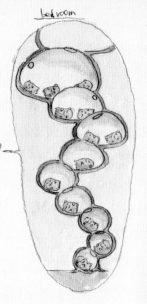

Simon Rodgers

(top & above) Takao Noguchi

(above & following pages) Olivier Tossan

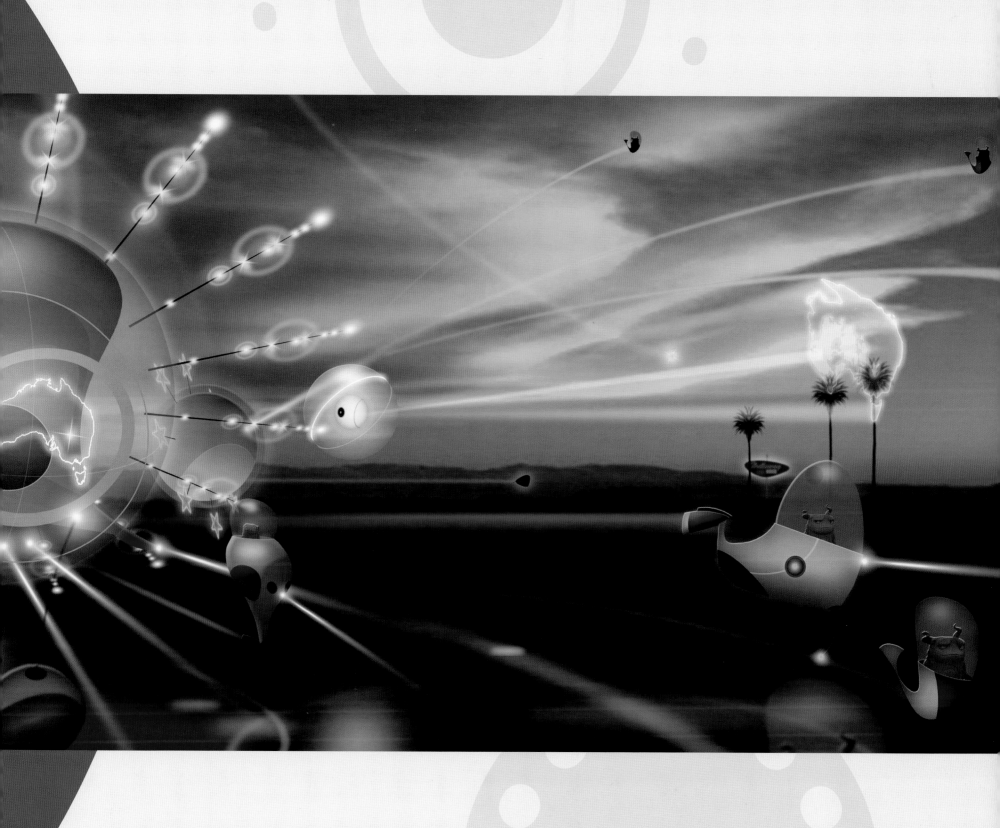

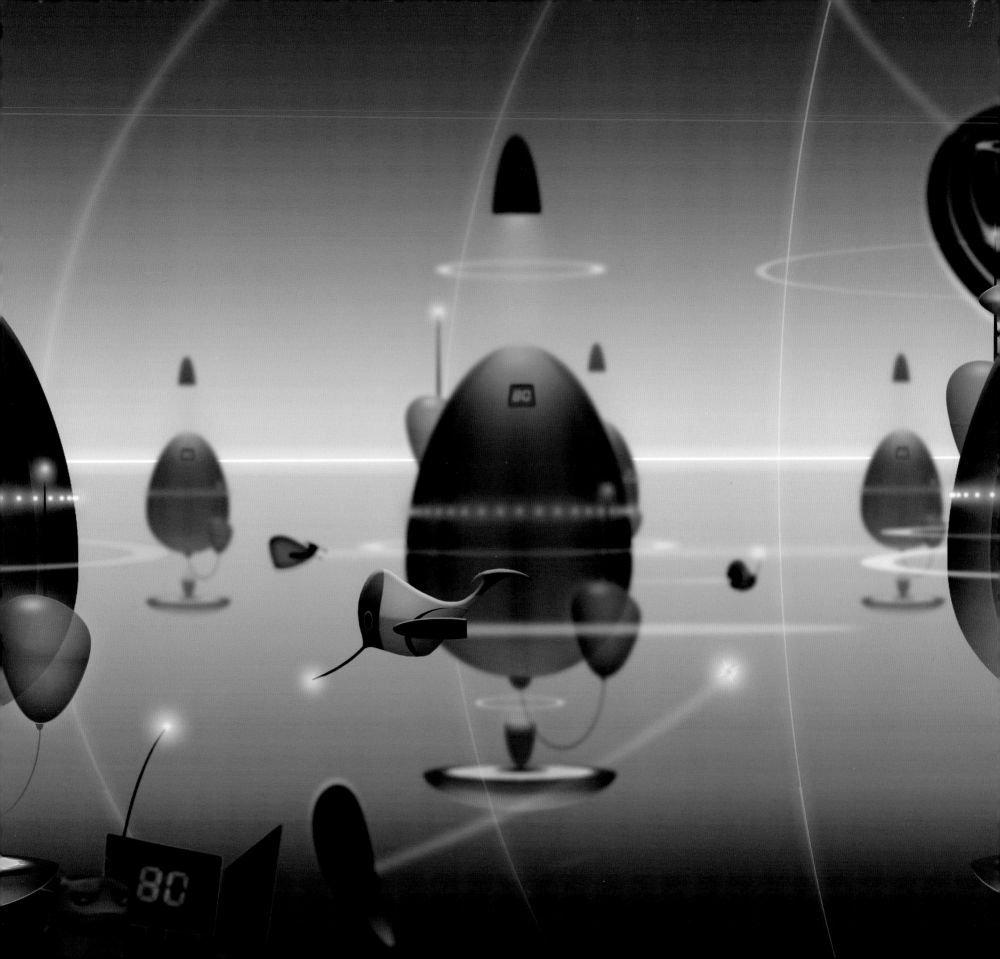

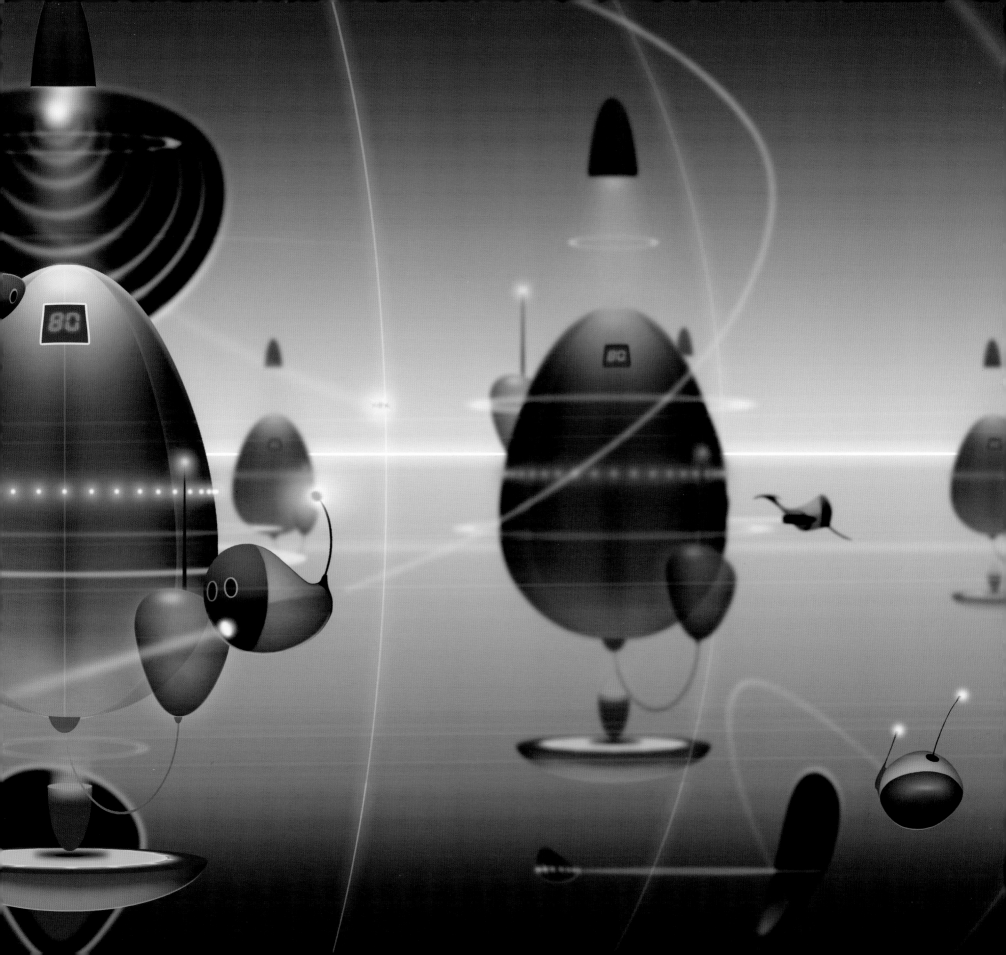

Boov's red scoop bubble on the vehicle

(pedals)
six holes for
tube leg control

top view

bottom view

Back

Front

Red scoop Bubbles

Bule Capture bubble bottom

Red scoop bubble bottom

search light

Holes for tube legs

Blue capture bubble.

vehicle walk'in mode

Takao Noguchi

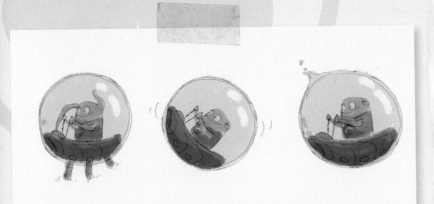

Takao Noguchi

"One of the fun challenges of this movie has to be working with Boov aliens that have six legs and can move in any direction they want, since in crowds, we usually work with characters that just move straight. Here we have an invasion, so there are Boovs everywhere—you have tons of aliens walking and flying all over the place. We wanted the aliens to be close to each other and look like they're walking next to each other, but not avoiding one another. We wanted them to look like they were magically crossing paths but never intersecting each other, which is quite an interesting challenge. Of course, the characters also change colors, so we had to be very mindful of that, especially in the way our surfacing is implemented.

"In the climactic scenes of the movie, when the Gorg and the Boov arrive, we have thousands of these aliens in our crowd scenes. The Boov have put all the human beings from our entire planet in this one spot, and we have to see all of them represented. So you have tens of thousands of characters [by] the end of the movie—you have all these humans represented at the reserve, on top of all the aliens that are featured in this scene."

— Sean Fennell, Head of Crowds

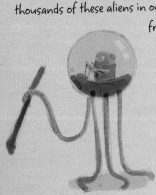

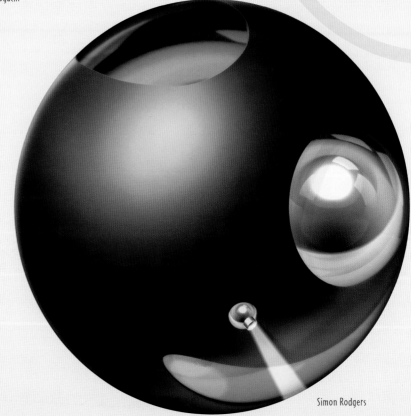

Simon Rodgers

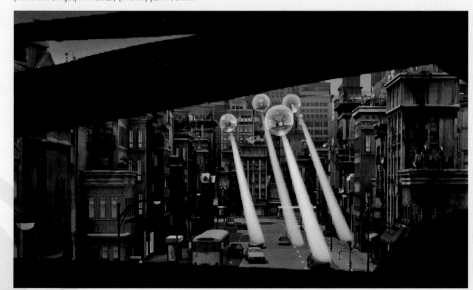
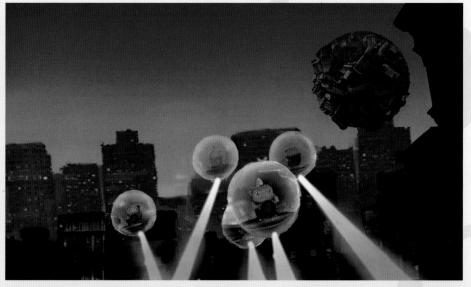
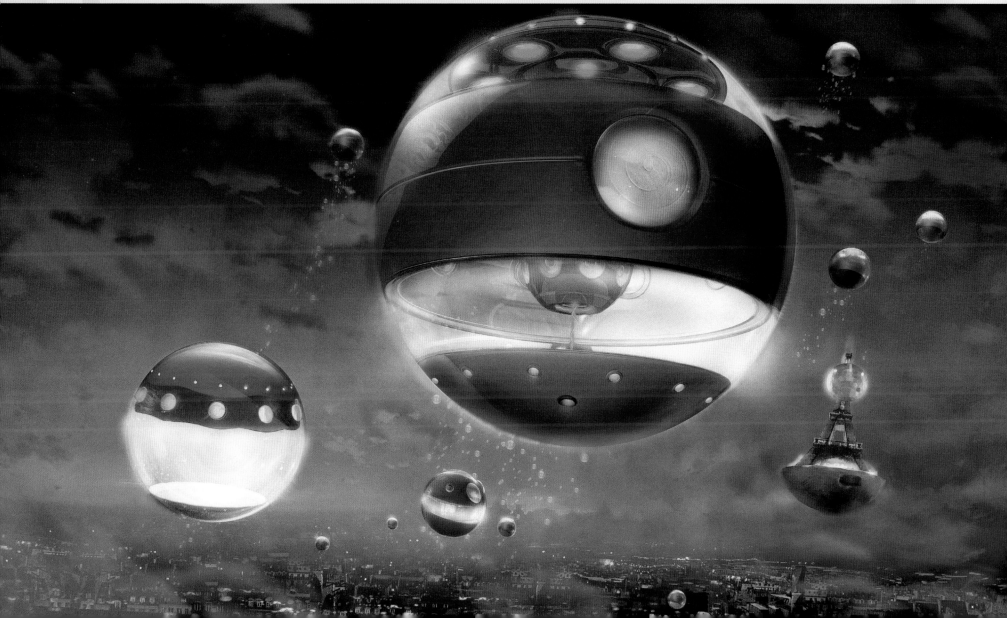

THE BOOV MOTHERSHIP

Mother ship

Earth

Mother ship = Moon

SAME SIZE AS MOON

Takao Noguchi

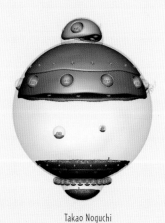

Takao Noguchi

Ron Lukas

Mikael Genachte-Le Bail & Onesimus Nuernberger

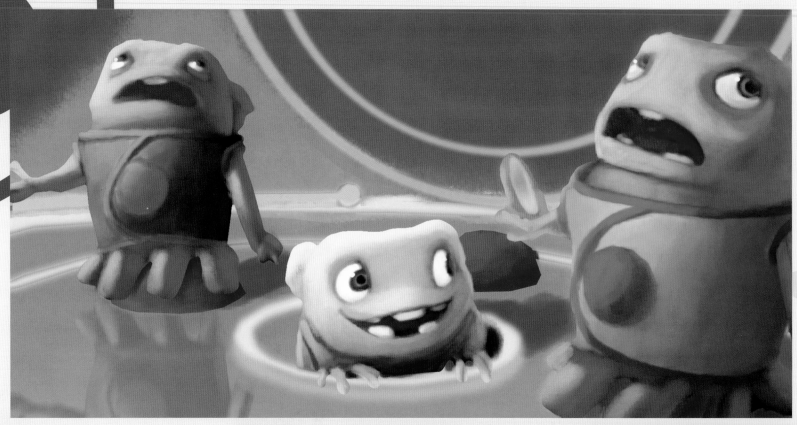

Because the Boov... ships are based on floating bubbles, we were able to really explore our 3-D stereoscopic abilities.

—TIM JOHNSON, DIRECTOR

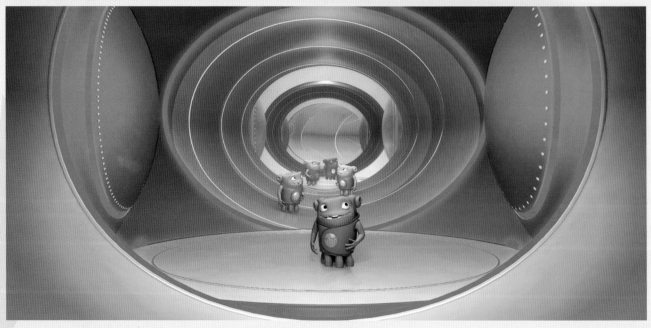

(top) Bill Kaufmann, (above) Stan Seo, (left) Takao Noguchi

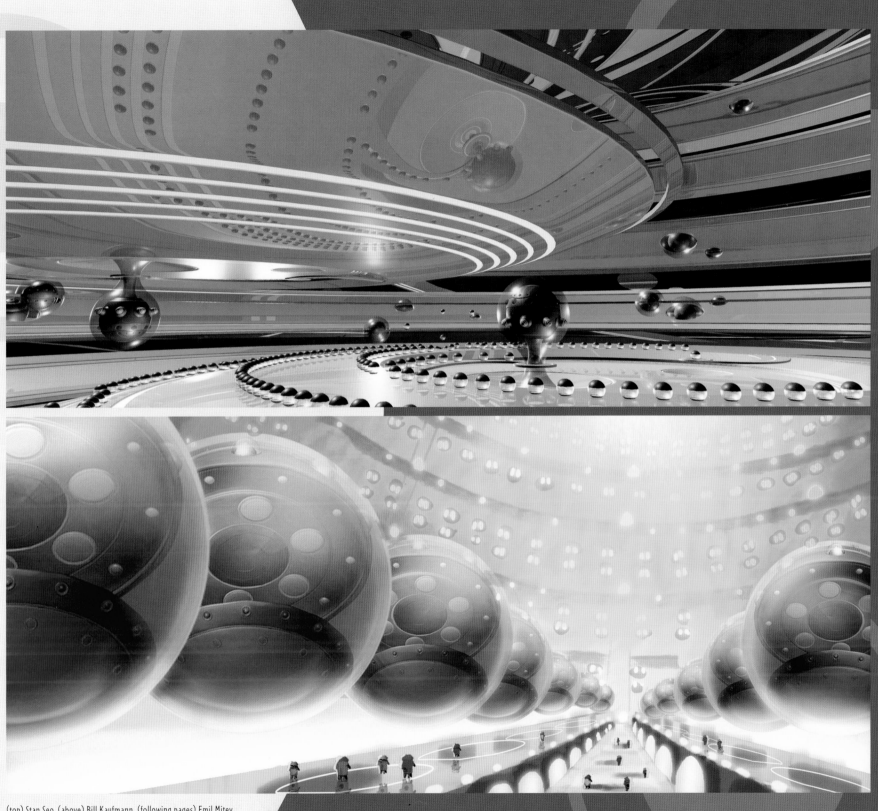

(top) Stan Seo, (above) Bill Kaufmann, (following pages) Emil Mitev

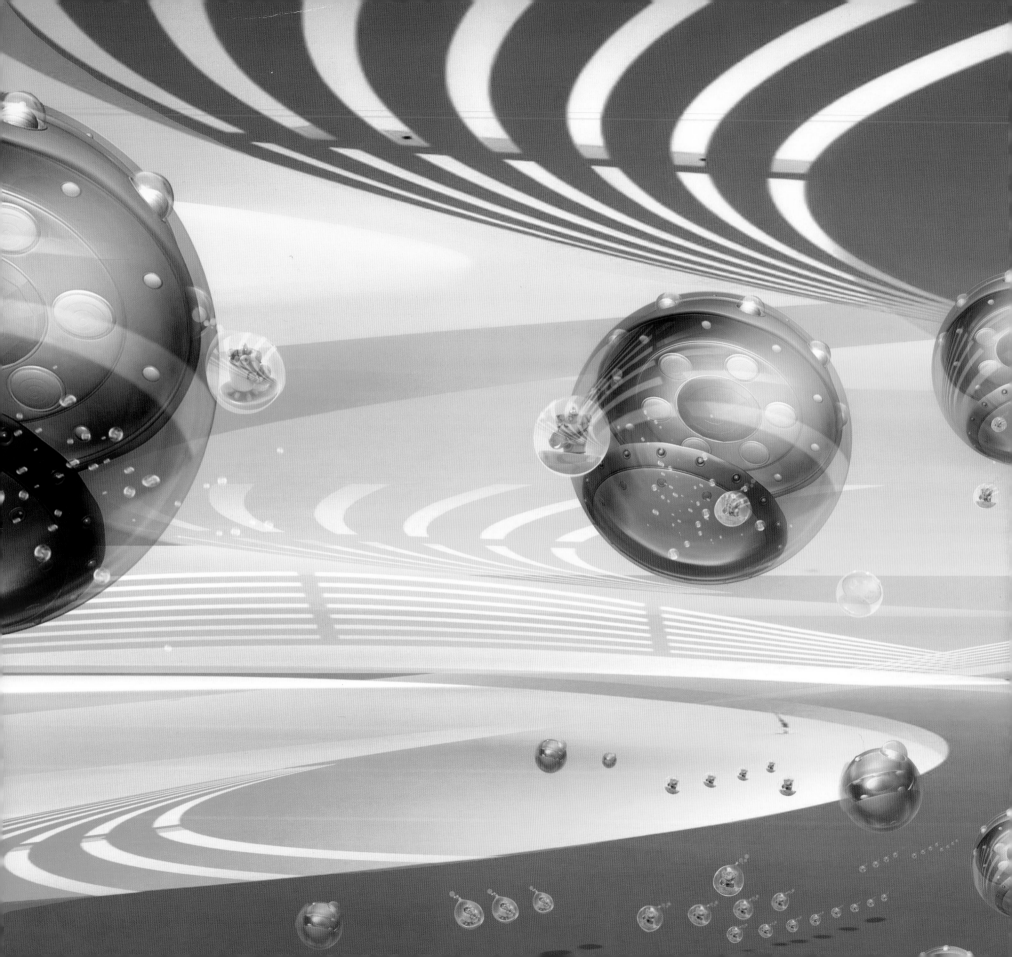

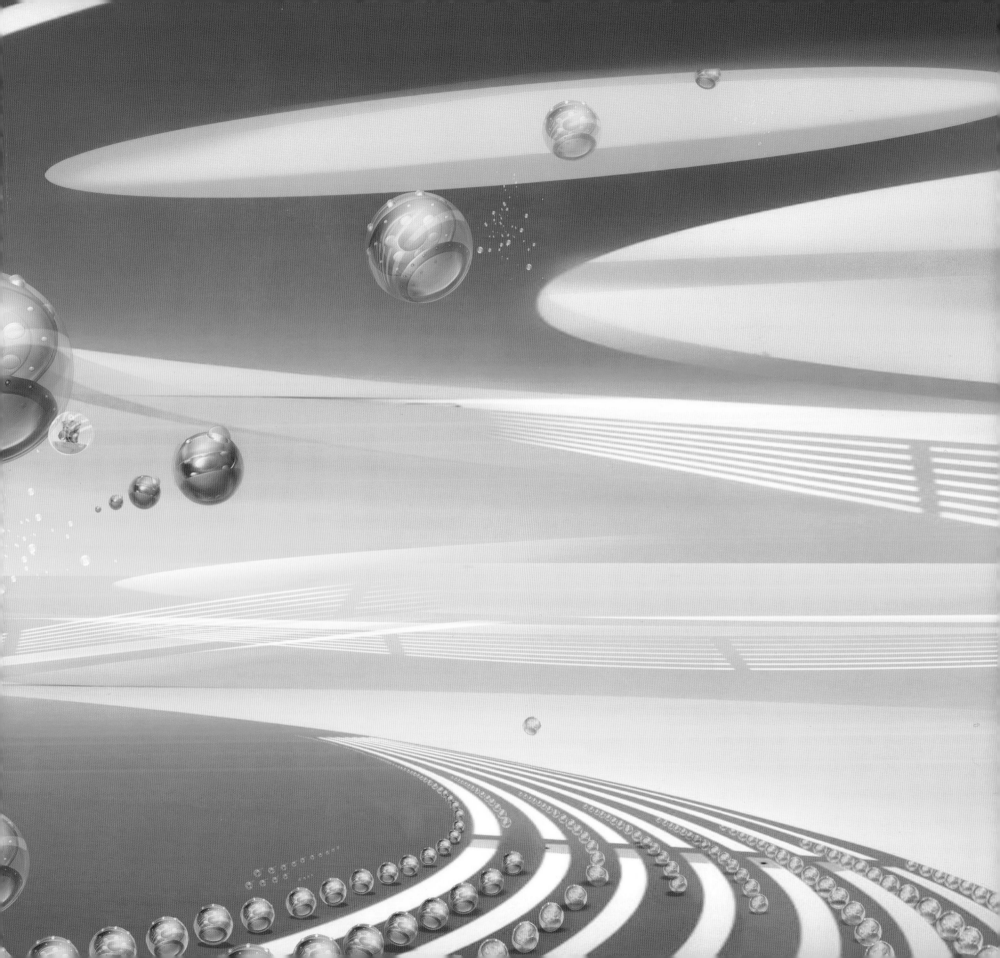

THE SMEK DECK

SMEK'S CENTER OF OPERATIONS—otherwise known as the "Smek Deck"—is a detachable bubble located at the top of the Mothership. This mobile command center is the hub of the Boov's invasion of Earth and a symbol of Smek's authority. The Captain issues his commands from an expanding platform of levitating, pancake-like discs.

"The Boov possess technology way beyond our own, with simple principles based on bubbles and gravity control," says Kathy Altieri. "These 'pancake stacks' that Captain Smek rides on are a good example—he seems to control them effortlessly, almost telepathically."

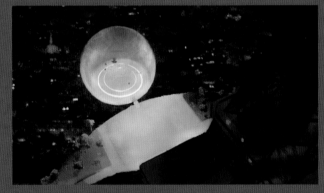

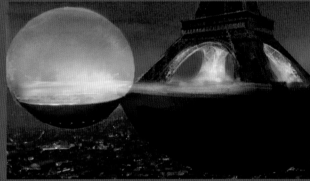

(above) Ron Lukas, (right) Emil Mitev

56

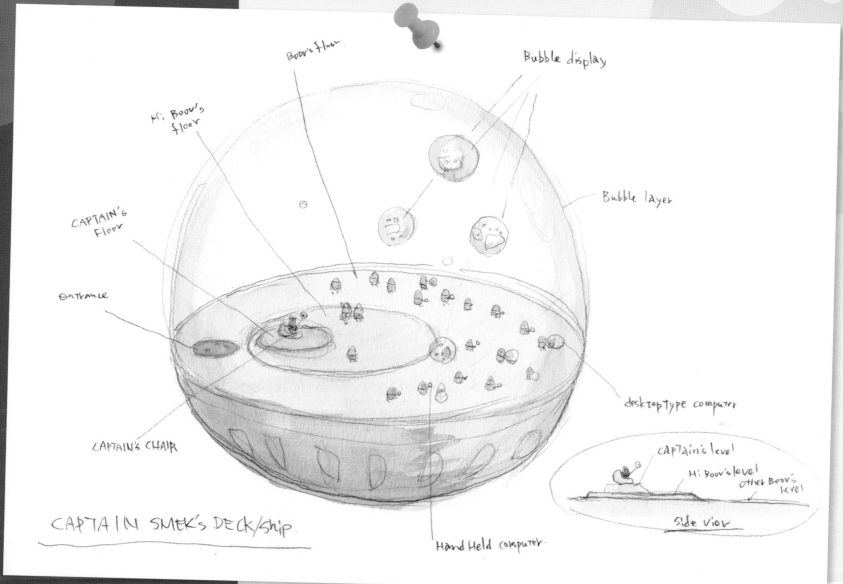

Boov's floor

Hi. Boov's floor

Bubble display

CAPTAIN'S Floor

Bubble layer

Entrance

CAPTAIN'S CHAIR

desktop type computer

CAPTAIN SMEK'S DECK/Ship

Captain's level

Hi Boov's level

other Boov's level

Side view

Hand Held computer

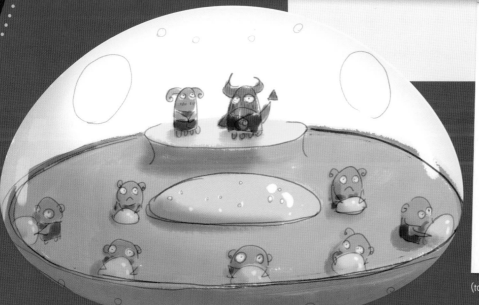

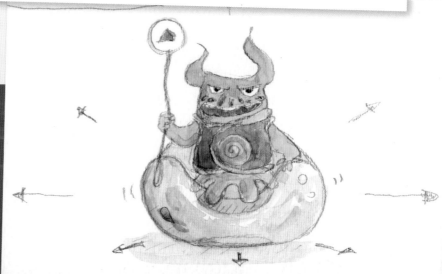

(top, left & above) Takao Noguchi

SHIP GRAPHICS

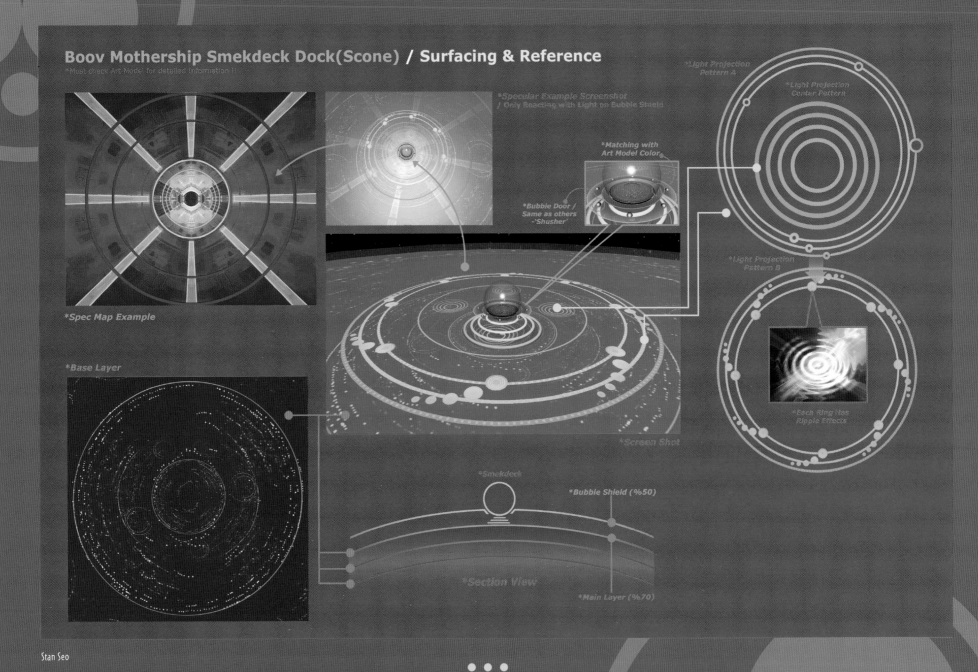

Boov Mothership Smekdeck Dock(Scone) / Surfacing & Reference
*Must check Art Model for detailed information !!

*Spec Map Example

*Base Layer

*Specular Example Screenshot
/ Only Reacting with Light on Bubble Shield

*Matching with
Art Model Color

*Bubble Door /
Same as others
-'Shusher'

*Light Projection
Pattern A

*Light Projection
Center Pattern

*Light Projection
Pattern B

*Each Ring Has
Ripple Effects

*Screen Shot

*Smekdeck

*Bubble Shield (%50)

*Section View

*Main Layer (%70)

Stan Seo

Part of the charm of the Boov technology is its simplicity, where we get to play and
have fun artistically but don't have to work too hard to explain ourselves.
—KATHY ALTIERI, PRODUCTION DESIGNER

(top) Vy Trinh, (above) Stan Seo

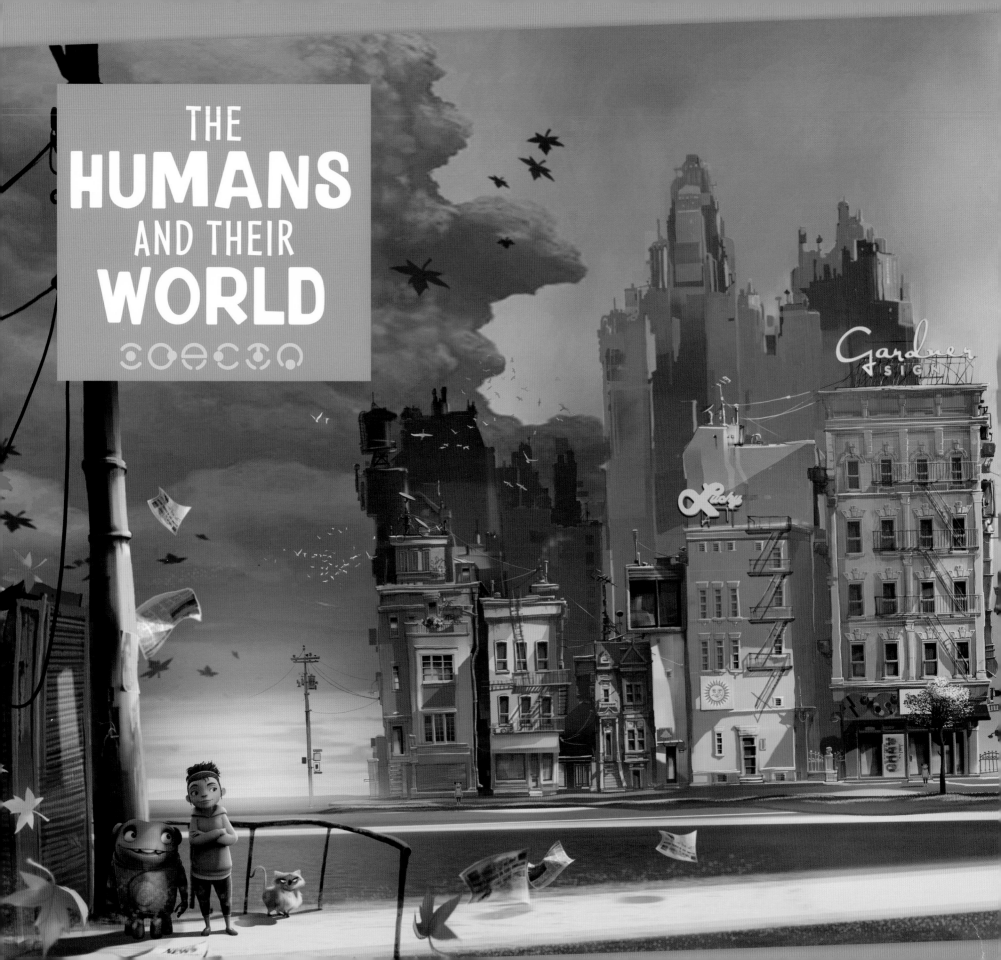

THE HUMANS AND THEIR WORLD

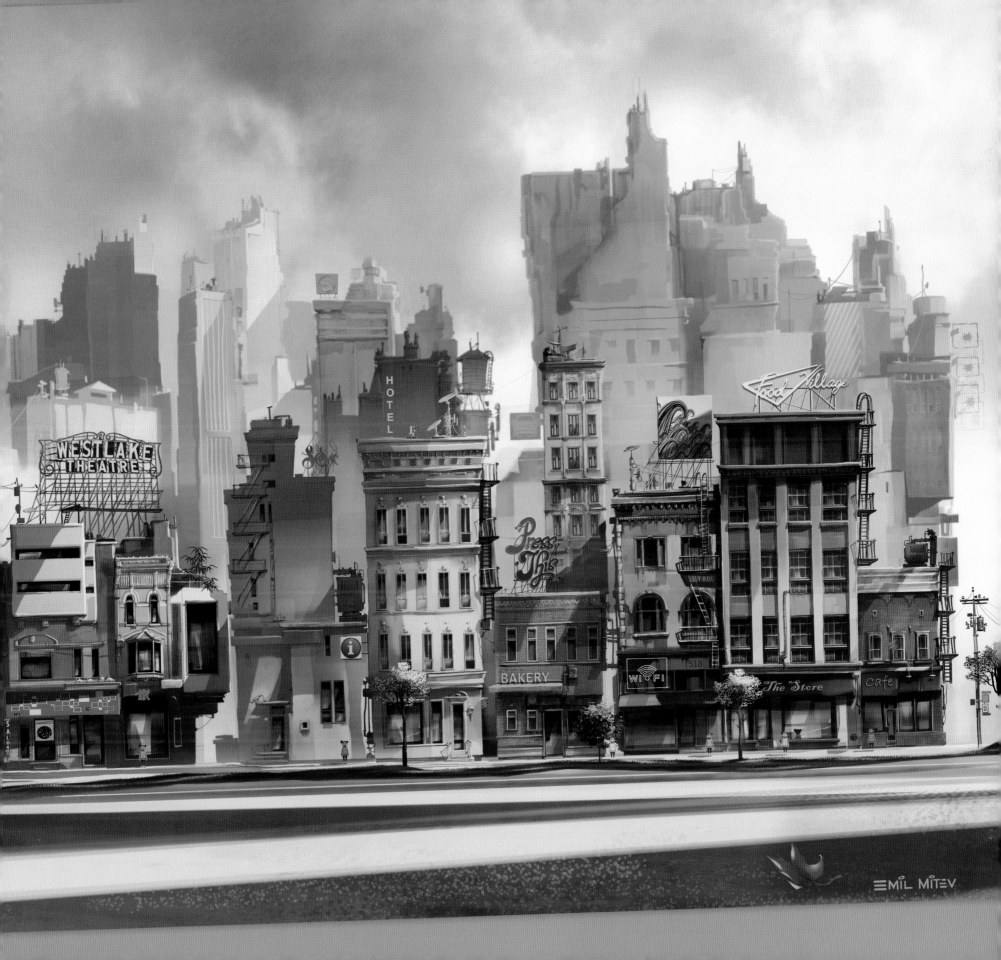

TIP

SHARP, BRAVE, AND READY TO BATTLE anything that dares keep
her from her mother, Gratuity "Tip" Tucci is the remarkable young girl at the heart of
the movie. Her friendship with Oh is the driving force that really defines the *Home*
experience. "She introduces Oh to the concepts of hope, family, art and music, and
all the things that make us human," says director Tim Johnson. "All these elements are
channeled from this wonderful young girl to this arrogant little alien until he finally
has to admit that he'd rather be a human than a Boov."

Johnson felt quite strongly that, from a design standpoint, Tip would stand out
from other portrayals of female characters in media and resemble an actual girl.
Producer Suzanne Buirgy echoes that sentiment: "For a long time, girls all looked alike
in the animated world, and it's only recently that we've begun to see representations
of what girls look like in the real world." As production designer Kathy Altieri recalls:
"She wasn't going to be your typical skinny girl character; we wanted her to have
good solid legs and a lean stomach. She was not a little girl, but not a woman yet.
We really wanted to find the right body proportions for her, so we played around with
the structure of her belly, her torso, her hips, and the proportion of her body and her
head. So we ended up with this character who definitely looks like a real girl."

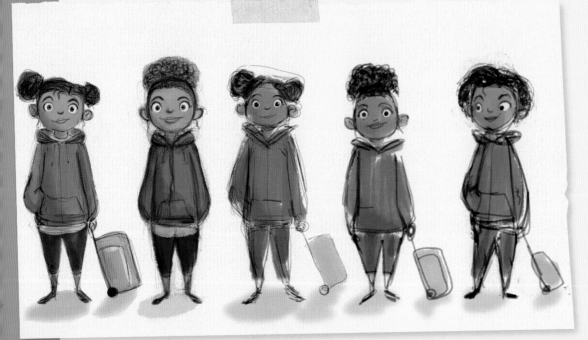

(previous pages) Emil Mitev, (above) Takao Noguchi

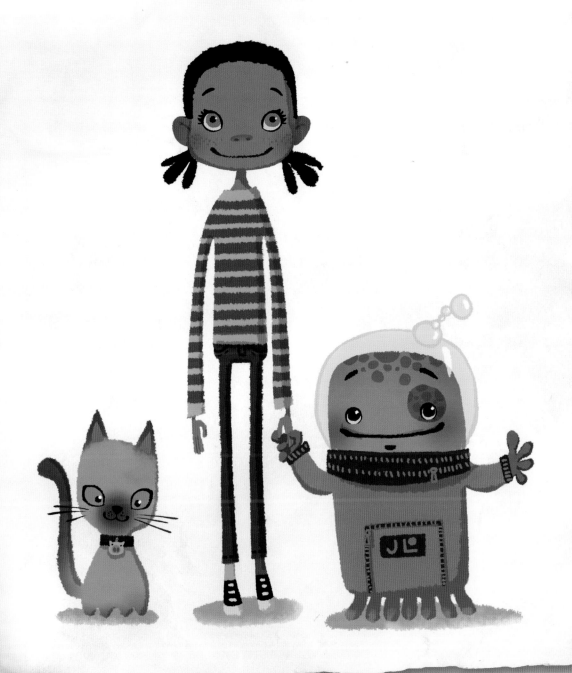

Andrew Erekson

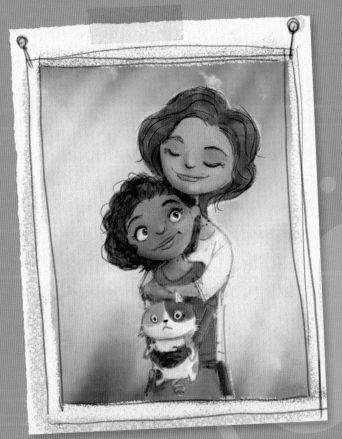

Takao Noguchi

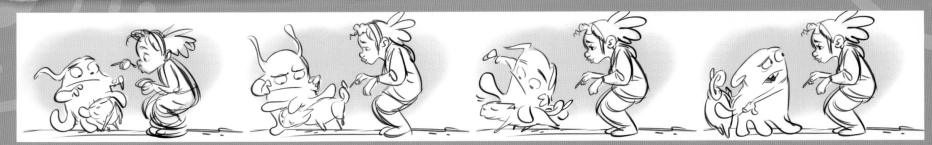

(top) Griselda Sastrawinata, (above) Jeff Snow

65

As Altieri explains, Tip is not your typical lead heroine of an animated movie. She grew up on Barbados and has a mixed heritage: Her father is from the Caribbean islands, and her mom is Puerto Rican. Buirgy says, "We are very excited to have an African-American girl at the center of our movie."

Producer Mireille Soria adds, "The really great thing about Tip is that she comes from a mixed ethnicity, and the film really celebrates who she is. We don't shy away from exploring it."

"Like so many people we know, she's trying to find her place in the world," says Altieri. "Plus, she's from another country and she's a teenager. There's a lot of respect for her in this movie because she's so capable, and she's determined to make her way back to her mom."

It was also important for character designer Takao Noguchi to emphasize Tip's connection with Oh by underlining their visual similarities and graphic proportions. "I tried to make them the perfect match—with similar simplified features, big eyes and big mouths," he says. "They resemble each other a little bit, but we can also see their differences, since like all classic comedic mismatches, they fight each other at first. We also studied Rihanna's curly hairstyle and facial features after she came on board. We combined that with our first design passes on the character."

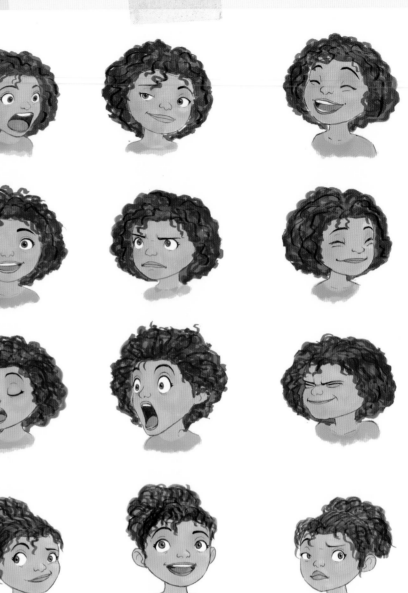

(above) Todd Wilderman, (right) Takao Noguchi

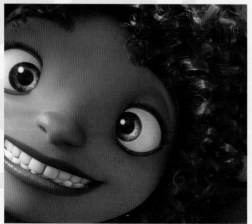
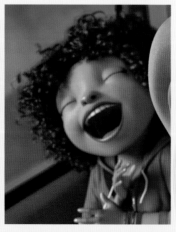
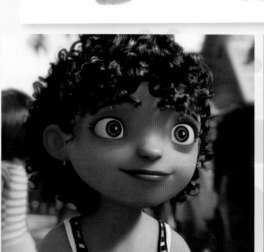
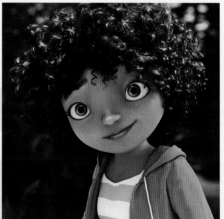

66

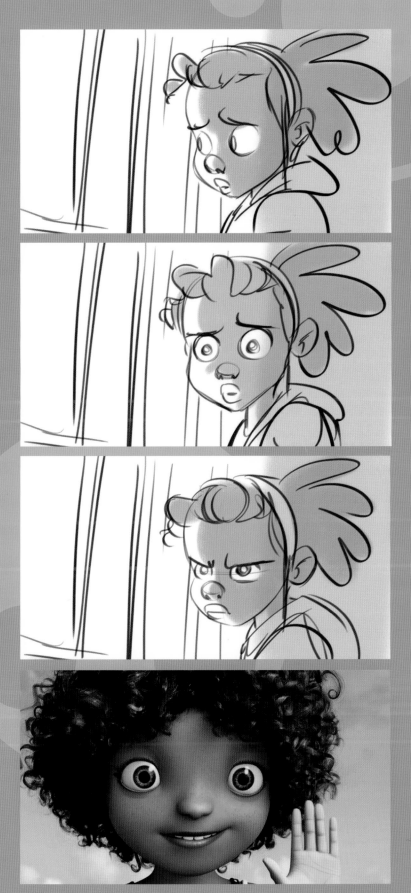

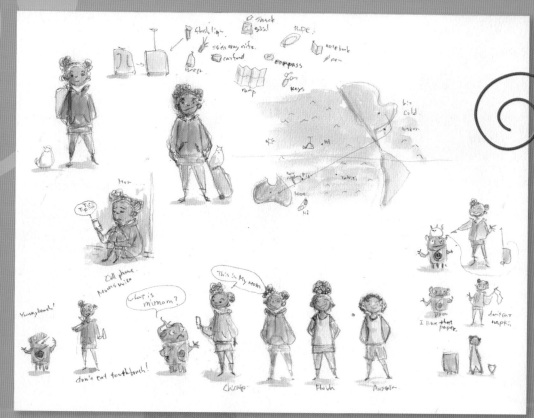

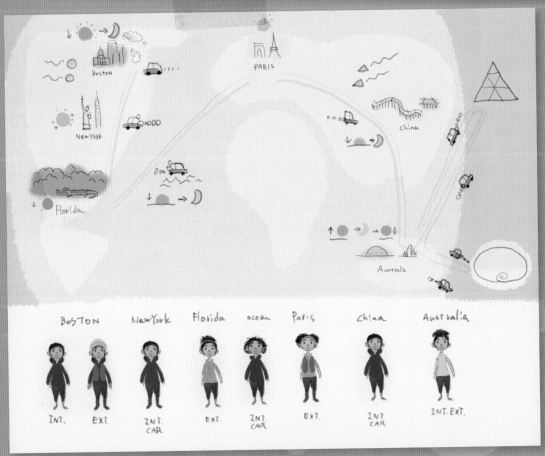

(top & above) Takao Noguchi

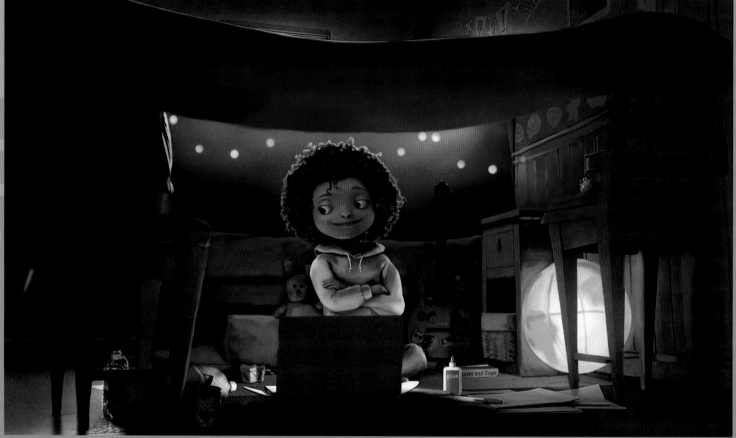

(top) Michael Lester, (center) Natalie Franscioni-Karp, (above) Jeff Snow

Ron Lukas

Paul Westacott

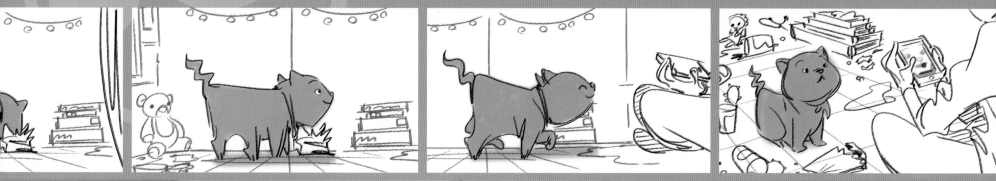

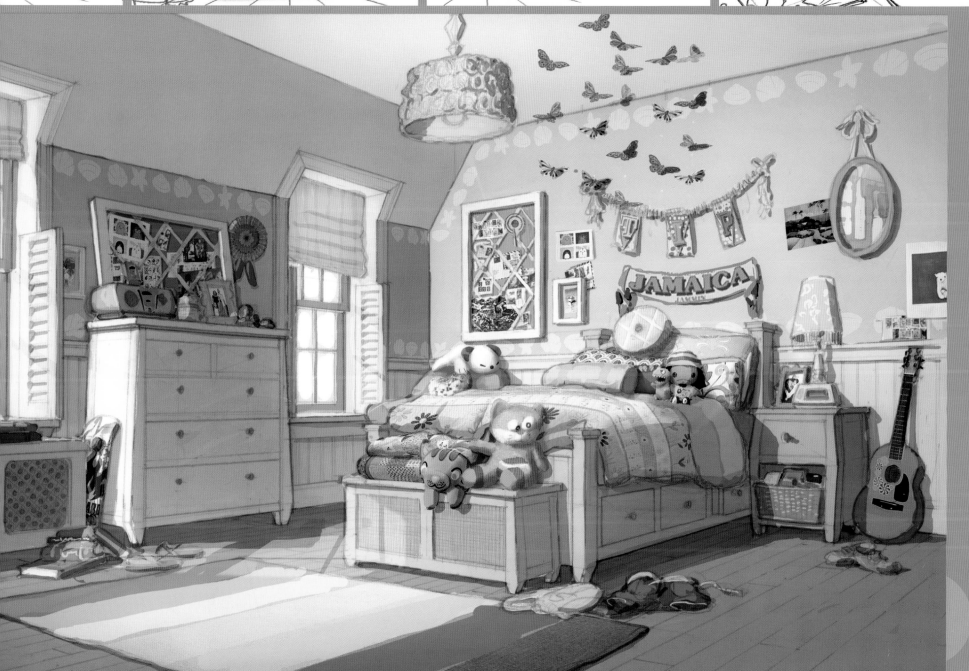

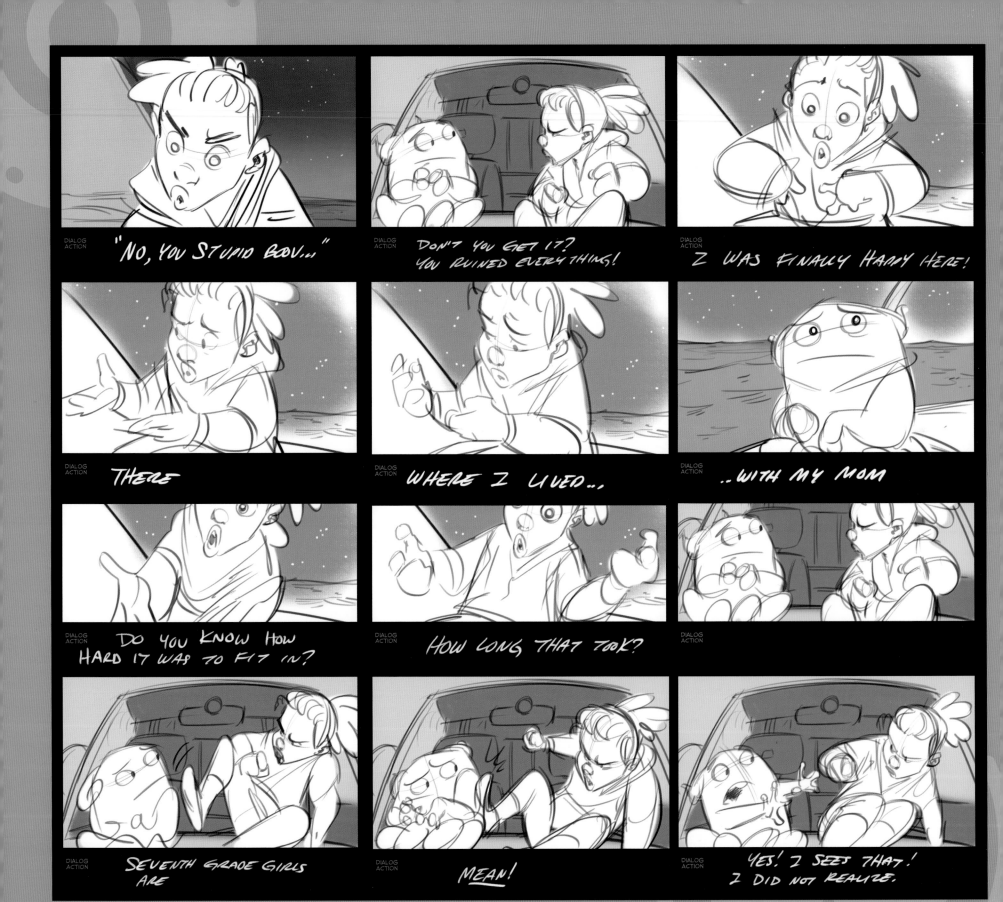

Jeff Snow

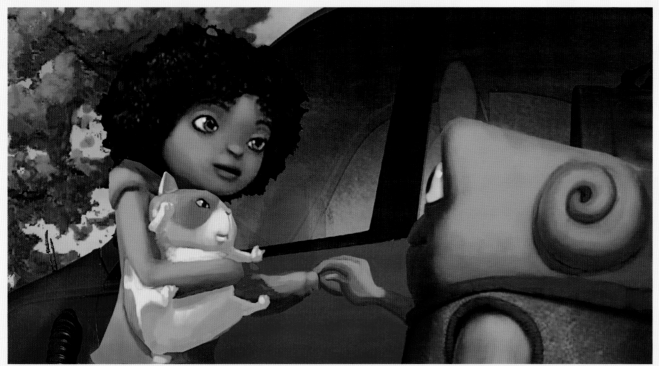

Bill Kaufmann

(top & above) Jeff Snow

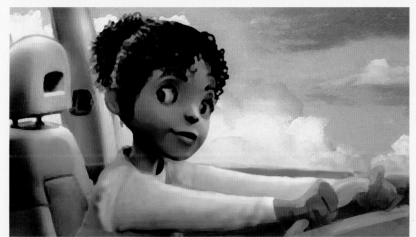

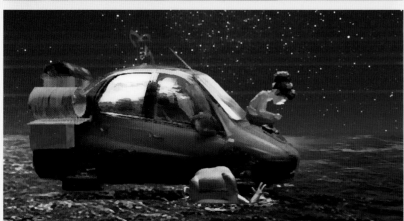

(center & above) Ron Lukas

"Part of my job as a VFX supervisor is to partner up with our production designer and come up with creative visual codes for the film. Our director Tim Johnson wanted to tell this sci-fi alien invasion movie from the point of view of these aliens that think they're actually helping us. Our job was to present a version of our world that felt altered—the audience had to feel like our planet had changed, but we didn't want it to look destroyed. It all had to be charming, whimsical, and surreal.

"Since we had few characters really featured in the movie, the story feels very intimate. Oh is an alien who is trying to belong, and he literally wears his emotions on his skin. Tip is a young girl who has several different hairstyles throughout the movie. Our new hair technology Willow allowed us to model random hair and have more control in designing and styling it. You'll see that in some scenes her hair is tied up, and in others, it's flowing loosely in the wind. She can put her hands through her hair and play with it—something that we could never do in previous movies.

"On a professional level, I loved the movie because I thought the story was fresh and allowed us to take some chances and offer a unique storyline. On the personal front, I was attracted to this project because my own daughter will be twelve when this movie comes out—the same age as Tip. Since the movie deals with friendship and coming to a new culture and the notion of belonging, I think my daughter and my family can really relate to the themes that we explore in Home.

— Mahesh Ramasubramanian, Visual Effects Supervisor

LUCY

TO BRING TIP'S MOM to animated life, the designers set out to create a character who would inspire a young girl to travel the world to be reunited with her. It was important for Lucy to be a very warm character so that the audience would empathize with Tip as she races across the globe to find her.

The filmmakers stayed true to the original concepts of Adam Rex's book and made the smart choice of keeping Tip a multicultural girl with mixed race parents. "I think it was very important for us to keep the message of the book," says Jenkins. "It's a lovely thing to include that message of diversity in an animated movie."

A stylish woman in her thirties, Lucy bears a striking resemblance to her daughter. They have similar eyes and mouths and look beautiful together. Tip's mom also owes a lot to Jennifer Lopez's special sense of style and fashion. "After our very first meeting with Jennifer, she shared some insights about the character—what she would be wearing and what kind of hairstyle she would have," recalls Jenkins. "She asked us to jazz her up a little bit and make her more of a modern mom, without being too glamorous. As a result, we lightened up her hair, gave her accessories like bracelets that Tip had made for her, and generally designed her clothes with Jennifer's ideas in mind."

(above & right) Todd Wilderman

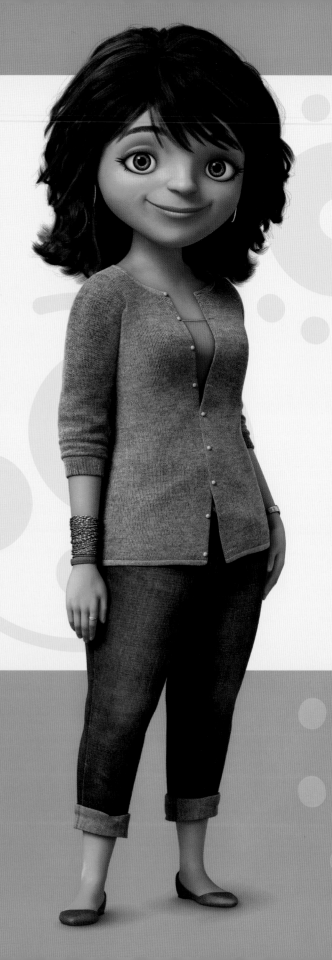

"For this movie, we were able to work with Willow, our new proprietary hair tool that allows us to create high-density hair. We were also able to have our character run her hands through her hair, which is something a young girl like Tip will naturally do a lot. With this technology, our character effects artists can see the full hair that will be rendered and actually visualize it before the render. We used the hair software both on Tip and her mother.

"We were able to include unique articles of clothing in the film as well. Tip has a couple of hooded sweatshirts with pockets, and we were able to have her backpack react with the sweatshirts. Her hair can go up and down. We could also have the car seatbelts react with their clothing and the hair—none of these things would have been possible a few years ago. Also, we were able to give Tip several outfit changes—about seven overall. We put our good work into simulations, so that viewers wouldn't notice anything different. You see something like a pair of jeans or a hoodie every day, so if they don't move right, you immediately notice it."

— Damon Crowe, Character Effects Supervisor

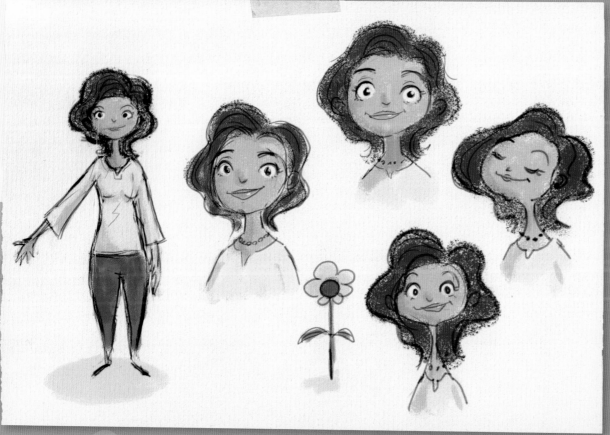

Takao Noguchi

Todd Wilderman

73

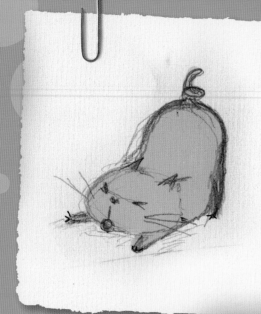

Takao Noguchi

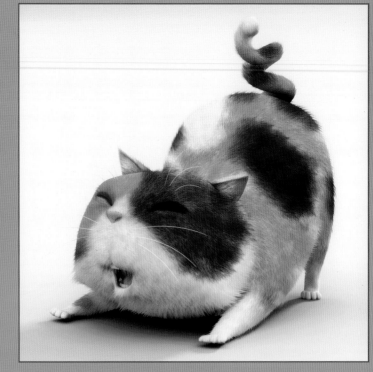

Takao Noguchi

PIG

YOU CAN TELL A LOT about Tip's chubby cat, Pig, just by looking at him. He looks more like a pug than an ordinary feline and seems very comfortable with his full belly and curly tail. The first time we meet him in the movie, he is on the prowl for food, which is the one thing that truly brings this charming character to life. Of course, as fiercely independent as he is, Pig also loves Tip very much. Not only is he a great comic relief character and not bothered by much, Pig is also the perfect match for Tip's alien pal, Oh.

"One of my favorite things about Pig is that he really, really, really likes Oh," says Kathy Altieri. "Pig seems fascinated with Oh and is drawn to him right from the very beginning. And of course, he likes riding on Oh's flat head."

To deliver the look for Pig, character designer Takao Noguchi followed the same simple, round designs he had come up with for Oh and Tip. "The three of them feel like they belong to the same family," he notes. "It's all about simplified proportions. We wanted them to resemble each other."

Real-world references also played a big part in Pig's visuals. "We realized after the twentieth cat video that we might be watching YouTube up until our release date," Jenkins jokes. "Fortunately, with so many cat owners on the show, everyone had an observation to share and include in Pig's character."

Takao Noguchi

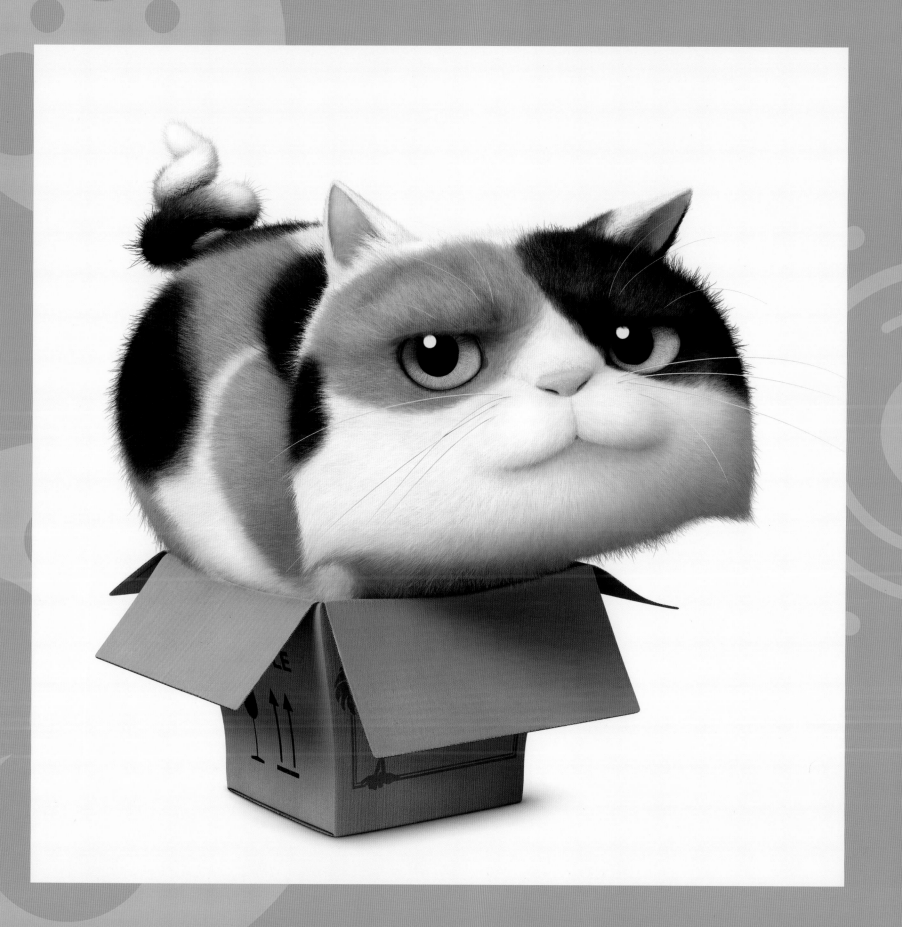

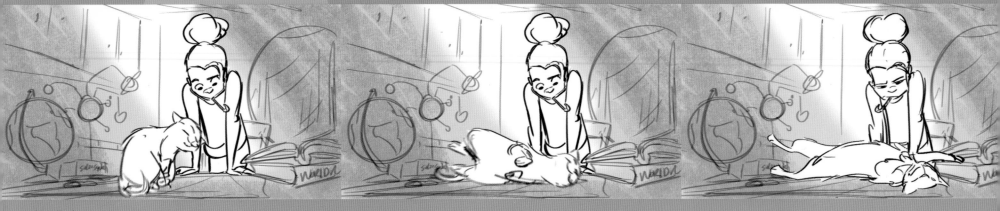
Aimee Marsh

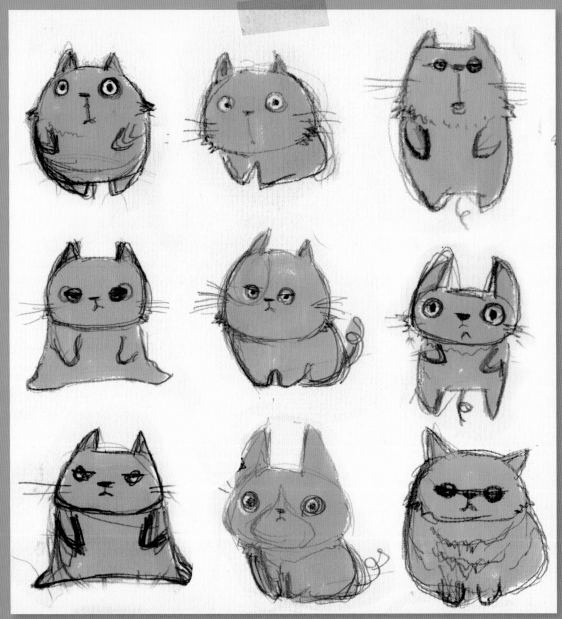
Takao Noguchi

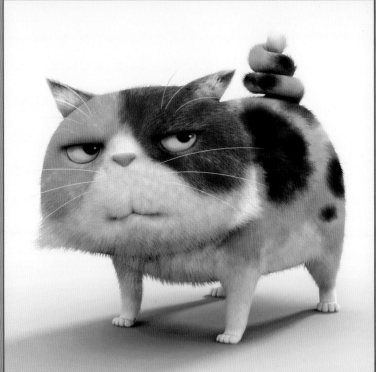
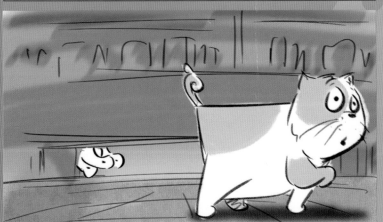
(top) Takao Noguchi, (bottom) Todd Wilderman

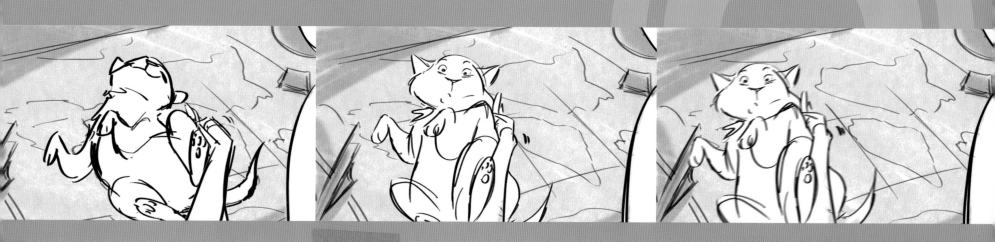

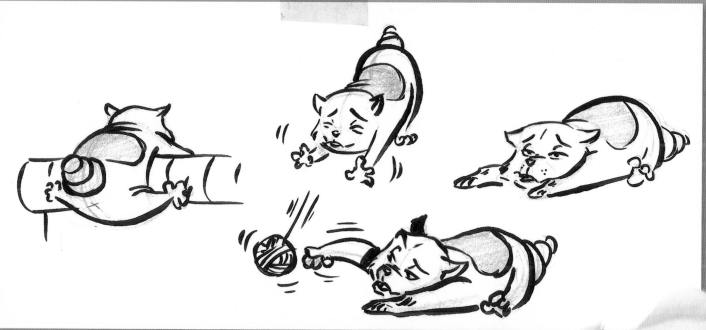

Andrew Erekson

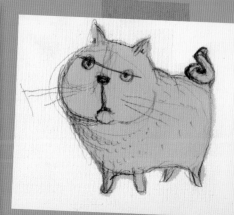

According to Adam Rex, Boov evolved from aquatic
creatures, thus we suspect he smells slightly of fish—
and for Pig, that only adds to the attraction.

—KATHY ALTIERI, **PRODUCTION DESIGNER**

SLUSHIOUS

IF YOU'RE GOING TO TRAVEL EARTH in search of your mother accompanied by a very odd alien, you couldn't ask for a better vehicle than a super flying car created from the parts of a slushy machine! Designed by art director Emil Mitev, this fantastic flying machine answers the wish fulfillment fantasies of the child in all of us. Yet it is a far cry from the slick flying machines typically featured in science fiction movies.

"We didn't want Slushious to be just another super car," Mitev recalls. "So we took a very average family midsize as a base and transformed it using Boovish technology, combined with anything you could find from a regular convenience store. With a slushy machine at its core, Oh literally duct-tapes a high-fructose–powered, flying super car into existence."

Inspired in equal parts by the flying car in *Chitty Chitty Bang Bang* and James Bond's Aston Martin DB5, Slushious has the ability to shoot missile-like burritos from its back and deliver a tray of hot dogs at the press of a button.

Head of character animation Jason Reisig says his team strove to find the line where the car goes from being a machine to becoming a character with personality. "Slushious becomes this interesting vehicle that is flying in space like a hovercraft," he says. "You can never see it changing its expressions, but we pushed it harder than we had originally planned. This is a slushy with a definite kick to it!"

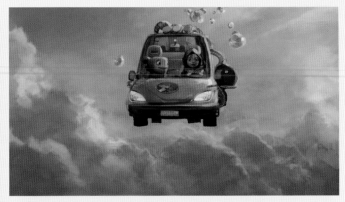

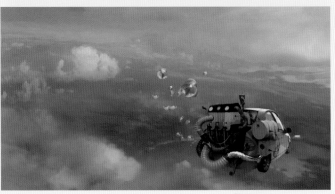

Ron Lukas

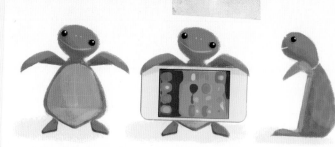

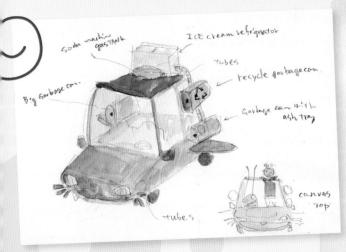

(above, right & far right) Takao Noguchi

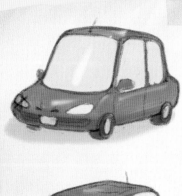

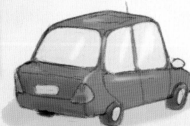

78

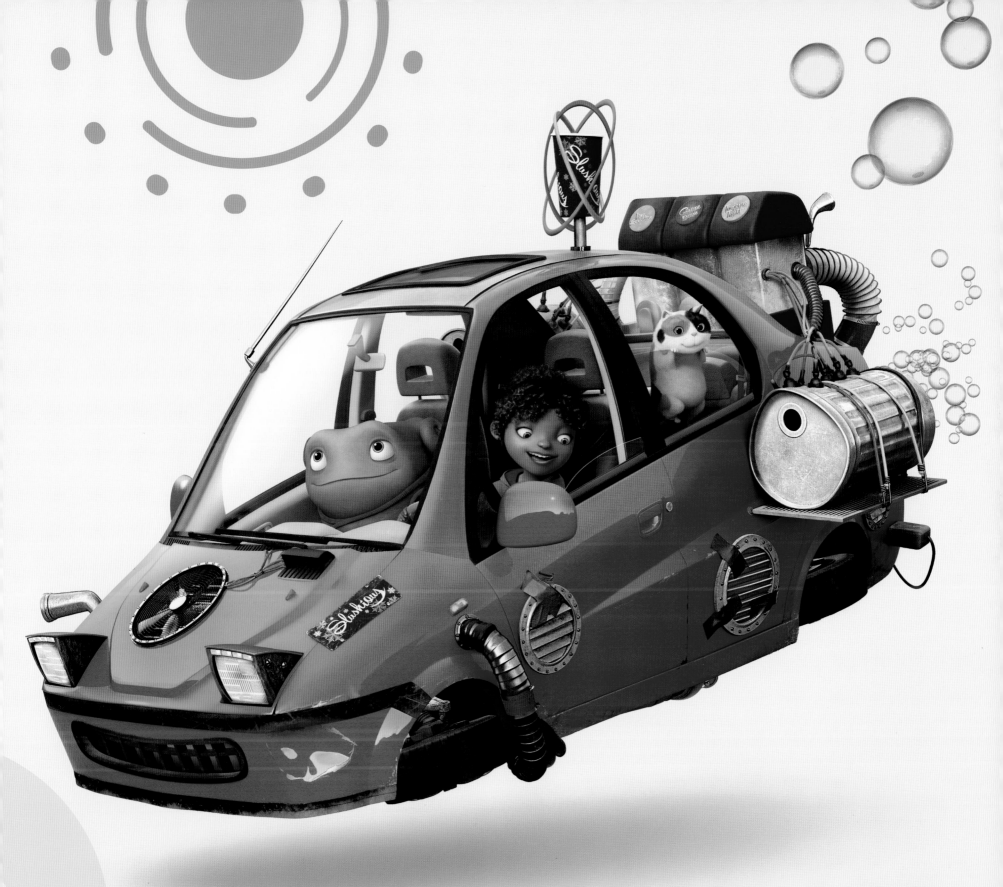

CLICK IT
OR TICKET

ROCKET SPEED

PREPARING
FOR TAKE OFF

EXHAUSTED

(top) Todd Wilderman, (above left & right) Stan Seo

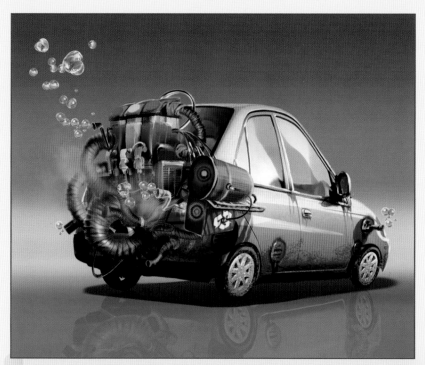

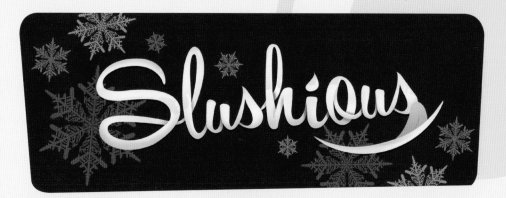

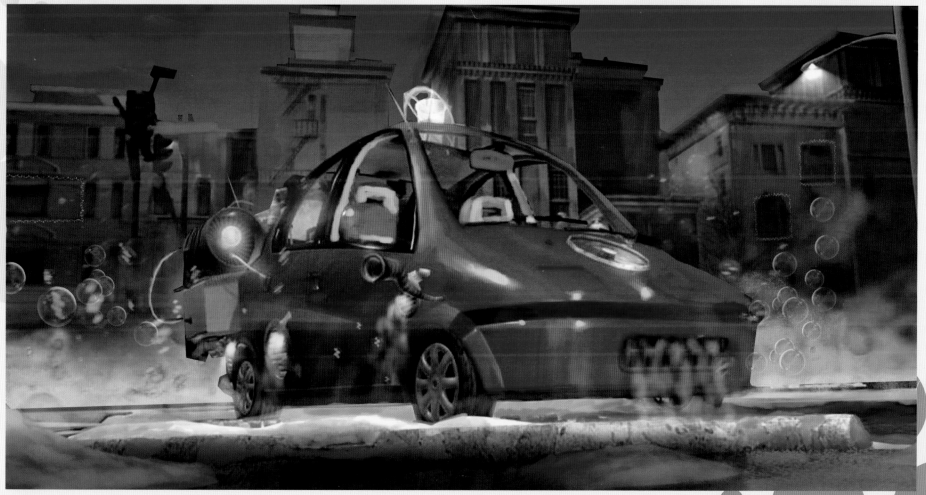

(top left) Emil Mitev, (top right) Vy Trinh, (above) Bill Kaufmann

THE CITY

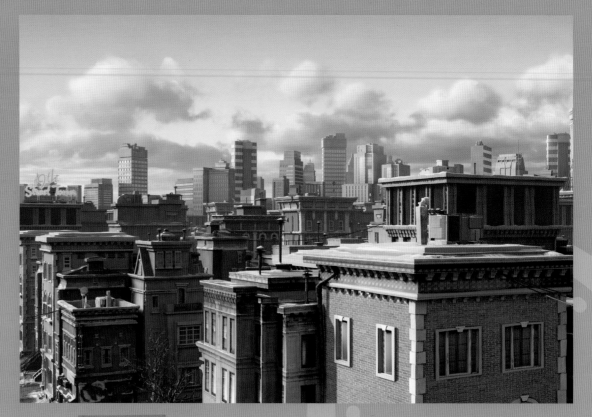

OUR HEROES' JOURNEY BEGINS in a midwestern city, where Tip and her mom lived before the alien invasion. It's in a little Bostonian convenience store that Tip and Oh meet for the first time. The DreamWorks team used Midwestern urban architecture as a template for the city, incorporating a mixture of shapes and the juxtaposition of buildings new and old. And when the Boov take over, they bring their fondness for spherical shapes to the city.

The city sequences in *Home* echo Michael Arias and Hiroaki Ando's seminal 2006 anime feature, *Tekkonkinkreet*. "We were going for a fantastic urban landscape, with a certain hand-drawn feel to it, even though our film is CG-animated," says production designer Kathy Altieri. "We aimed for a watercolor, painterly look to the rendering of the cities because we really wanted to stress the sense of humanity throughout the movie."

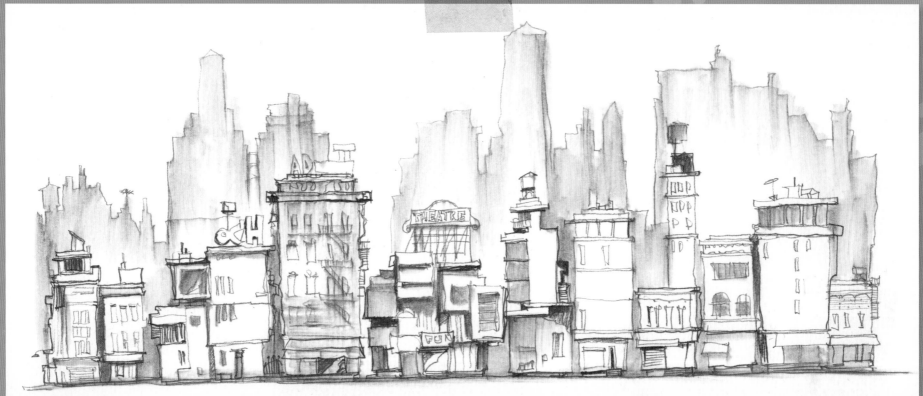

(top) Mikael Genachte-Le Bail, (above) Emil Mitev

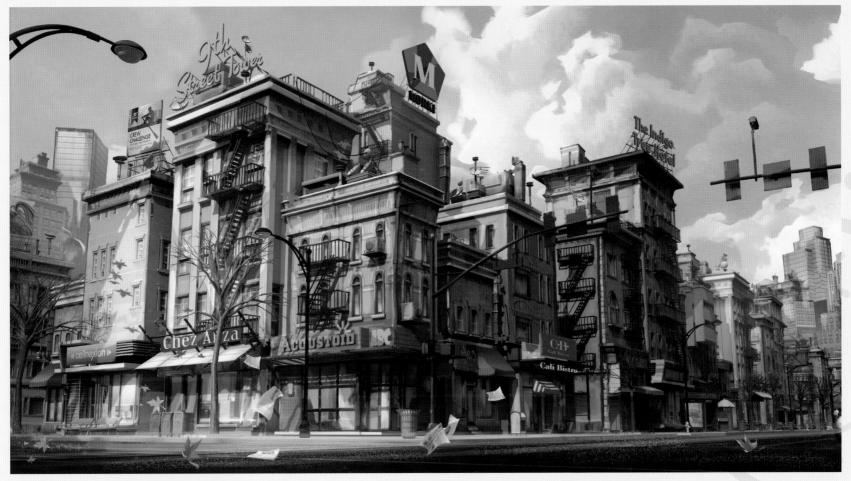

Ravinder Kundi

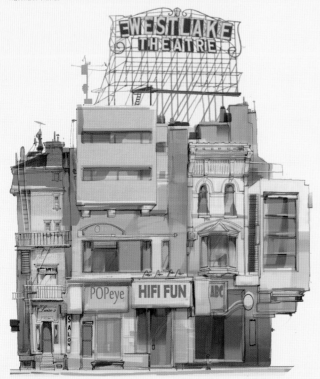

Emil Mitev

"I thought the movie was a very interesting project because it dealt with profound, heavy themes like colonial attitudes and cultural arrogance without being heavy and dark. Home also had a very ambitious slate, with all its many man-made locations, such as Paris. For example, for the city where Tip and her mother used to live, we had to create versions of the city that represented both the time before and after the alien invasion. Creating a city that had buildings with large holes in them was logistically quite challenging. It provided us with a really interesting puzzle to solve.

"The movie travels to a lot of locations. It's really a road trip movie. That's why we had a wide variety of modeling tasks to work on. In addition to the cities, we also had to model inside the Boov's spaceship, which was a completely different kind of environment. Of course, throughout the entire project, we followed the whimsical charm and visual language of the movie closely. Although we didn't use extreme caricatures as with a movie like *Madagascar* and we were more grounded in reality, we did have the stylization of everyday elements."

— Jeff Hayes, Head of Modeling

83

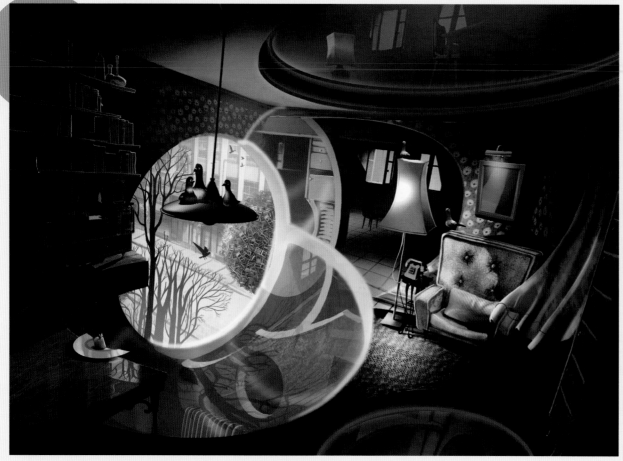

Emil Mitev

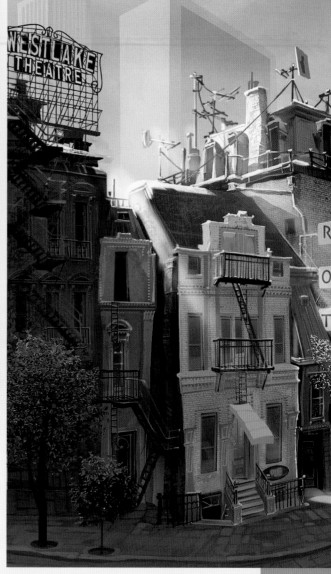

Emil Mitev

Emil Mitev

GRAVITY BALLS BOUNCING LIKE
BEACH BALLS.

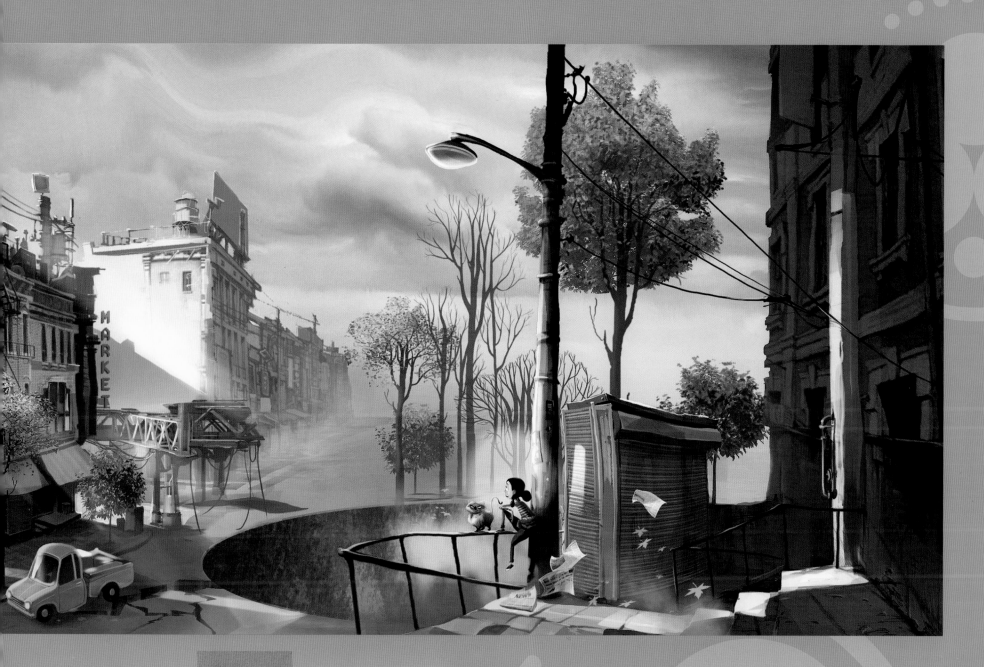

FLOATING LAND MOUNDS

We aimed for a watercolor, painterly look to the rendering of the cities because we really wanted to stress the sense of humanity throughout the movie.
—KATHY ALTIERI, PRODUCTION DESIGNER

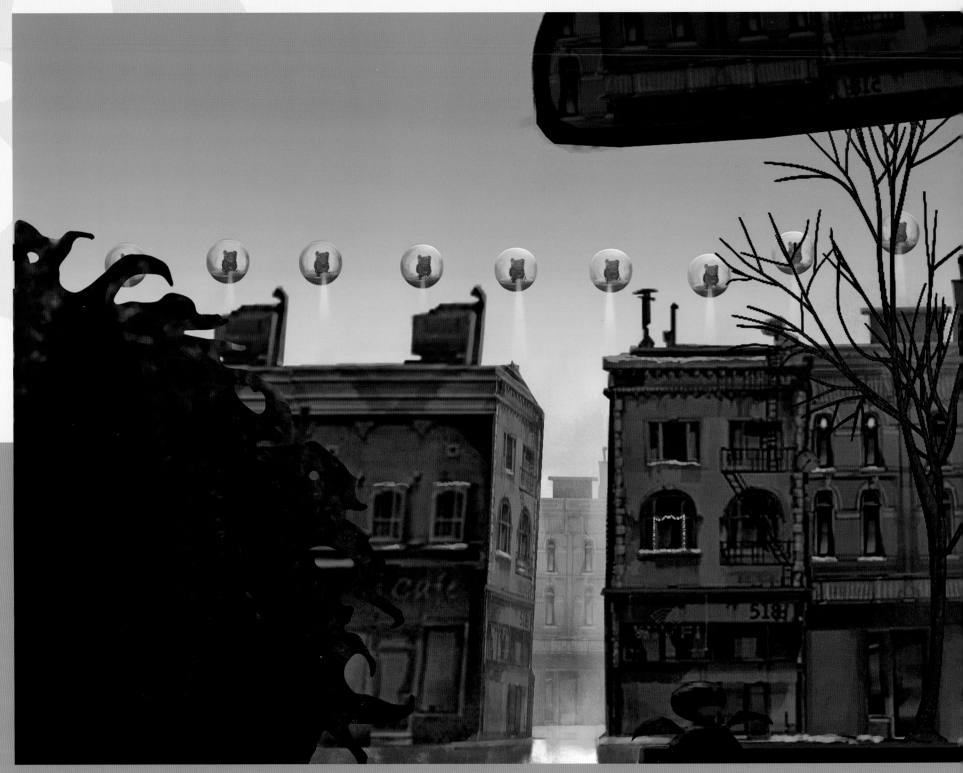

Bill Kaufmann

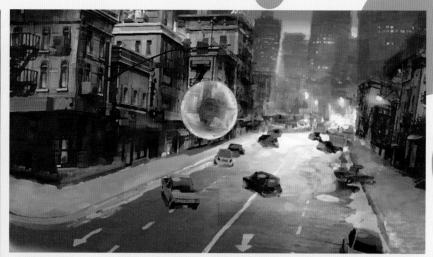

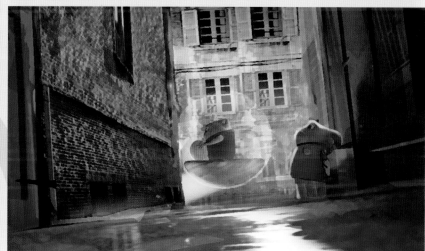

Ron Lukas

Bill Kaufmann

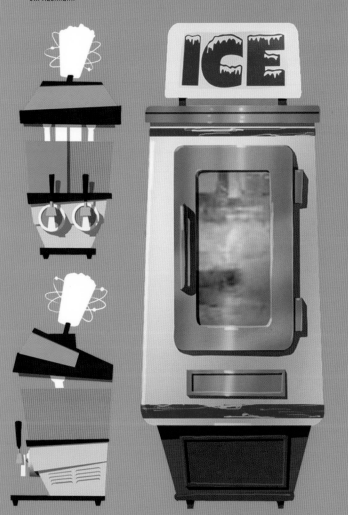

Emil Mitev

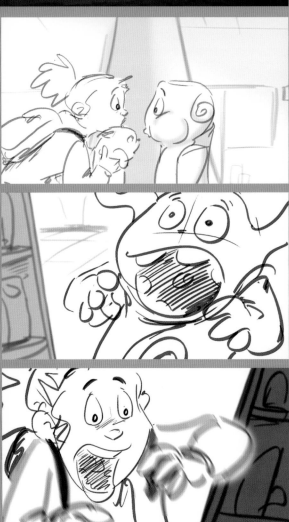

Aimee Marsh

Ravinder Kundi, Emil Mitev & Jason Scheier

88

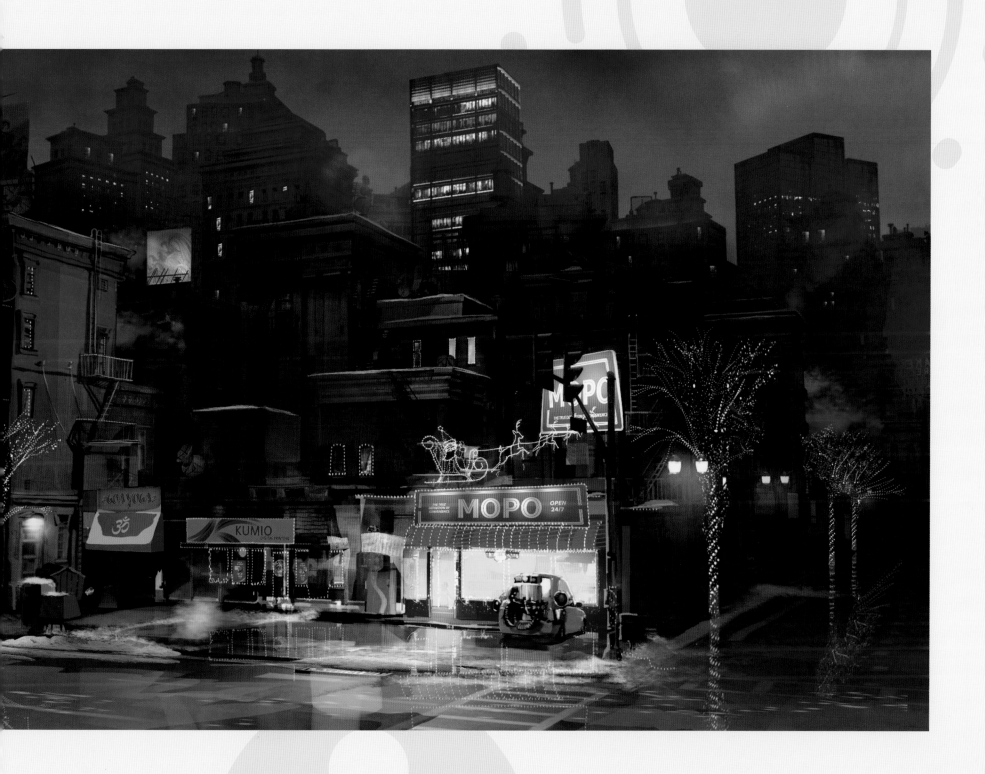

PARIS

A LARGE PART OF THE FILM takes place in Paris, where the Boov make a floating headquarters out of the city's world-famous Eiffel Tower. The DreamWorks team had a very specific look in mind for the City of Lights, and they kept it in mind as they created elaborate environments. "The Paris scenes have a real old masters' feel to them, since we gave the shadows a warm hue," says production designer Kathy Altieri.

"We really tried to capture the charm of the city," says art director Emil Mitev. "The old buildings are never perfectly straight and aligned." Although the scenes were complicated to stage, the team stepped up to the challenge. "The entire set is created from just four buildings with different faces and six interchangeable rooftops," explains Mitev. "This modular approach gave us great variety without compromising downstream departments."

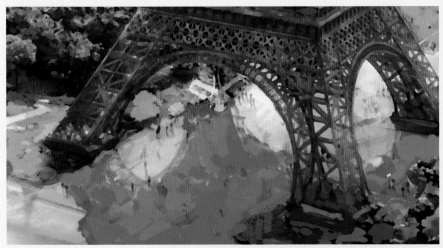

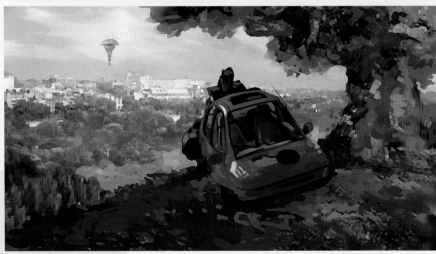

(top) Ron Lukas, (above) Bill Kaufmann

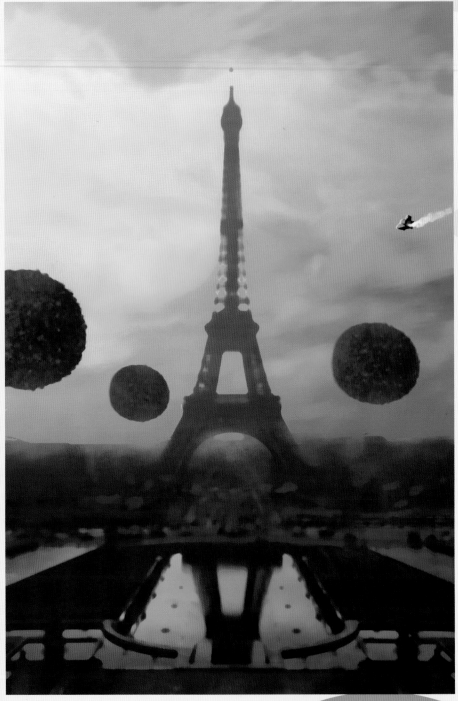

Bill Kaufmann

90

(opposite) Emil Mitev

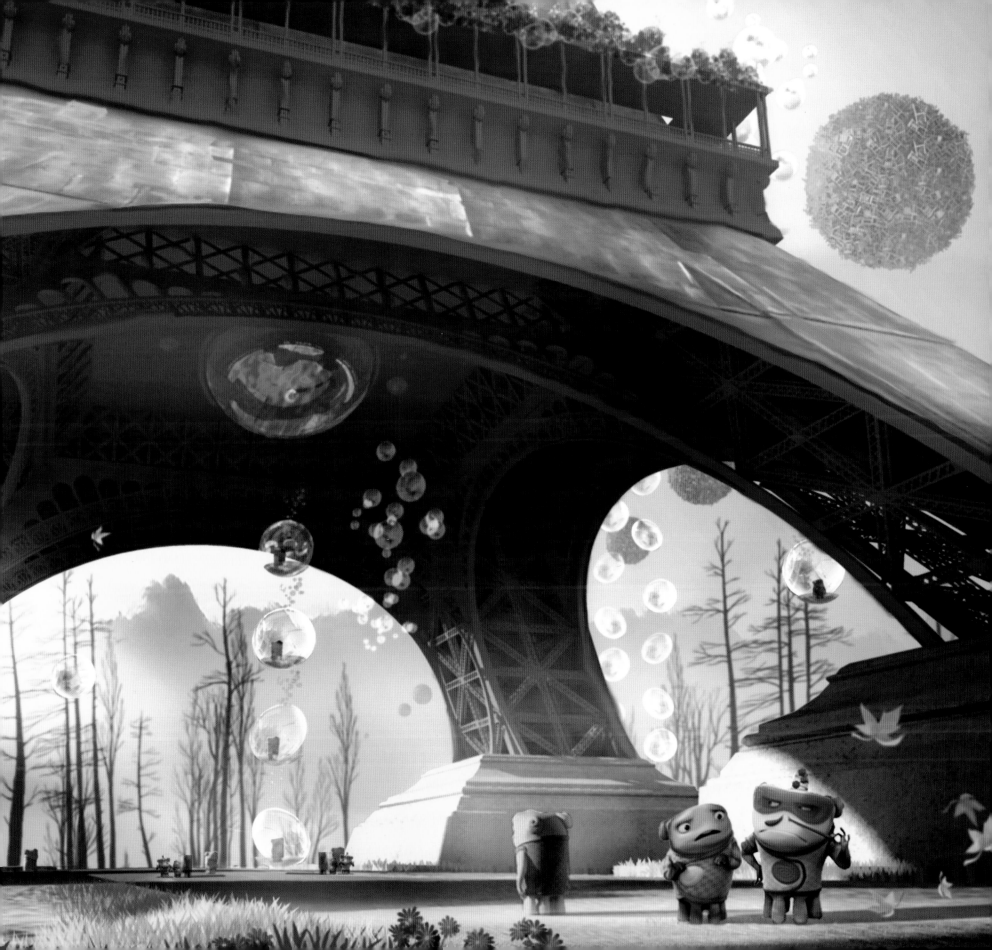

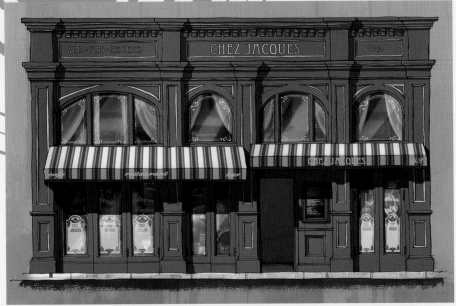

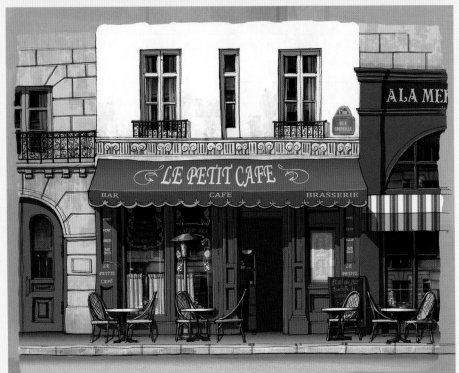

(top & above) Paul Westacott

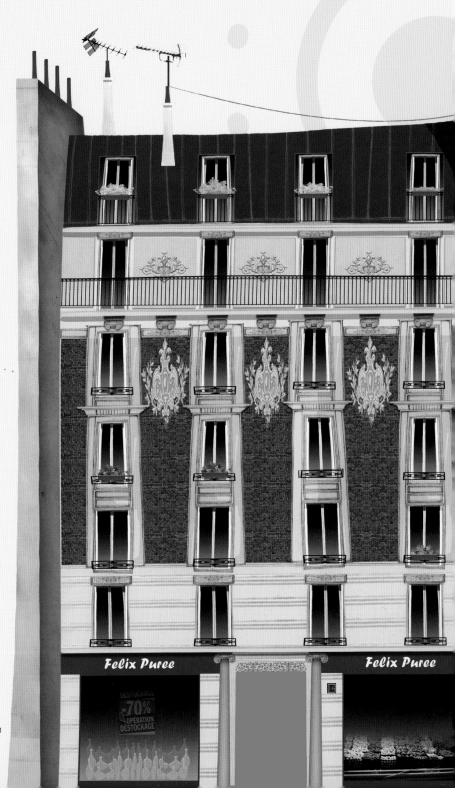

Olivier Tossan

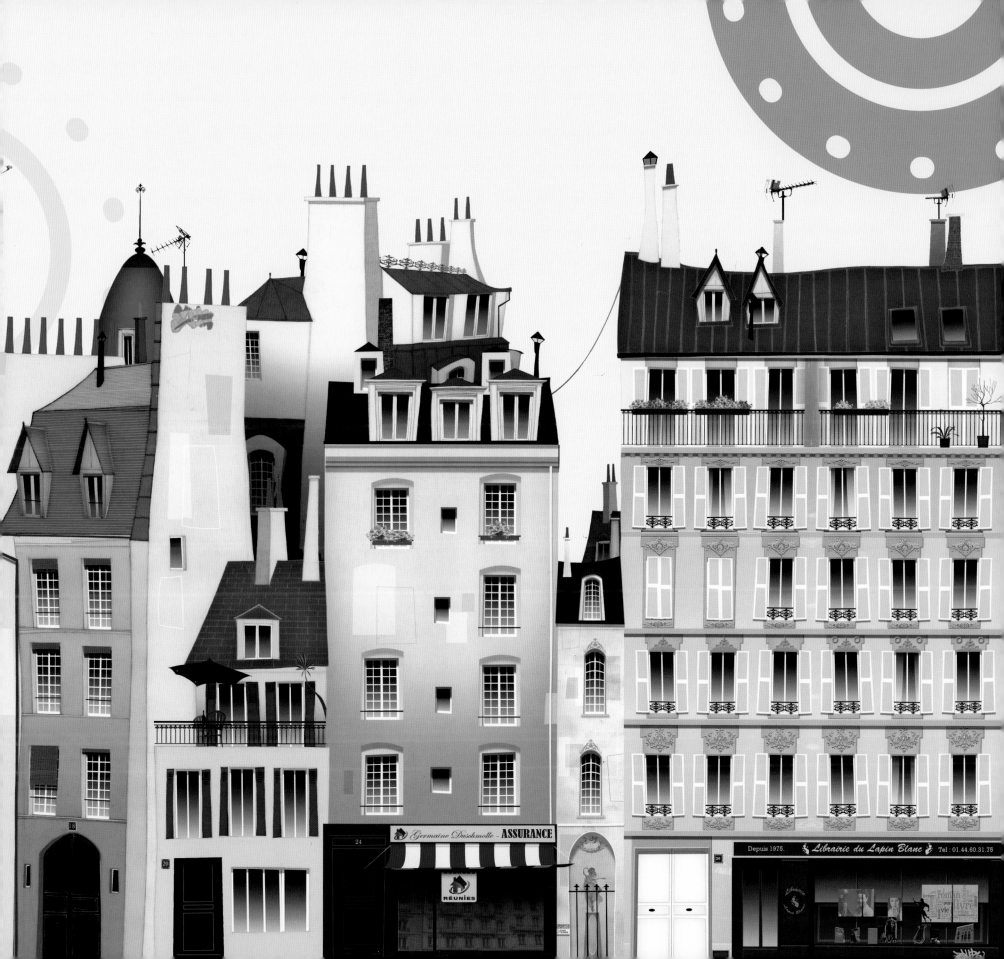

"[Some] of the most elaborate paintings to work on were the Parisian sequences, which also involve heavy technological details and a lot of geometry. We take over anything beyond the main characters: the foregrounds, the clouds, the mountains, the buildings—anything that the characters don't react with directly. We render everything in full 3-D, but we work just like the background painters in the old movies. In the old days, we used to do a lot of cheating when it came to the backgrounds, but today, because of all the stereoscopic detail, we really have to figure out the correct distances, the scale—everything has to be built in real-world space.

"Because Home travels to many different locations, we did extensive research into the different landscapes and cityscapes. We relied on advanced libraries of our own travels and used real photographs as the foundation for our backgrounds. Sometimes we took some of the modern buildings out of Paris just to make it really feel like Paris. It's all about combining actual research, reality, and artistic style."

— Chris Grun, Matte Painting Supervisor

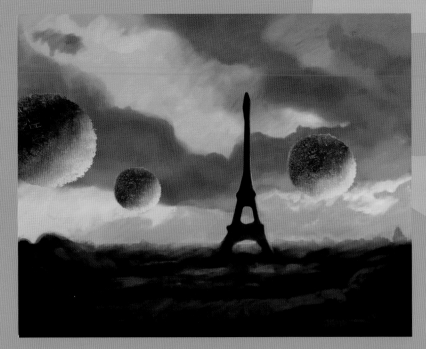

Bill Kaufmann

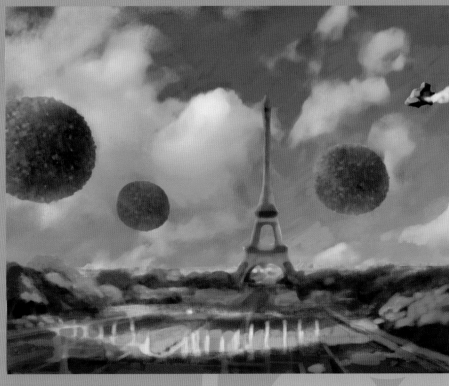

Bill Kaufmann

94

(top) Emil Mitev, (above) Ron Lukas

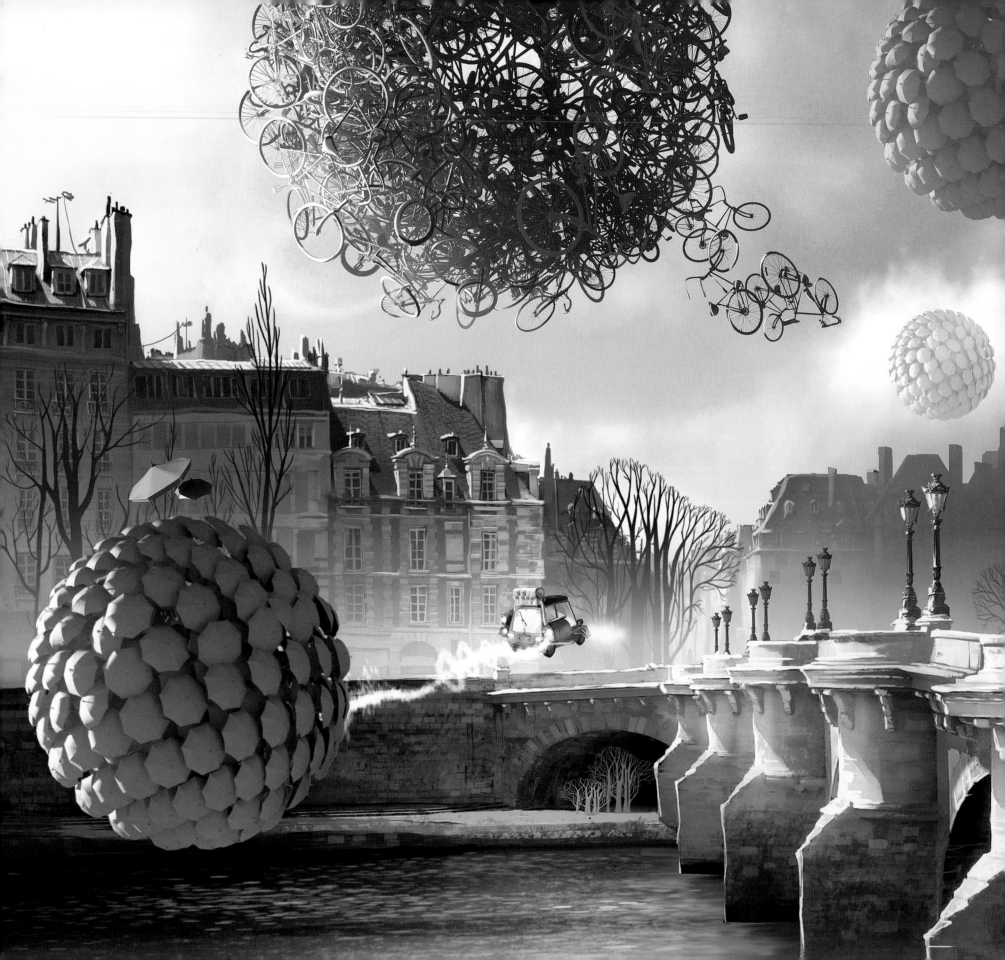

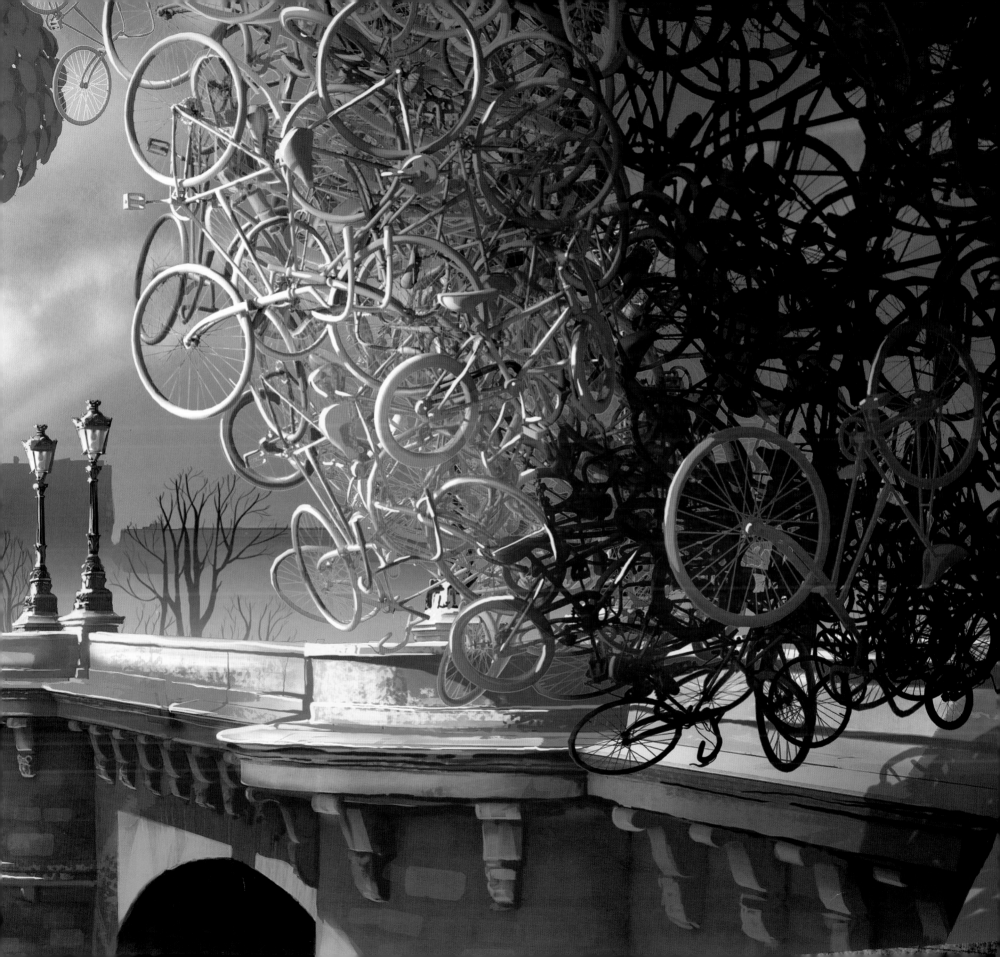

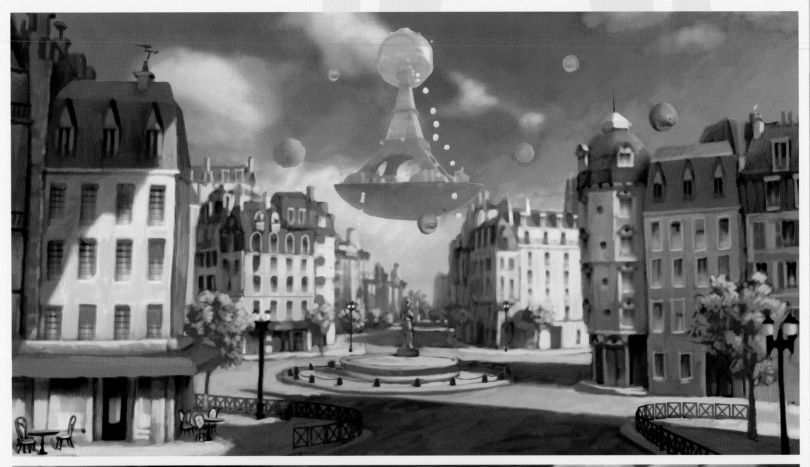

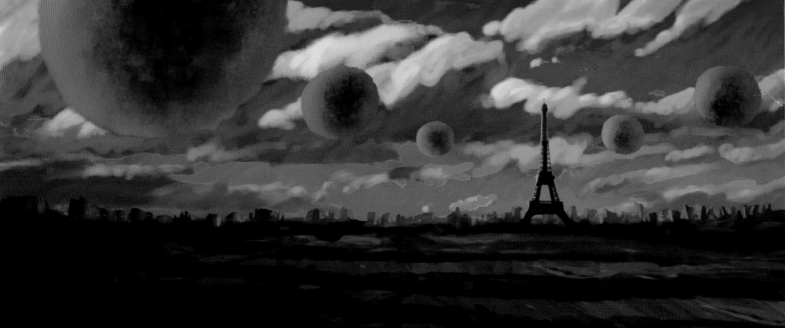

(previous pages) Emil Mitev, (top & above) Bill Kaufmann

(right) Emil Mitev

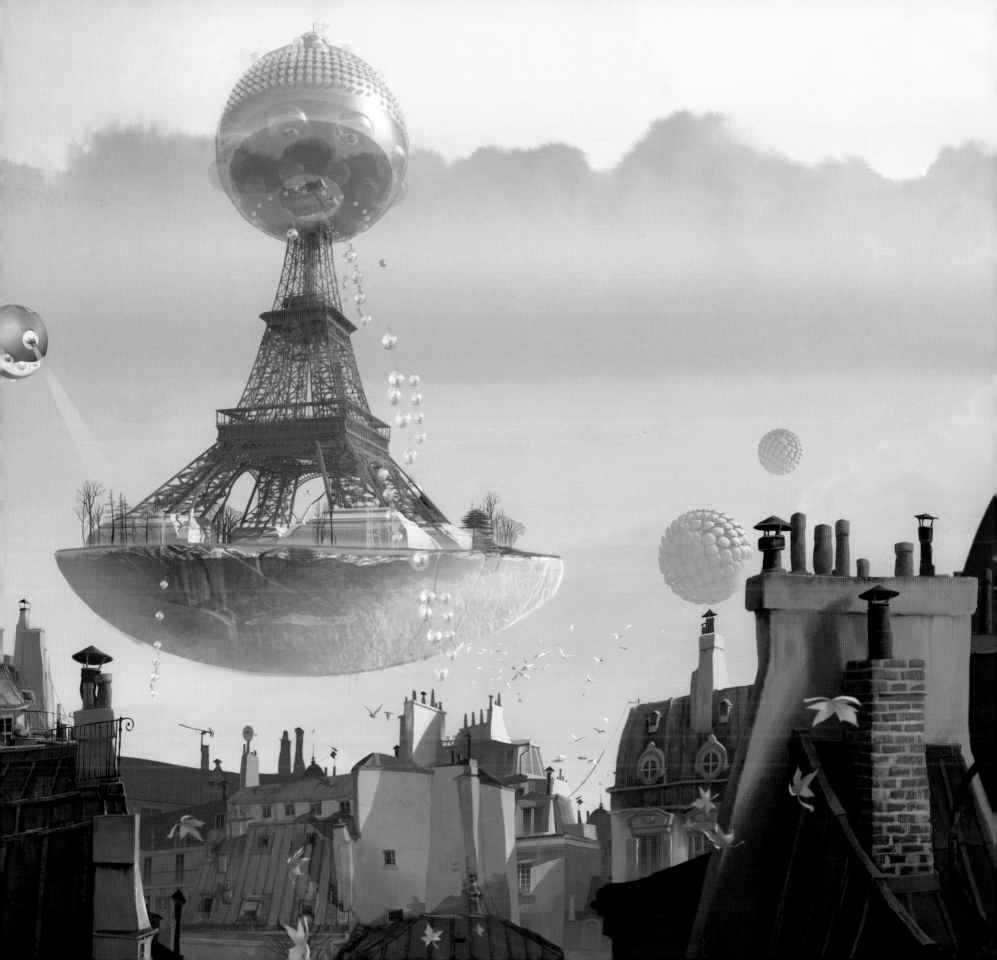

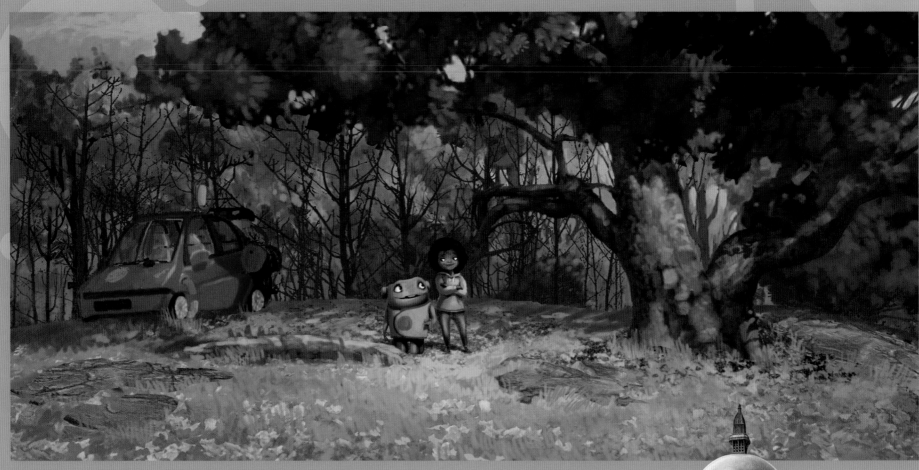

Bill Kaufmann

"Since I am from Paris originally, it was very amusing for me to work on the sequences that depict the destruction of that city. It was also quite interesting to feature an alien invasion of our planet without making it look too destructive or scary. Our goal was to make the invasion look dramatic visually, but not scare the kids into running out of the theaters!

"What makes this movie quite special is its unique visual language. Each race of aliens gets a special representation. The Boov technology has a special circular whimsy, while the Gorg are triangular, with sharp points. We also had to respect that visual language in terms of special effects.

"I can't think of another movie in which the main characters change color when they are feeling emotions. It may sound like a simple task, but it's actually very tricky to get it right. The effect has to look natural and can't overwhelm the animation. When Oh is lying, he is betrayed by the color shifts and patterns that pass through his face. We had to find new colors that were appealing, readable, and reflected the mood. Overall, all our effects had to be grounded in reality."

— Amaury Aubel, Head of Visual Effects

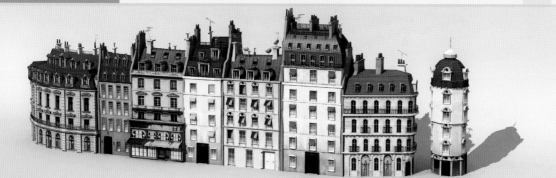

Parts of the buildings are sagging; others squashed from centuries of weight. Some buildings stick out, and others are set back. Together they look as if they were frozen in an old dance.

—EMIL MITEV, ART DIRECTOR

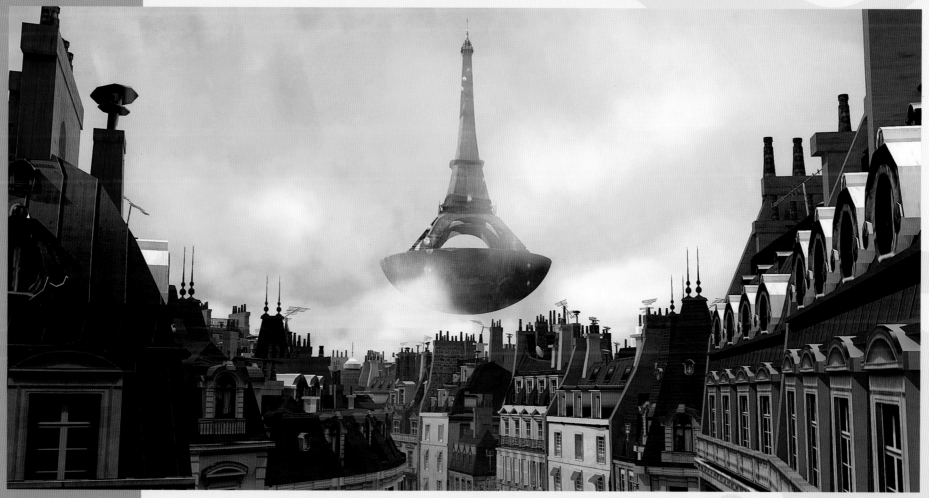

(top) Emil Mitev & Ravinder Kundi, (above) Ravinder Kundi

COMPUTER ROOM

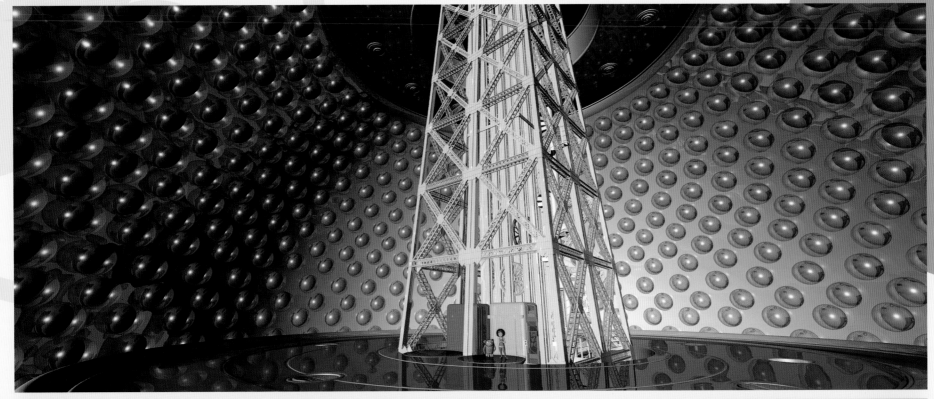

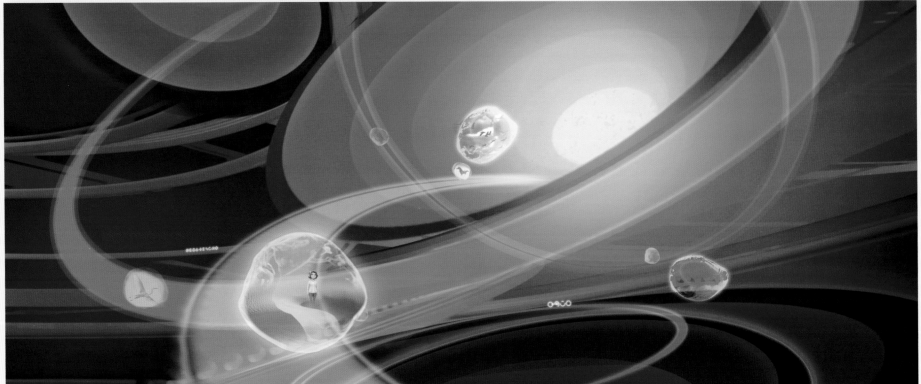

(top) Stan Seo & Ravinder Kundi, (above, opposite top & opposite bottom) Emil Mitev

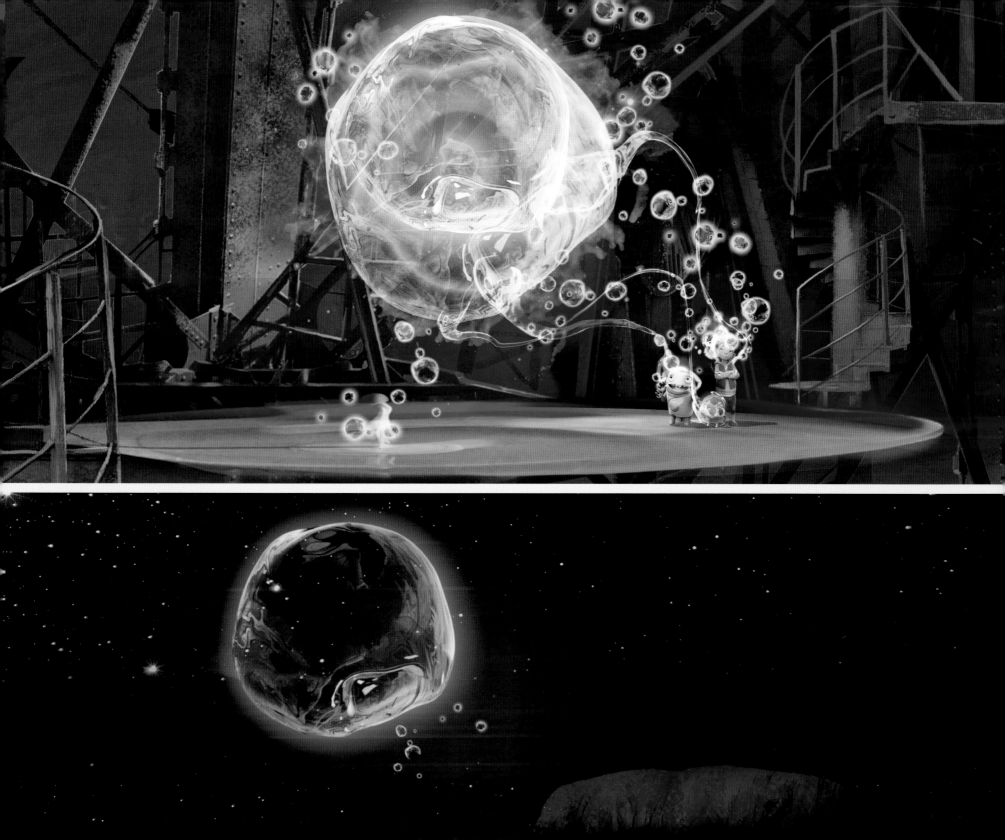

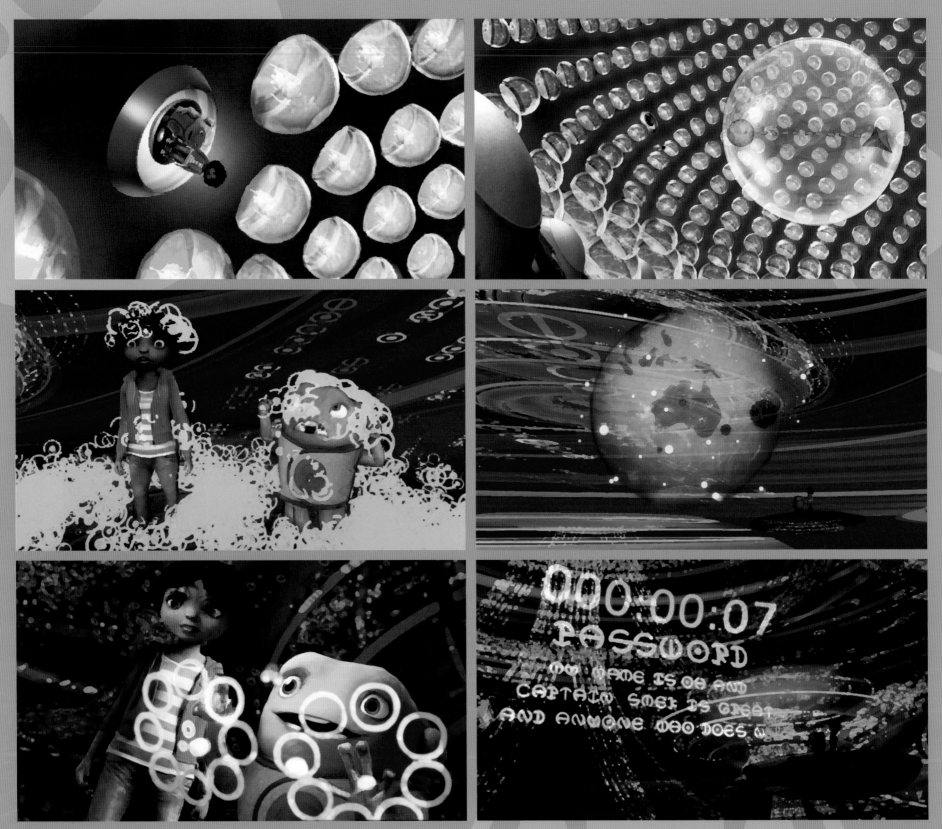

Ron Lukas

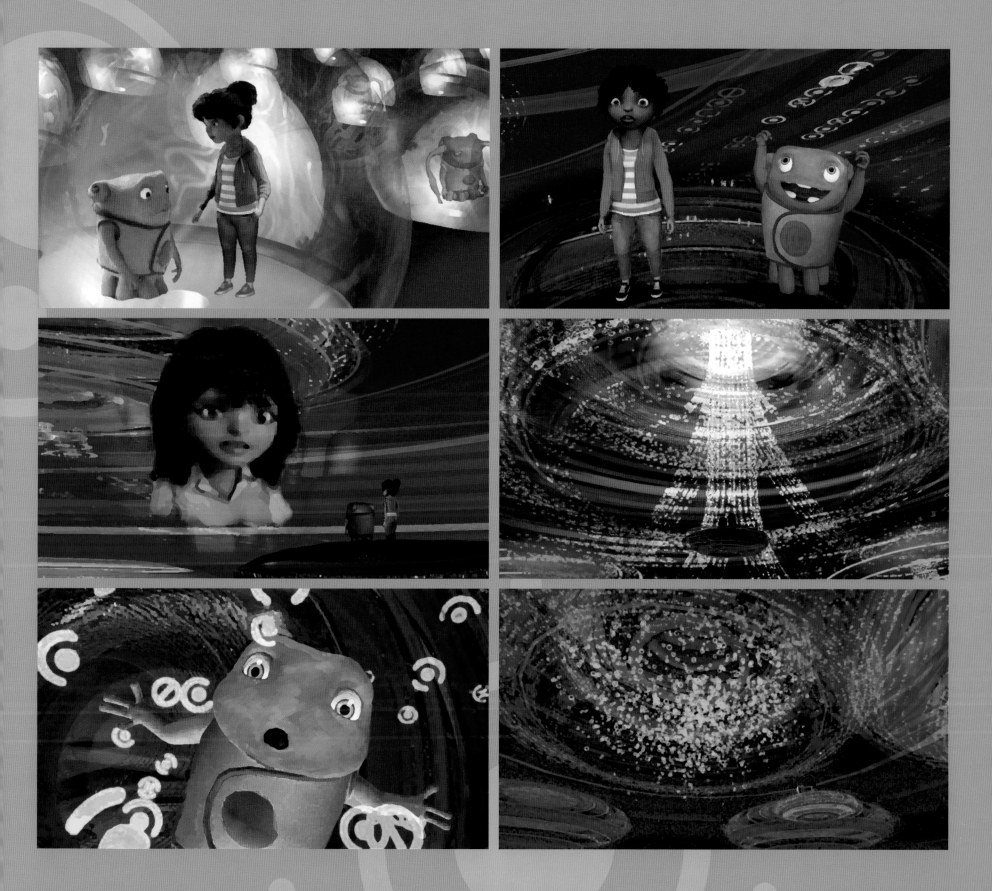

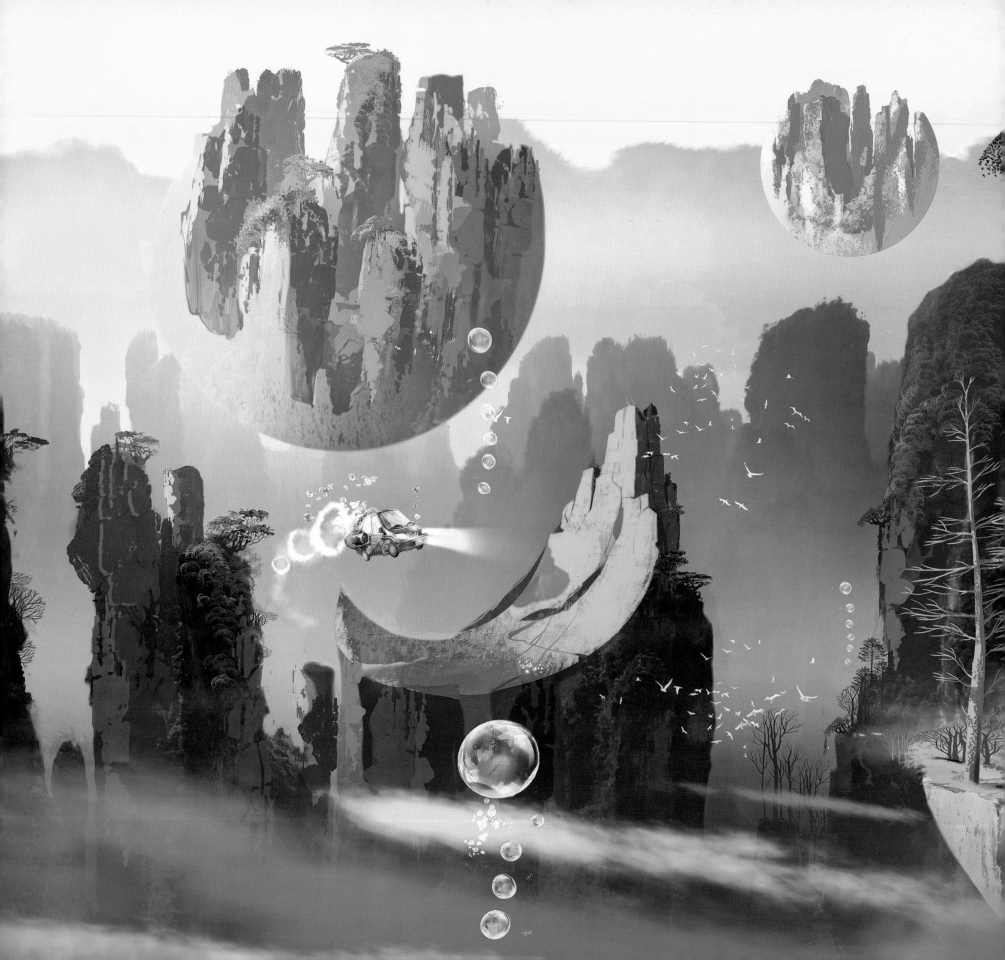

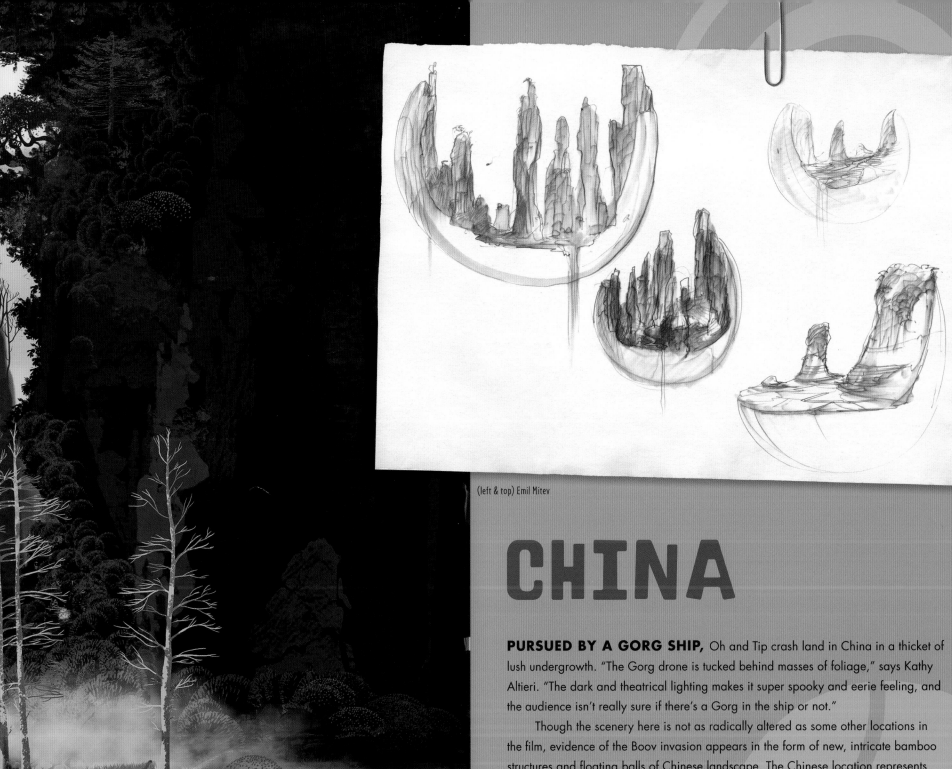

(left & top) Emil Mitev

CHINA

PURSUED BY A GORG SHIP, Oh and Tip crash land in China in a thicket of lush undergrowth. "The Gorg drone is tucked behind masses of foliage," says Kathy Altieri. "The dark and theatrical lighting makes it super spooky and eerie feeling, and the audience isn't really sure if there's a Gorg in the ship or not."

Though the scenery here is not as radically altered as some other locations in the film, evidence of the Boov invasion appears in the form of new, intricate bamboo structures and floating balls of Chinese landscape. The Chinese location represents the raw natural beauty of the planet.

Inspiration for the look of this part of the film came from stunning photographs of China: "We looked at the iconic images from the region," Altieri says. "We loved the landscape of the Guilin province, which is known for its striking beauty and statuesque mountains. A wonderful excuse for some more gorgeous matte paintings!"

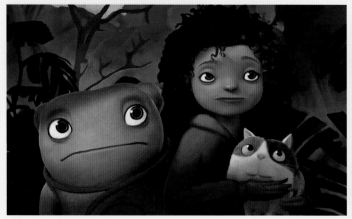

(top) Le Tang, (above & right) Bill Kaufmann

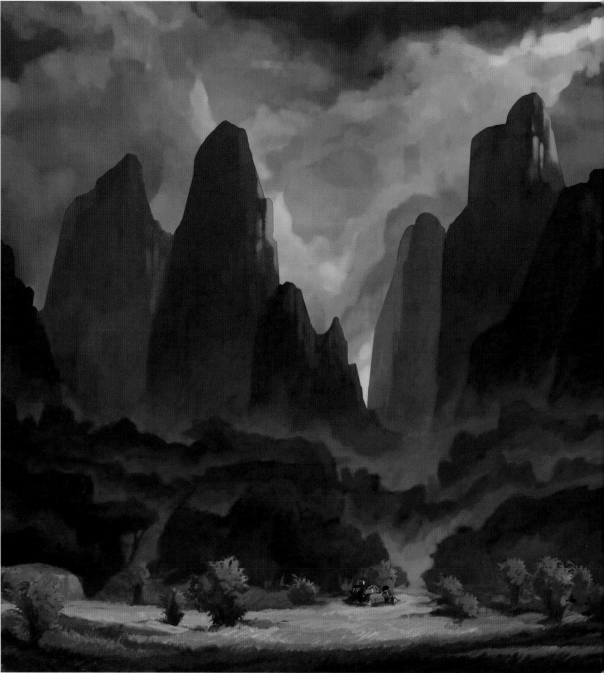

...

We [were inspired by] the landscape of the Guilin Province, which is known for its striking beauty and statuesque mountains.
—**KATHY ALTIERI, PRODUCTION DESIGNER**

...

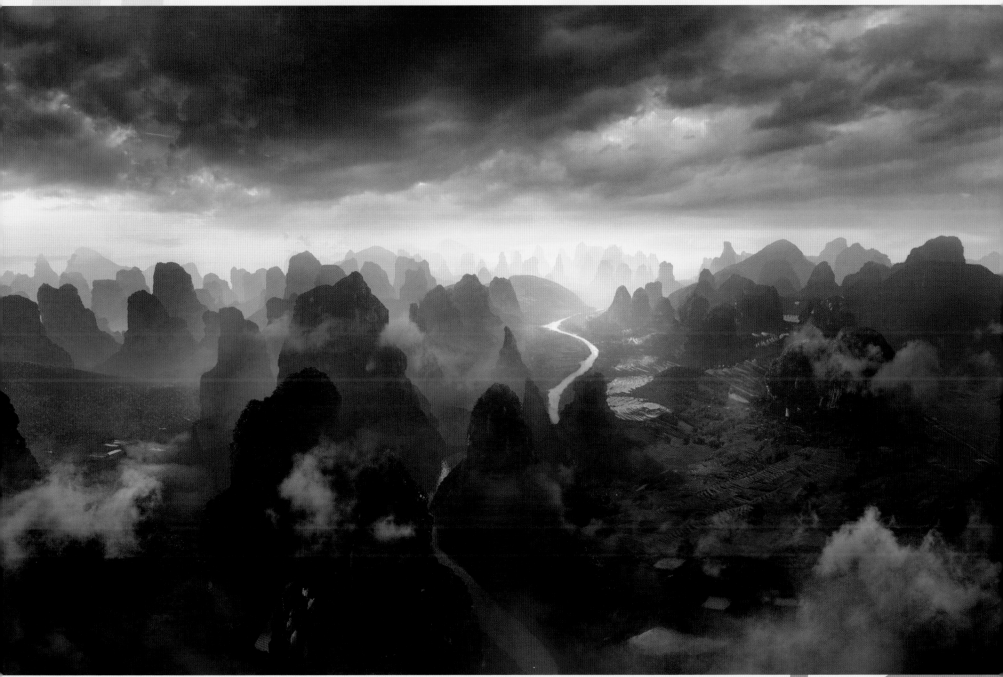

Kristi Valk

FLYBYS

YOU CAN'T HAVE a deeply satisfying road trip movie without fantastic locations and eye-popping cityscapes. That's why the creative forces behind *Home* set out to make Tip and Oh's global journey as visually intriguing as possible by taking them to a wide range of destinations—everywhere from the city where they first meet to Paris, China, and the Australian Outback.

Director Tim Johnson says Tip and Oh's road trip across the planet allowed him and the design team to celebrate the distinct beauty and diversity of our world: "The title of the film says it all. We have this beautiful home planet. We start with a wintery city in the Midwest and end up in summery Australia. We cross the Atlantic Ocean and see it both with its full storm-like waves and in its placid, gorgeous calm. We highlight Paris and showcase a floating, Boovified version of the Eiffel Tower and travel to China, where we depict these amazing structures made of bamboo. Throughout the movie, we celebrate the emotional journey of our characters as well as the hypnotic beauty of the diverse locations on our planet."

But these are no ordinary vistas that Oh and Tip witness, due to the Boov's distinctive way of changing the planets they invade. With their advanced technology, they rebuild Earth's landscapes and landmarks to their own liking—which usually involves round shapes and smooth surfaces.

"We worked hard to make the 'Boovified' cities and landscapes somewhat recognizable while still feeling like they have been transformed in a surreal manner," says art director Emil Mitev. "We wanted what the Boov have done to be playful, not menacing."

After Tip and Oh leave Paris, they cross the globe in Slushious. As Kathy Altieri explains, "When Tip and Oh leave for Australia, they have really become united as friends. To enhance the romantic sense of the sequence, we had them fly across surreal landscapes made of land masses from various regions of the world transformed by the Boov takeover. The lighting is theatrical

Chris Grun

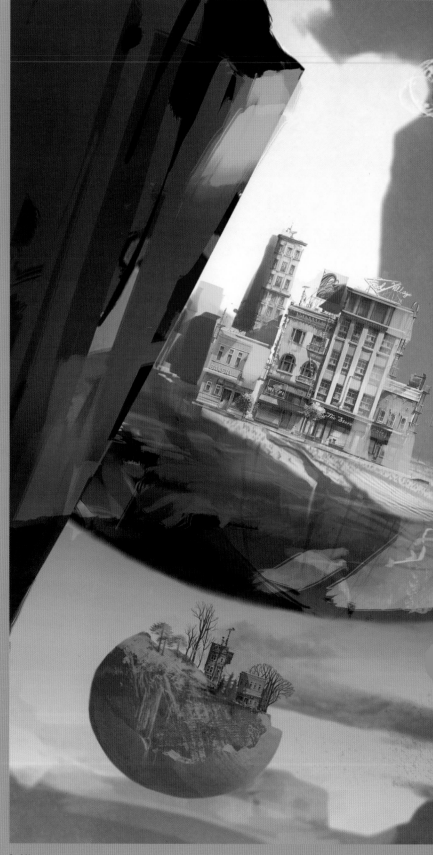

Emil Mitev

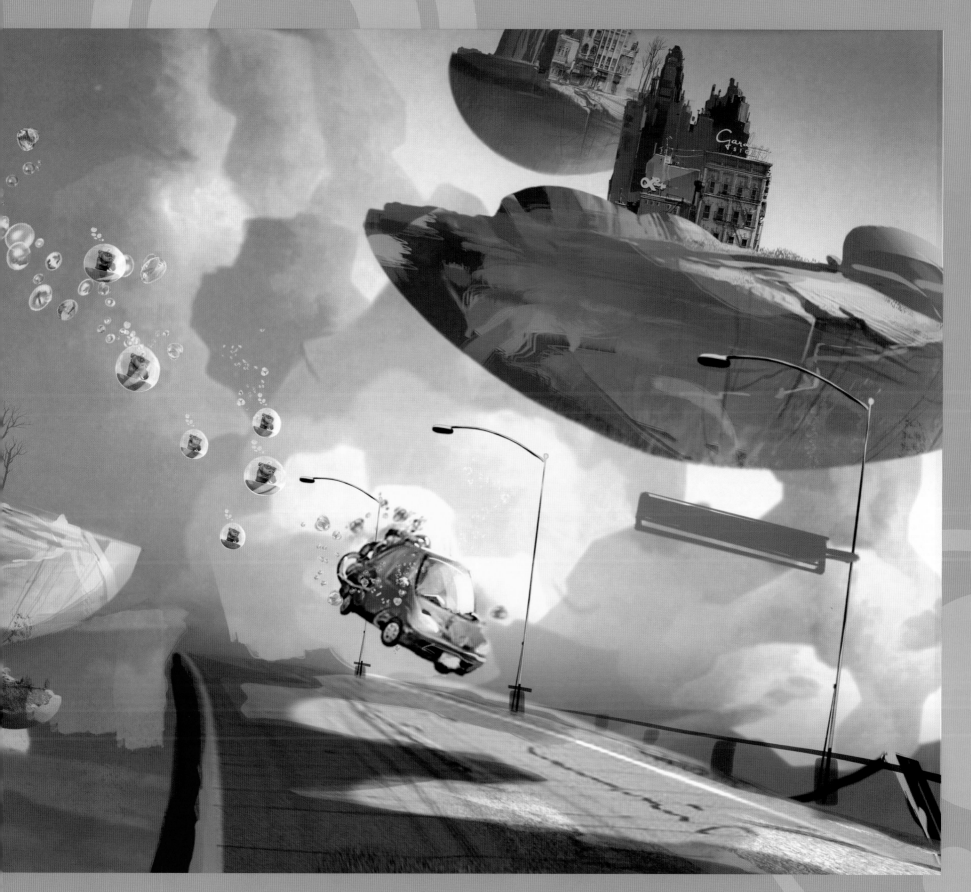

but soft, the colors are saturated, and the imagery is iconic to the locations they're passing through."

In Tibet, we see that the Boov have put a line straight through the Himalayas because they wanted a clean shortcut across the mountains. In Italy, the meticulous aliens resculpted the beautiful coast—a villa was cut in half by the Boov ships because they didn't care for the "crinkly edge" of the continent and wanted a smooth, tidy coastal line. In London, we see a cluster of the iconic red telephone booths floating in midair as the aliens couldn't find any practical use for them. And in Egypt, the Sphinx's head has been replaced by Captain Smek's visage! As the film's creative team planned out Tip and Oh's worldwide itinerary, they mapped out numerous locations across the globe. Although some of these magnificent backdrops only appear briefly in the final cut of the film, they are beautiful to behold.

(below) Emil Mitev

> Showing the audience the Boov's surreal impact on cities such as Rome, Egypt, and Burma let us stretch our design sensibilities while maintaining the integrity and topography of the real-life locations.
> —EMIL MITEV, ART DIRECTOR

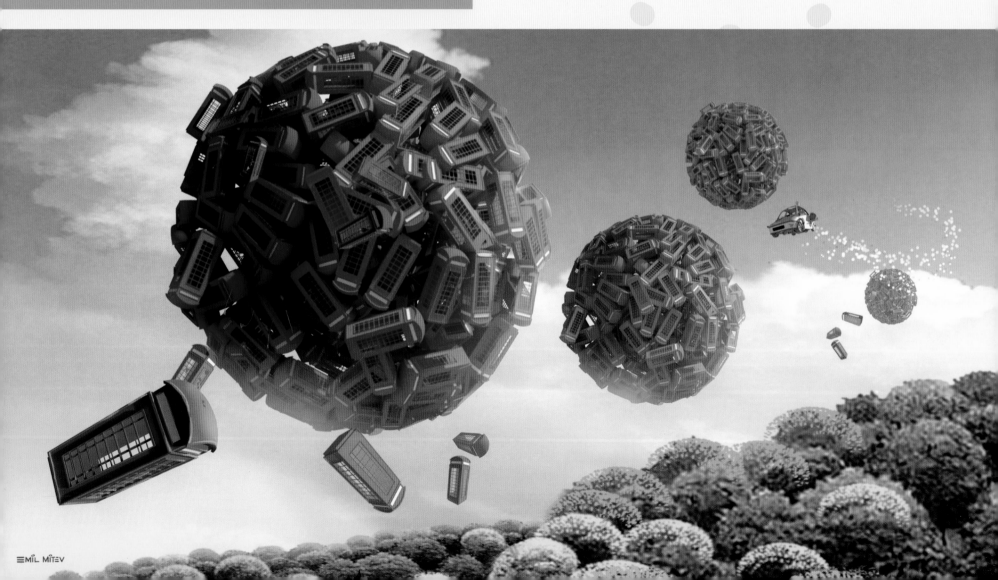

EMIL MITEV

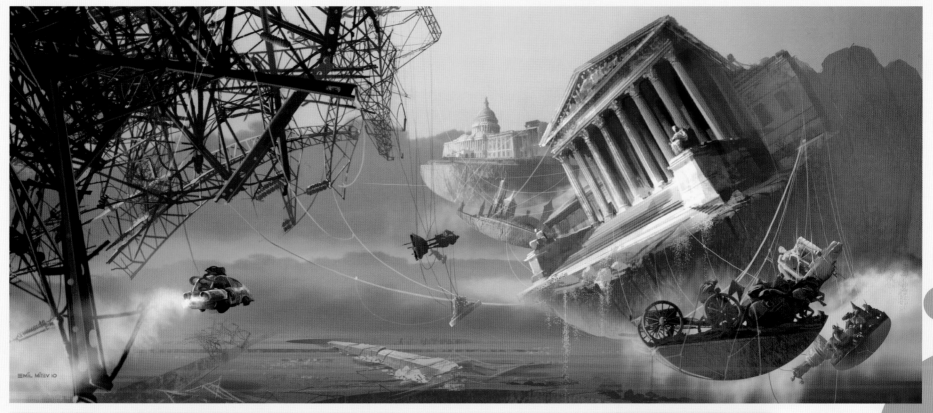

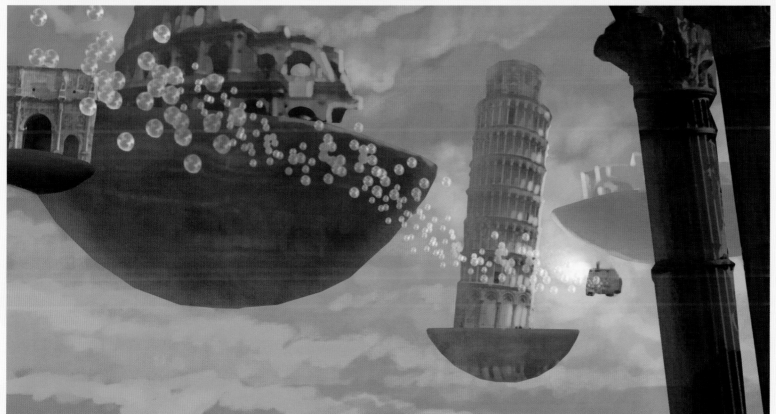

(top) Emil Mitev, (above) Bill Kaufmann

Chris Grun

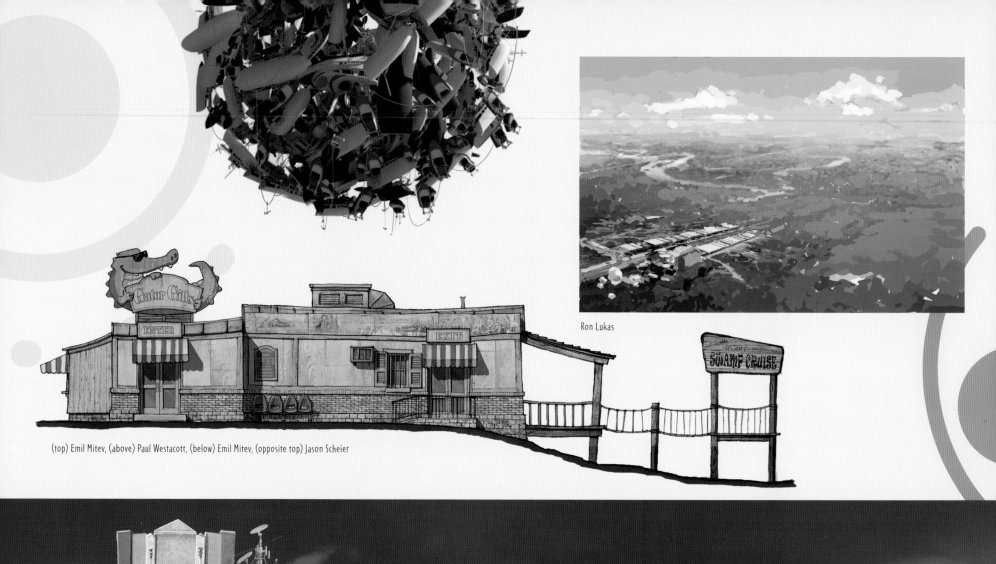

Ron Lukas

(top) Emil Mitev, (above) Paul Westacott, (below) Emil Mitev, (opposite top) Jason Scheier

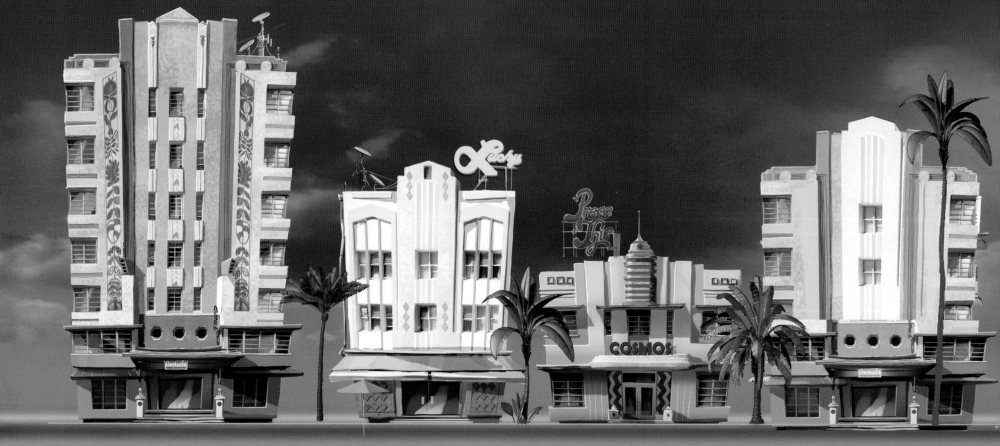

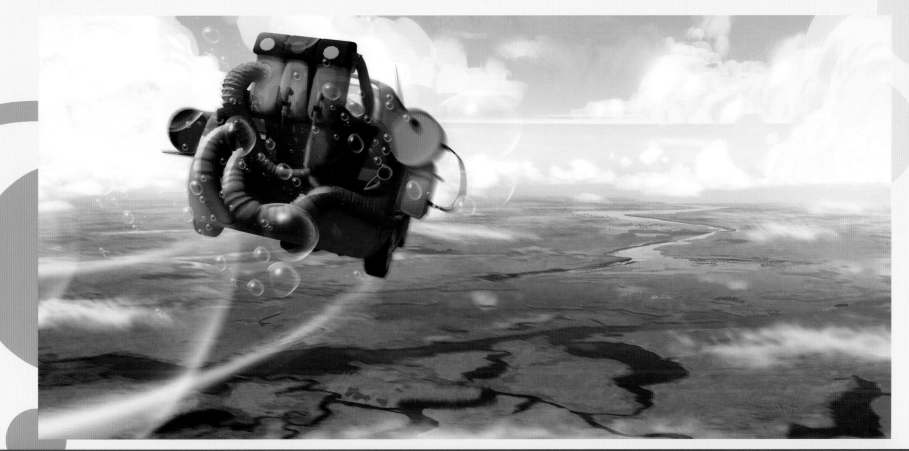

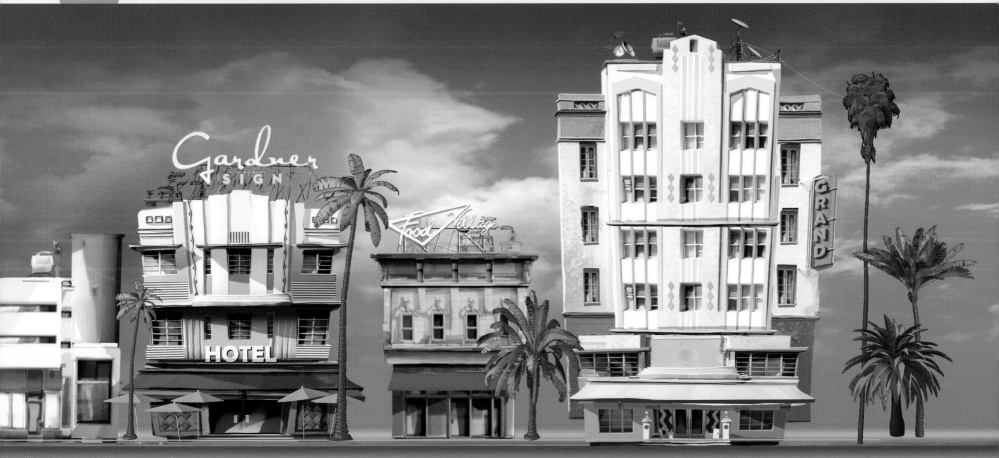

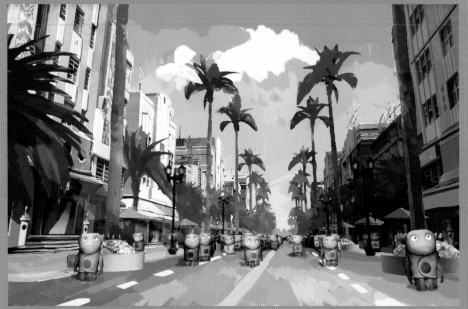

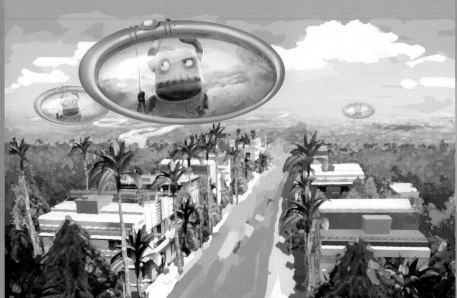

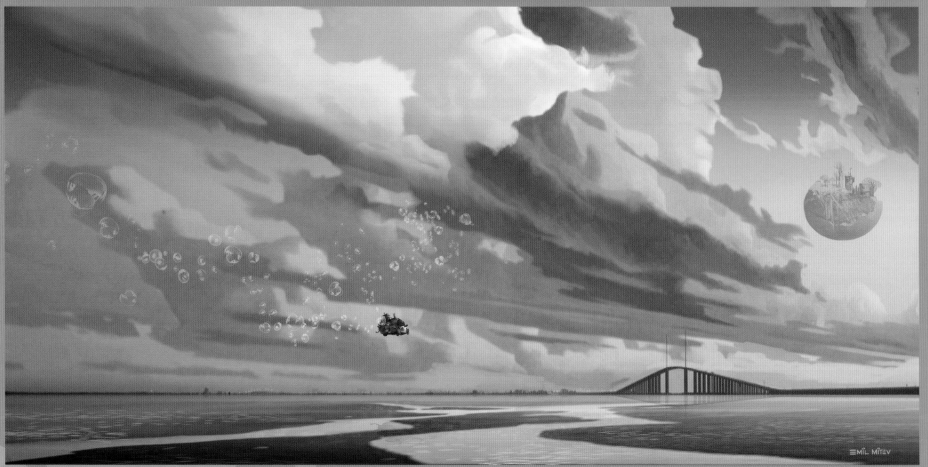

(top left & top right) Ron Lukas, (above) Emil Mitev

Todd Wilderman

Emil Mitev

Paul Westacott

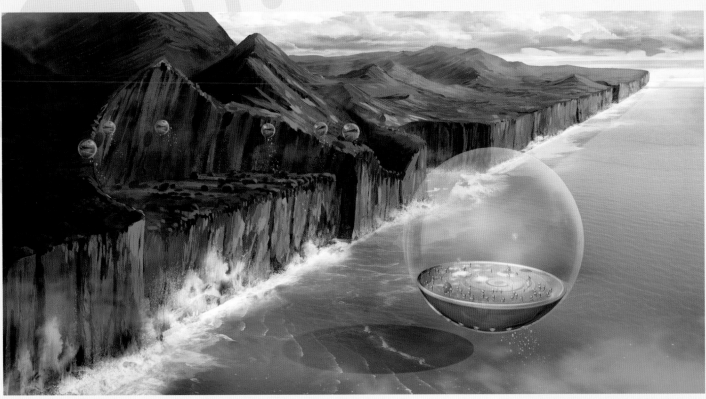

(above) Jason Scheier, (right & top right) Emil Mitev

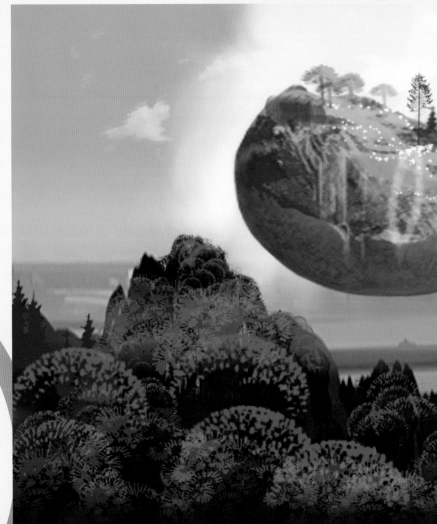

"Our characters go on a road trip and spend a significant time in a car. We had the challenge of making all of those driving/flying sequences dynamic and unique to the story moments. We also worked on characters that each had different looks: one who changes her clothes and hairstyles, and one that changes colors. Our lighting challenge was to keep them looking like themselves in all their variety.

"I think the most unique challenge in this movie was working on the Gravity Balls. We have huge floating bundles of everyday items like cars and umbrellas meander through the sky in scenes. We have lit umbrellas and cars before in other movies, but when there are hundreds of them stuck together floating around in a giant ball, the look can be dramatically different."

— Betsy Nofsinger, Head of Lighting

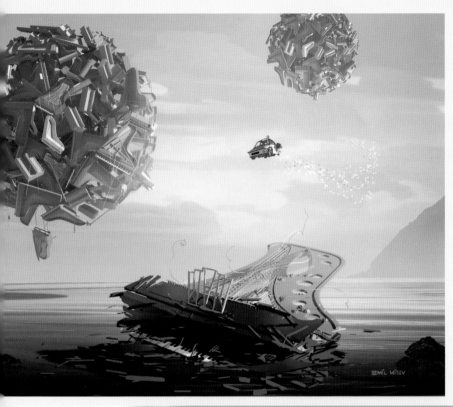

Since the whimsical multi-location voyage had to be told in the space of a few minutes, our goal was to make the locations instantly recognizable—but with a Boov twist.

—EMIL MITEV, ART DIRECTOR

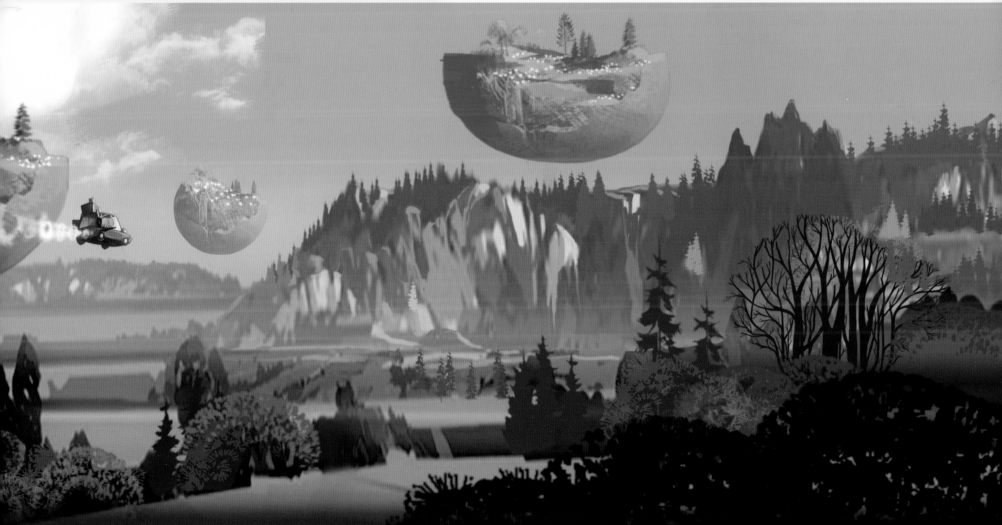

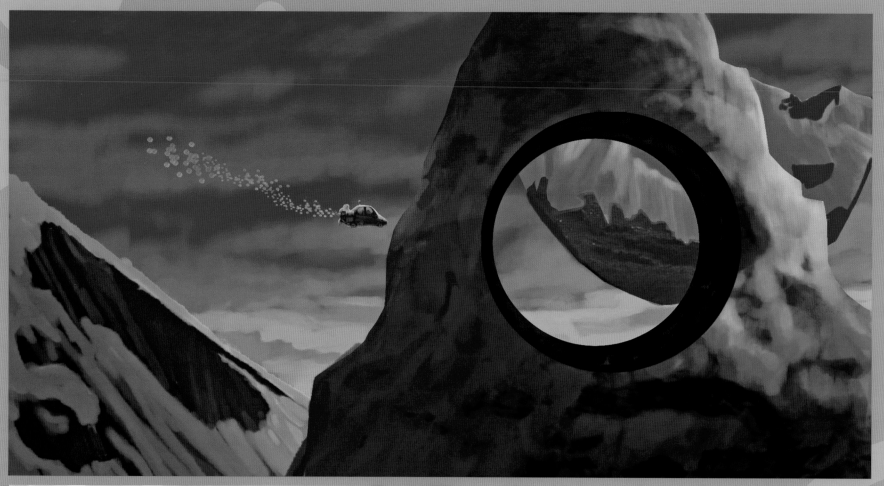

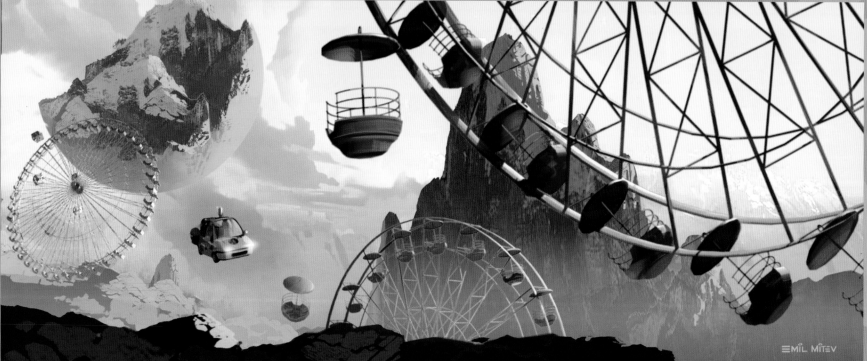

(top) Bill Kaufmann, (above) Emil Mitev

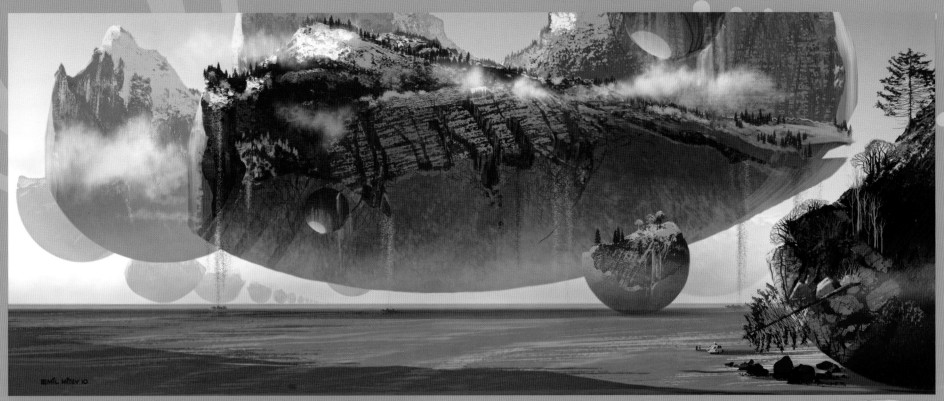

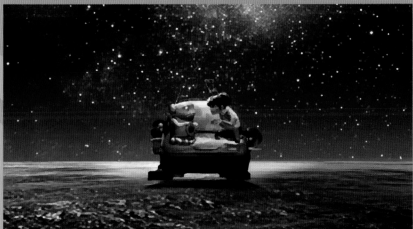

(top) Emil Mitev, (above) Ron Lukas

"We wanted to stay true to the quirky vibe of the source material, the children's book by Adam Rex. The characters are very well drawn both in terms of visuals and storytelling perspectives. They are so memorable that you just want to follow their stories and watch them on their journeys, no matter what they're doing.

"When I first heard the plot, I thought we had quite a challenge: The scope was so huge: We go from continent to continent, from one city to another. We have several backgrounds—Paris, the Australian Outback, China . . . then we have two kinds of aliens, two kinds of spacecraft, and a mothership the size of Texas. Human crowds for these cities, alien crowds, alien characters that change colors with their emotions, and a giant refugee camp with a crowd that represents every country on the planet!

"In terms of stylistic goals, we wanted to hit the sweet spot of having enough realistic elements while keeping the lovable simplicity of our character designer's work. His shapes and geometries are so elegant and adorable. We needed to complement his work in terms of textures and material. Our director Tim Johnson didn't want the movie to look overly photographic and pushed it to have a watercolor-y feel. The trees, the buildings, even the grime on the surface of the buildings—everything had to feel organic and traditional. We had a delicate job of balancing between the real and the painterly."

— Jeremy Engleman, Head of Surfacing

121

Le Tang

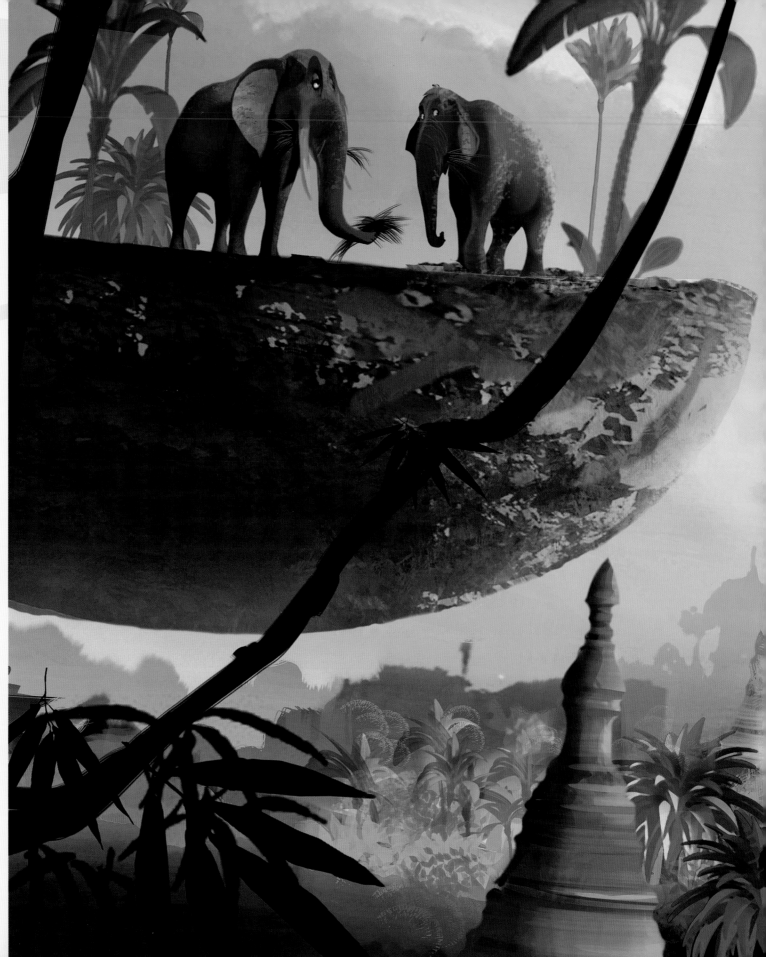

Emil Mitev

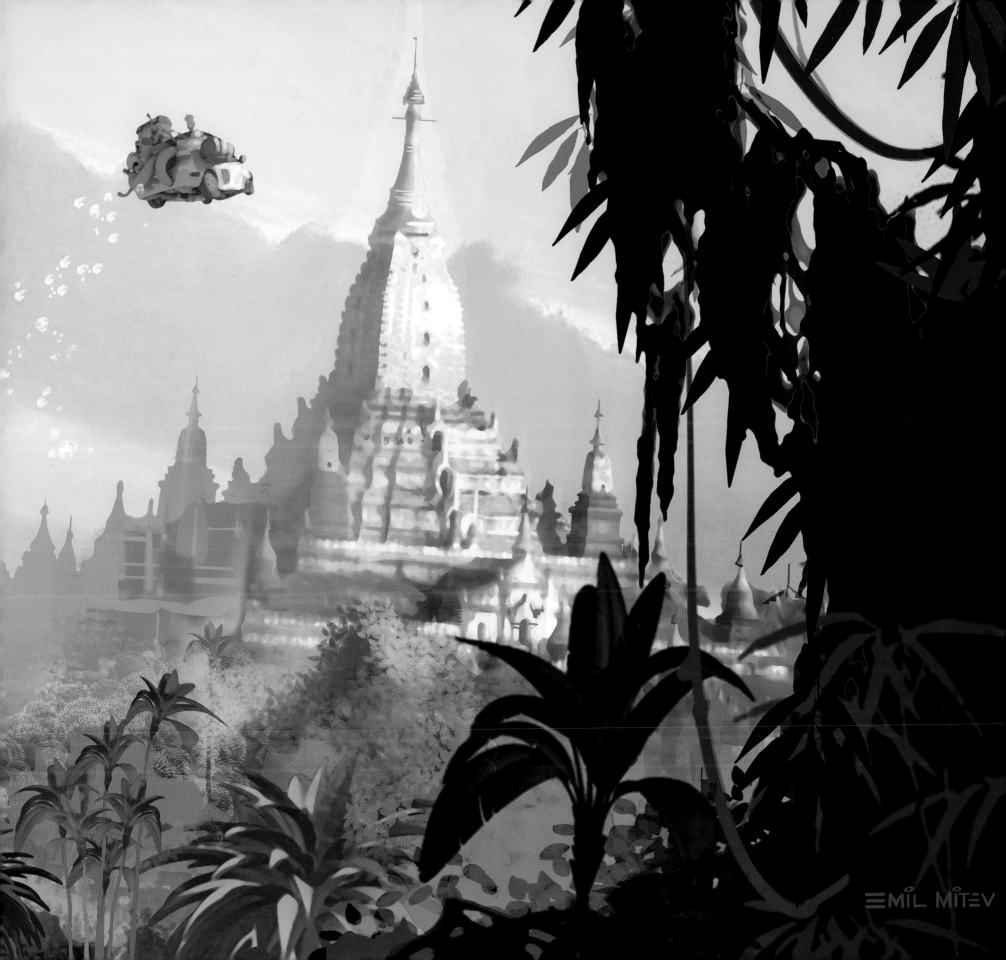

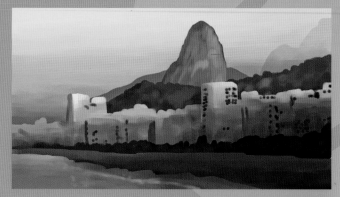

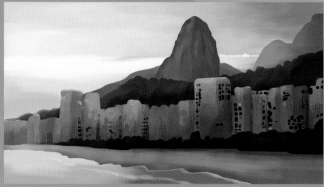

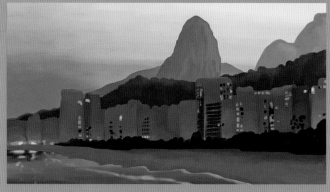

Natalie Franscioni-Karp

Emil Mitev

HAPPY HUMANSTOWN

WHEN THE BOOV COLONIZE EARTH, they decide to move all the planet's original inhabitants to a homogenous reserve in Australia, which they call "Happy Humanstown." In this artificial human colony, the "free-range humans" can eat all the ice cream they want and enjoy the comforts of their prefab homes, which are about two-thirds the size of average human houses—because as Oh says to Tip in the movie, "You looked shorter from space."

"The Boov are well-meaning but arrogant overlords," says producer Chris Jenkins. "They think they're taking care of us, but the houses are too small, the TVs are too big, and our only source of nourishment is 'sweetened bovine secretions'—or, as we know it, ice cream!"

The real-world inspirations for Happy Humanstown came from Celebration, the census-designated, master-planned community in Osceola County, Florida, as well as primly designed California suburbs. "When you drive around California, you come across these communities that are very prim and proper," says Jenkins. "Not one of them is the same, but they all have beautiful gardens and have the same feel. Our job was to scale them down and to make them both quaint and livable—and obviously, they had to look ridiculous, because the Boov were behind them."

He continues, "The idea was to portray a sense of irony, where even though the Boov think they're doing us a favor and have studied all our 'needs,' in truth they have a very superficial understanding of what makes us happy."

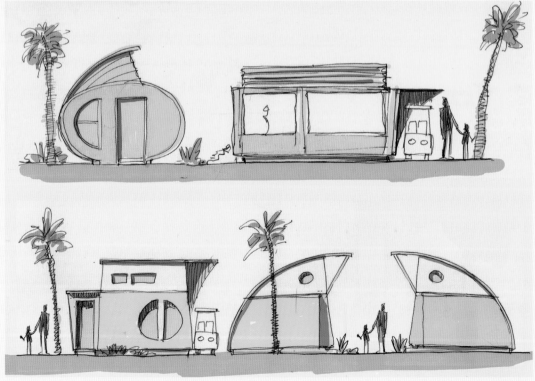

(top) Bill Kaufmann, (above) Paul Westacott

Paul Westacott

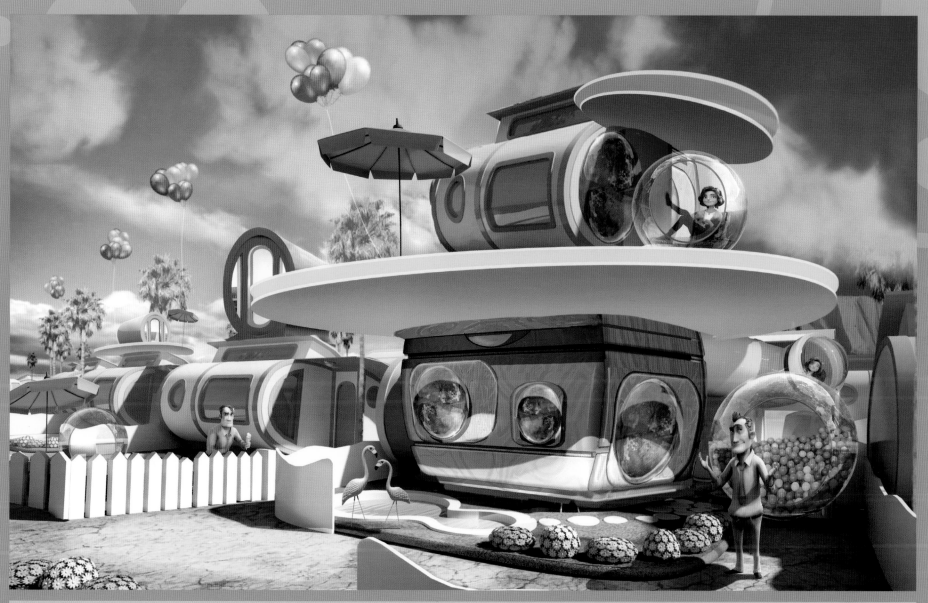

The Cape Cod

Casa Majorca

The Manhatten

The Colonial

(top) Emil Mitev, (above) Paul Westacott

127

Stan Seo & Emil Mitev

Emil Mitev

"One of the interesting aspects of the movie was being able to work on an animated movie with two characters in a flying car. I had worked on movies with flying characters before, but in *Home*, we have these two lost souls from different worlds going through different environments in the air. Then, there was the world of the Boov. Everything about them—their ship, their way of dealing with humans and life on Earth, the way they deal with our everyday objects—there was so much fun to be had with all of that.

"Music plays such a huge part in this movie. We had this unique opportunity to have someone who is as talented and special as Rihanna provide a key voice in the movie. The songs are fully integrated and truly embedded into the movie in a way that they are not just sitting on top of a montage sequence. We looked at movies like *The Graduate*, which featured the songs of Simon & Garfunkel, or Prince's *Purple Rain*, which have the same level of interplay between music and the film's central ideas. We have a scene start out with a vocal, then the vocal drops out and the music supports the dialog."

— Nick Fletcher, Lead Editor

129

Emil Mitev

130

Emil Mitev

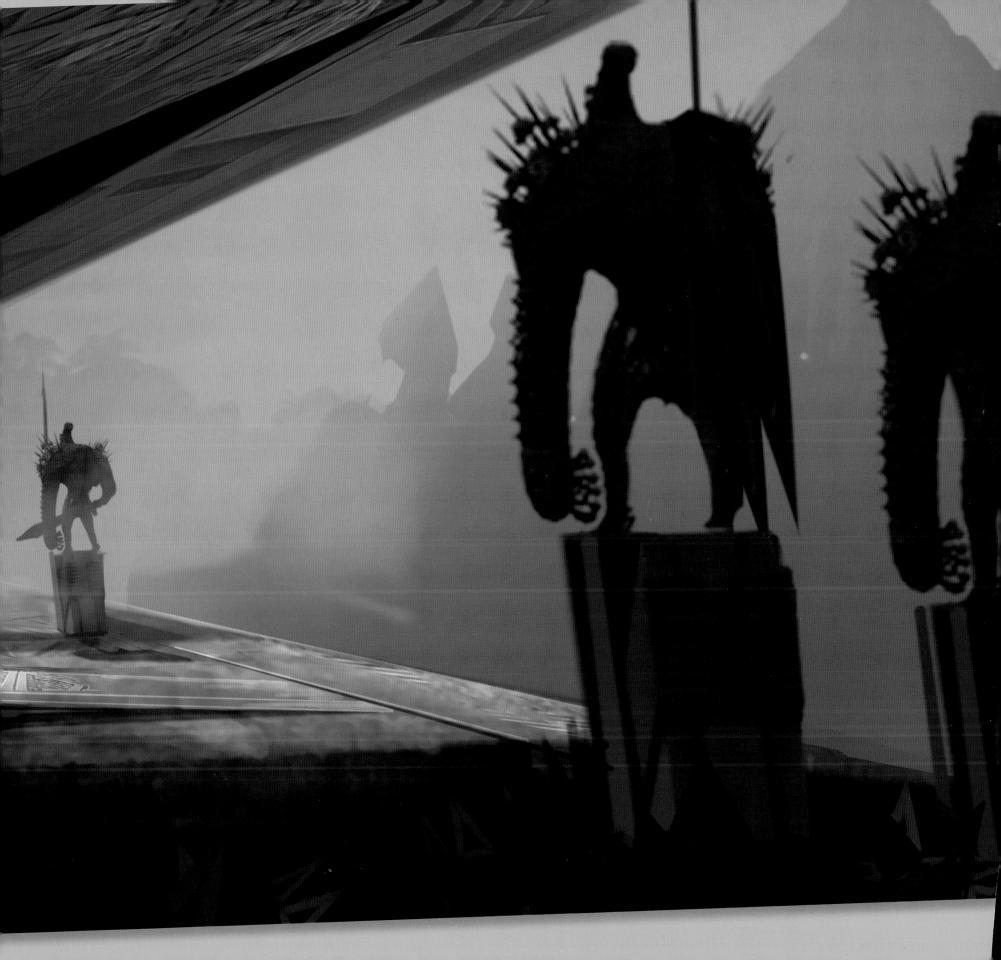

THE GORG

EARLY ON IN THE DESIGN PROCESS, it was decided that the human world would be defined by squares, the Boov would follow a round aesthetic, and the Gorg—who are the true antagonists and the big threat in the movie—would be defined by triangles and pyramids. "This hostile, angular shape was created to be a threat to both the humans and the Boov," says director Tim Johnson.

When creating the main Gorg alien, character designer Takao Noguchi set out to avoid typical horror movie clichés. He went back to the fact that perhaps these creatures had also evolved from sea creatures. "If you look closely at starfish and sea urchins, they are very spiky, and they look a bit scary or creepy to us," he explains. "Starfish have five tentacles, so I took each tentacle as an arm and added more spikes from the sea urchin to indicate a sense of danger."

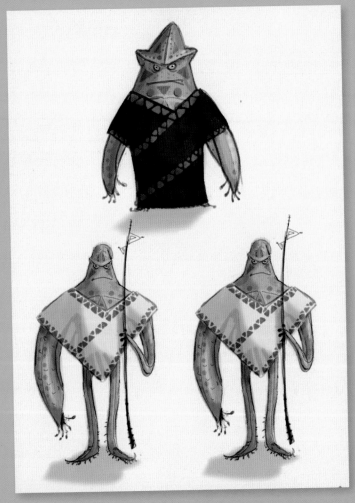

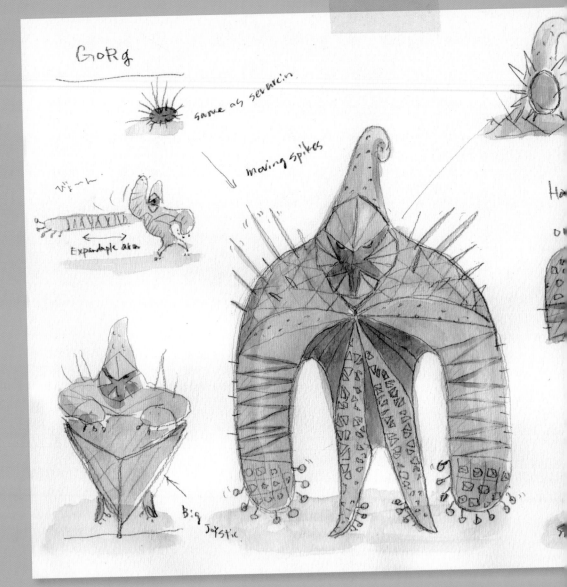

The Gorg's world is all about sharp lines and straight edges. This sets up a basic but strong visual contrast to the Boov's round bubble shapes.

—EMIL MITEV, ART DIRECTOR

(previous pages) Emil Mitev, (these pages) Takao Noguchi

134

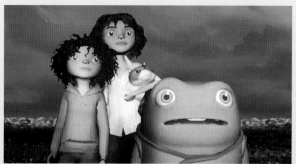

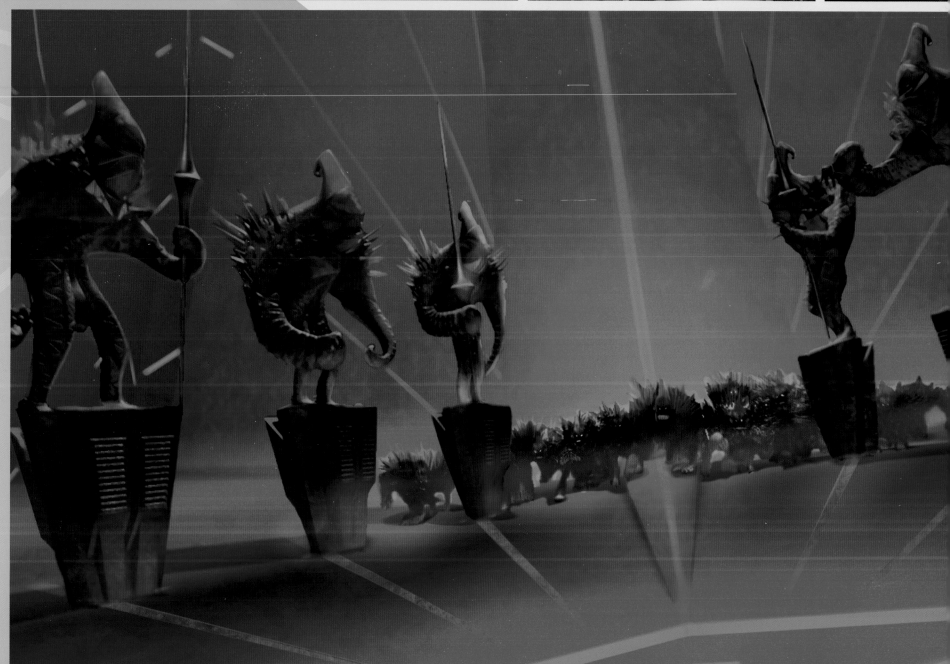

Emil Mitev & Stan Seo

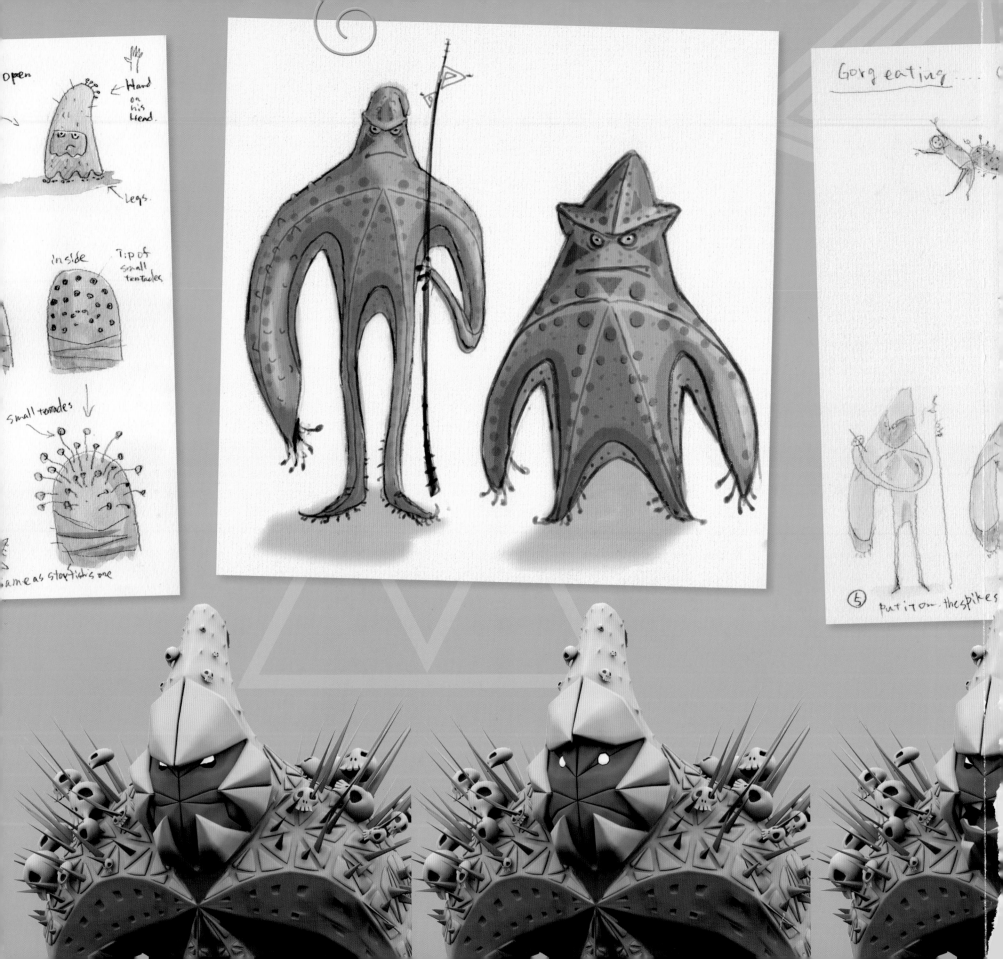

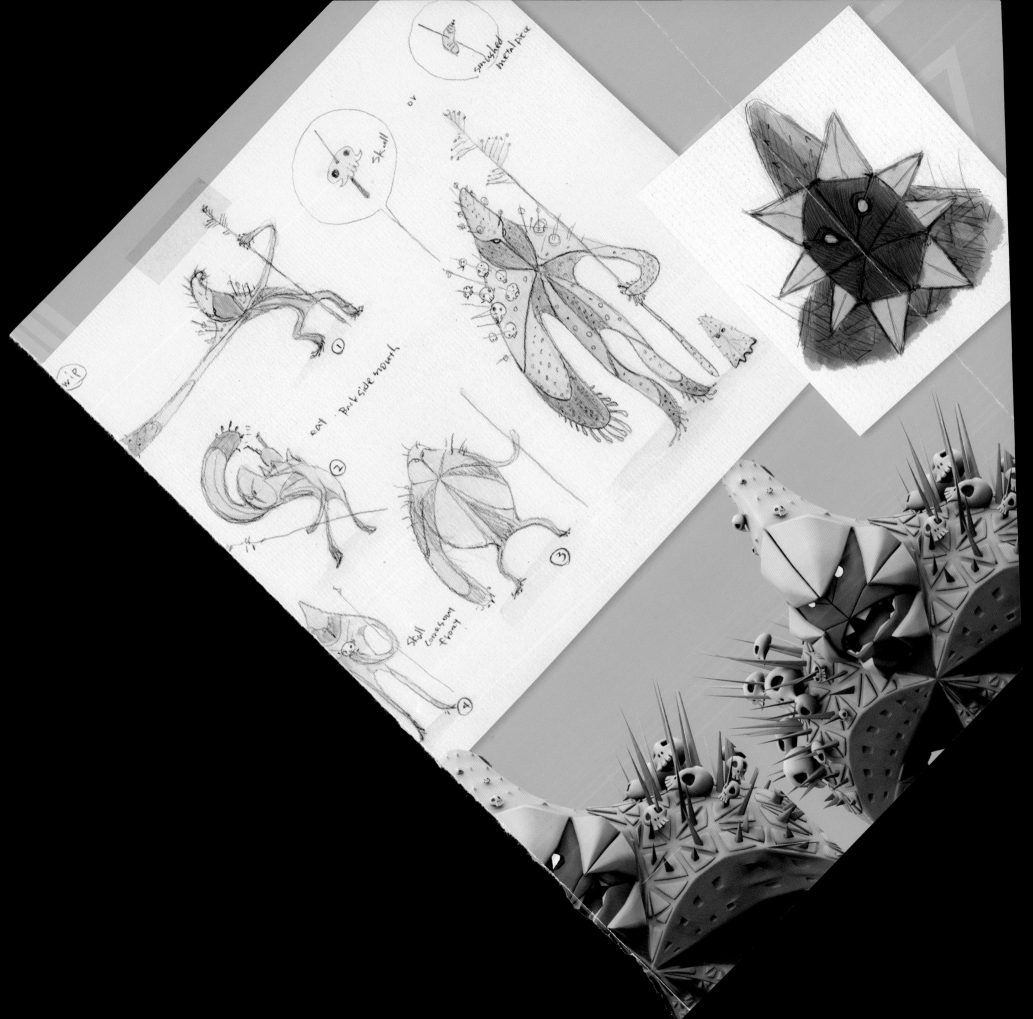

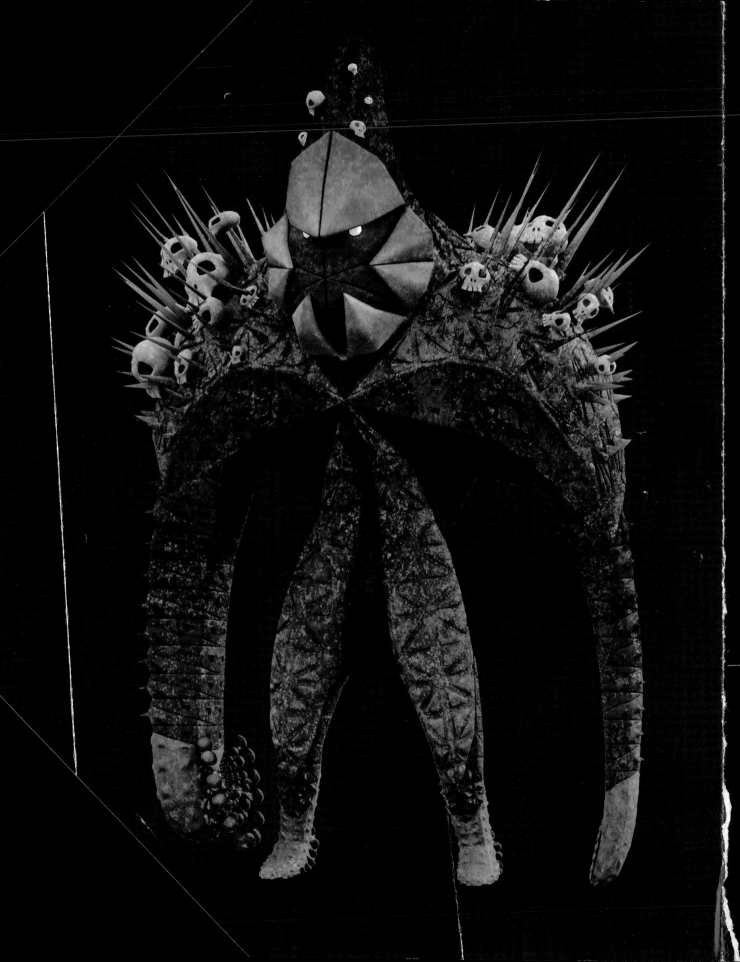

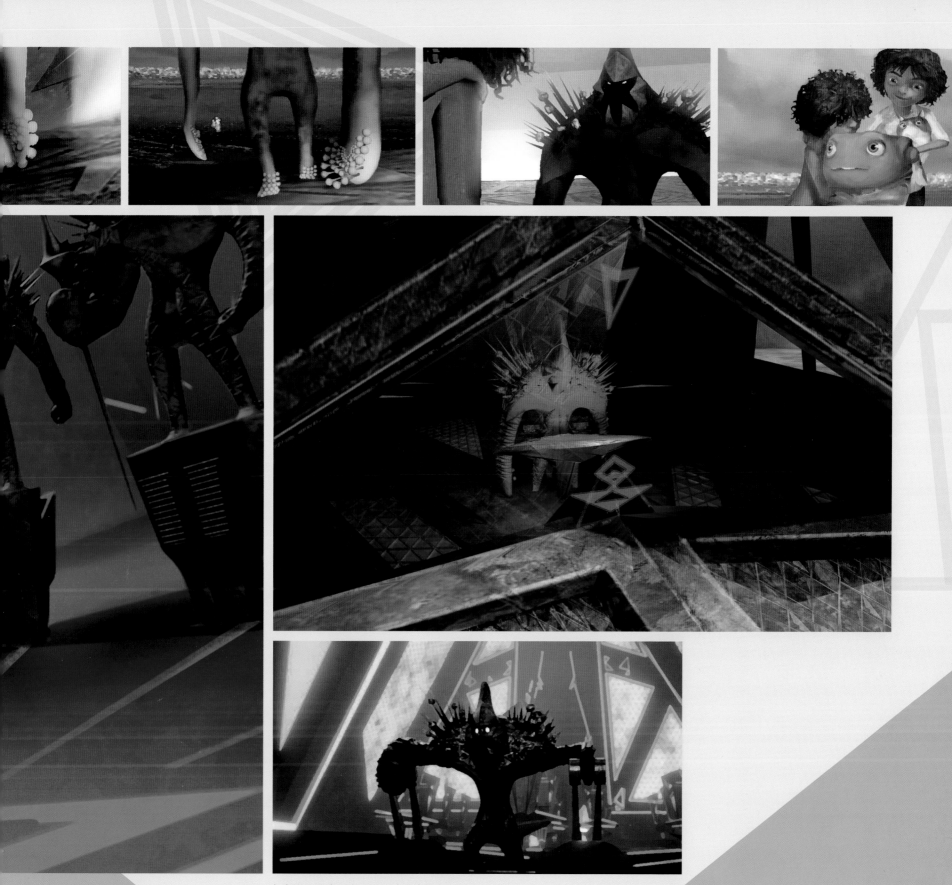

(top) Ron Lukas, (center) Emil Mitev, (above) Ron Lukas

139

GORG SHIP

BUILT TO REFLECT THE GORG'S general pattern of sharp and sea urchin–like textures, the Gorg ship is meant to be terrifying but strangely fascinating. Since the Boov technology is based on bubbles, the Gorg's sharp exteriors and spike-covered body is designed to pop all their soft bubbles.

The menacing ship travels the universe as a giant, triangular war machine, but as it lands on Boov-inhabited worlds, it can transform into a vast planet-destroying bulldozer. The massive ship that lands in Australia stretches from horizon to horizon, digging up the Outback with a terrifying wall of blades and gears.

The ship was an interesting challenge for the DreamWorks team. "When designing the Gorg ship, we returned to our basic shape-language ideology," says Emil Mitev. "Trying to stay true to the Gorg's main shape—the triangle—we used a giant tetrahedron for the basis of the ship design."

Kathy Altieri adds, "The ship's scale had to be enormous—Tim wanted the Earthcruncher portion to be forty miles high—and we had to integrate that into the overall design. In the end, the matte painting department helped us get the scale and the majesty we were looking for."

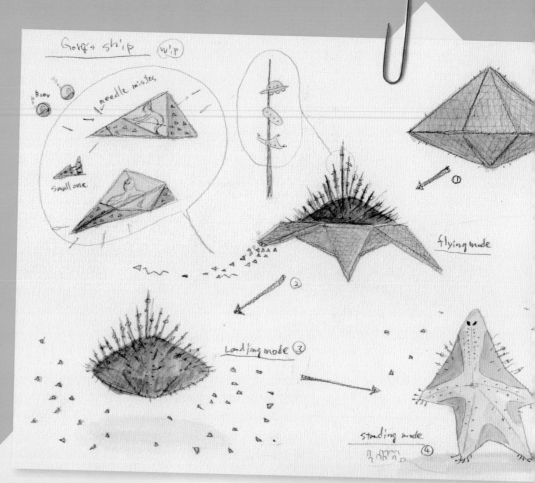

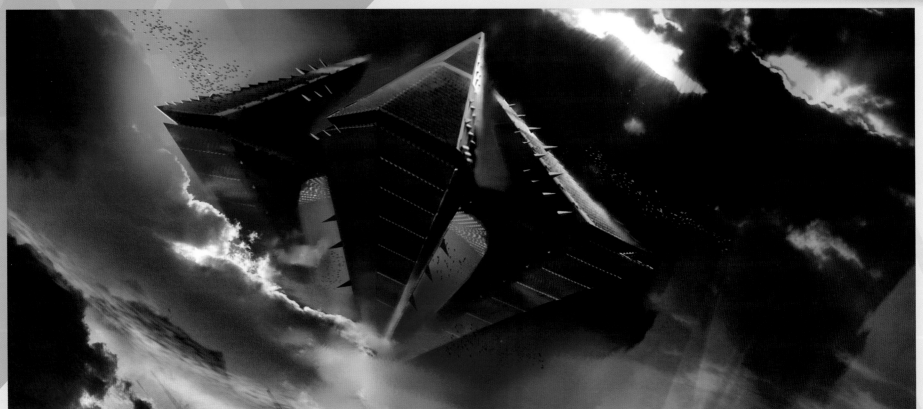

(top) Takao Noguchi, (above) Simon Rodgers

140

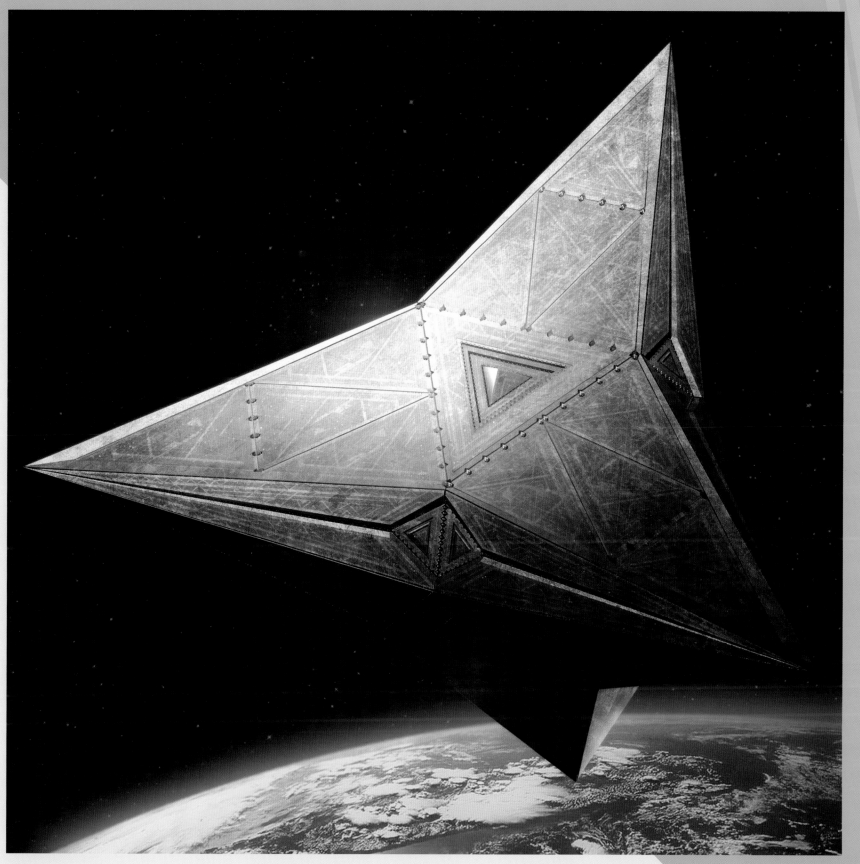

Stan Seo

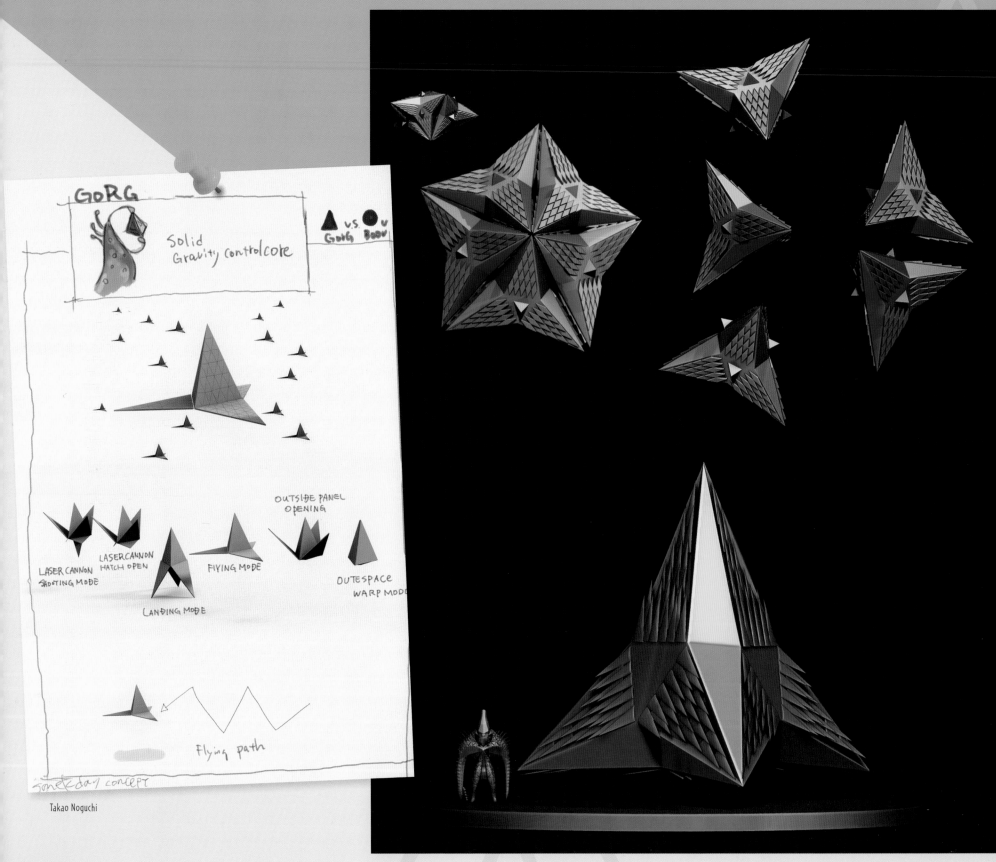

GORG

Solid
Gravity controlcore

△ v.s. ○
GORG BODY

OUTSIDE PANEL
OPENING

LASER CANNON
SHOOTING MODE

LASER CANNON
HATCH OPEN

FLYING MODE

LANDING MODE

OUTESPACE
WARP MODE

Flying path

someday concept

Takao Noguchi

Simon Rodgers

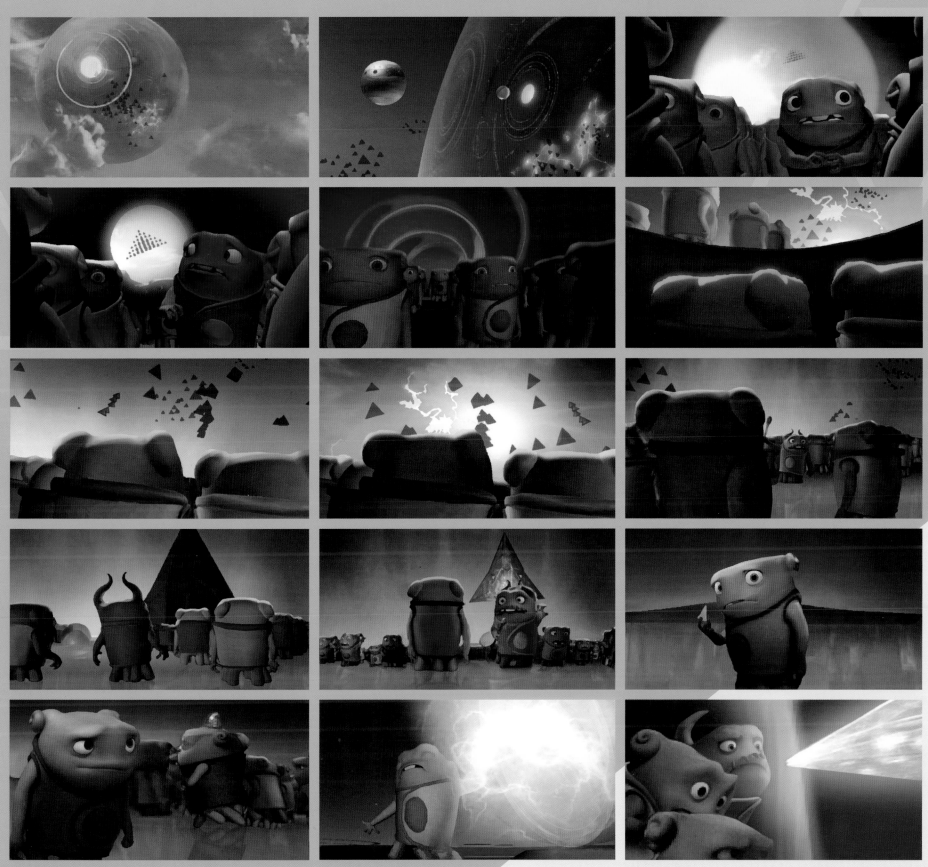

Ron Lukas

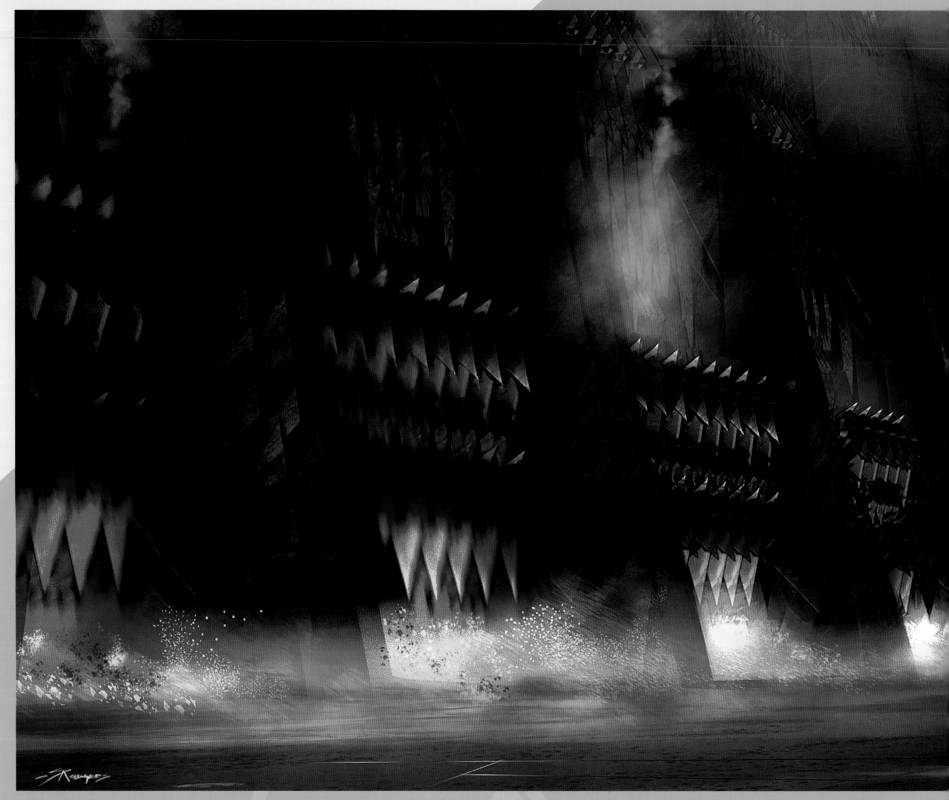

Simon Rodgers

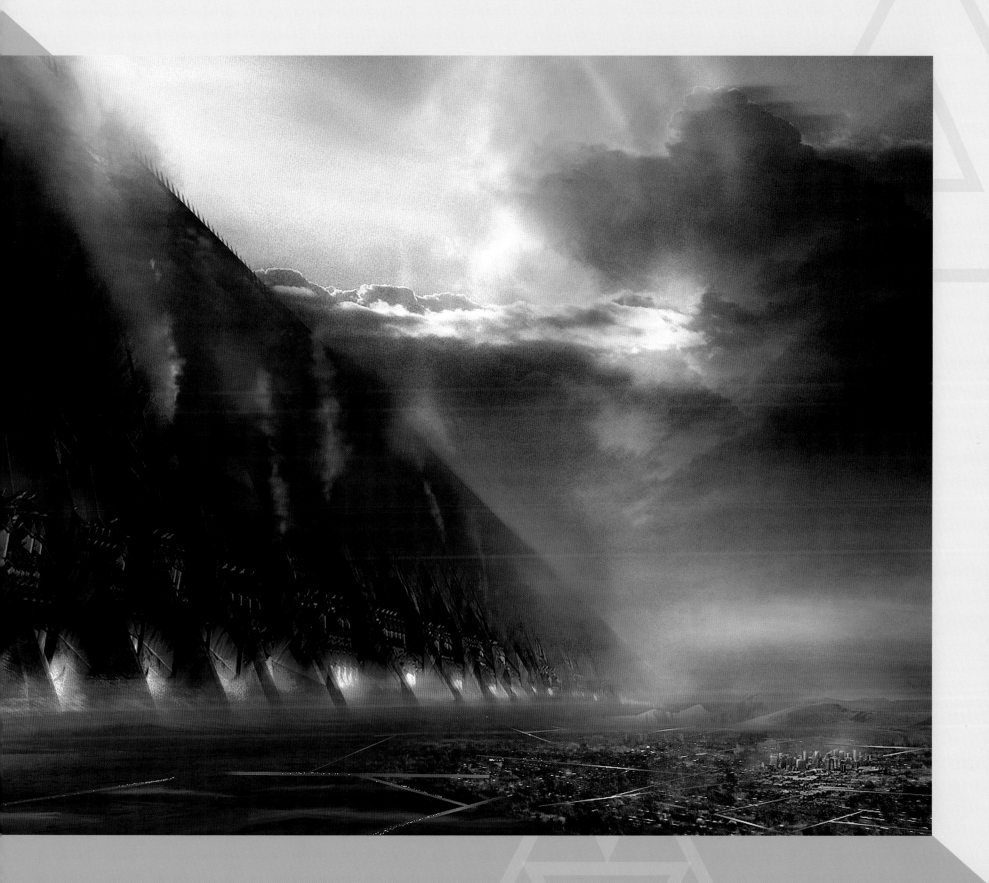

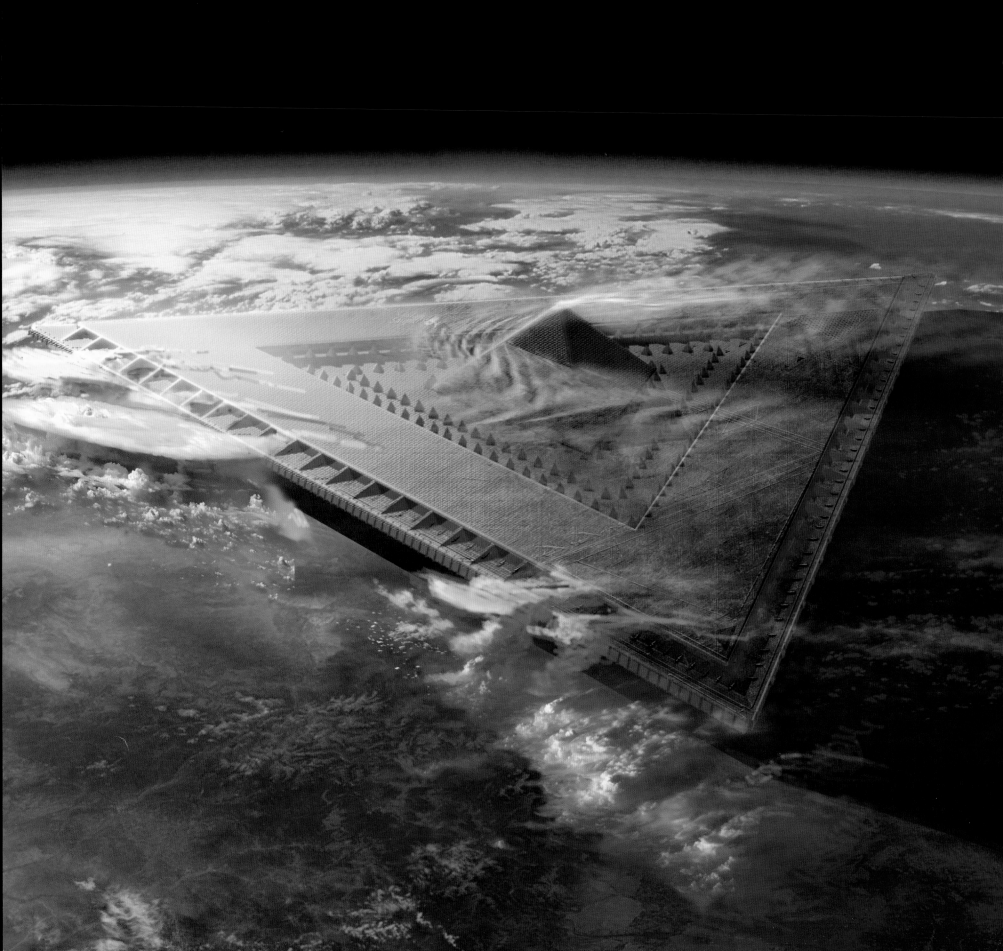

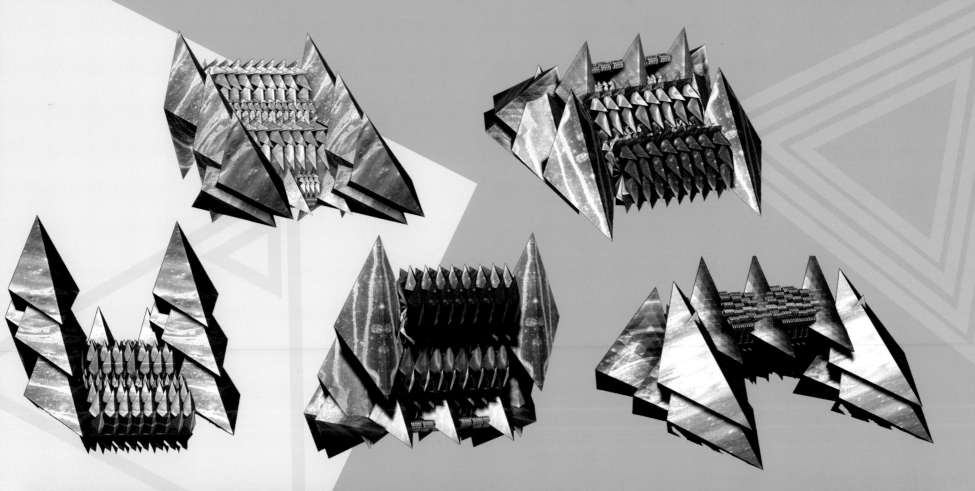

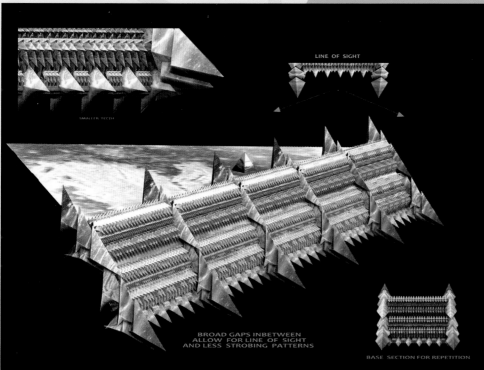

BROAD GAPS INBETWEEN
ALLOW FOR LINE OF SIGHT
AND LESS STROBING PATTERNS

BASE SECTION FOR REPETITION

LINE OF SIGHT

SMALLER TEETH

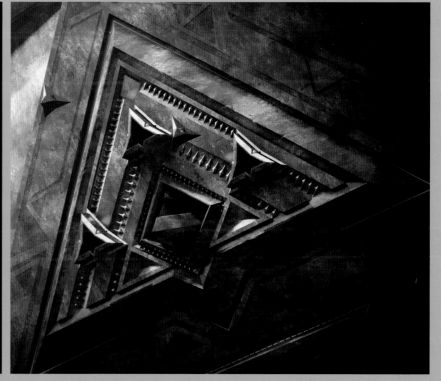

(top & above) Simon Rodgers

(above) Stan Seo, (opposite) Chris Grun

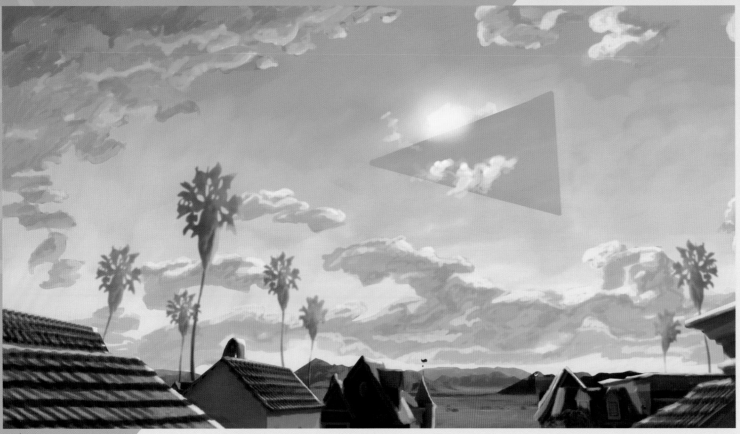

(top & right) Onesimus Nuernberger, (above) Bill Kaufmann

When creating the look of the Gorg ship, we wanted to get
away from all the stereotypical sci-fi cliches of ship designs.
—KATHY ALTIERI, PRODUCTION DESIGNER

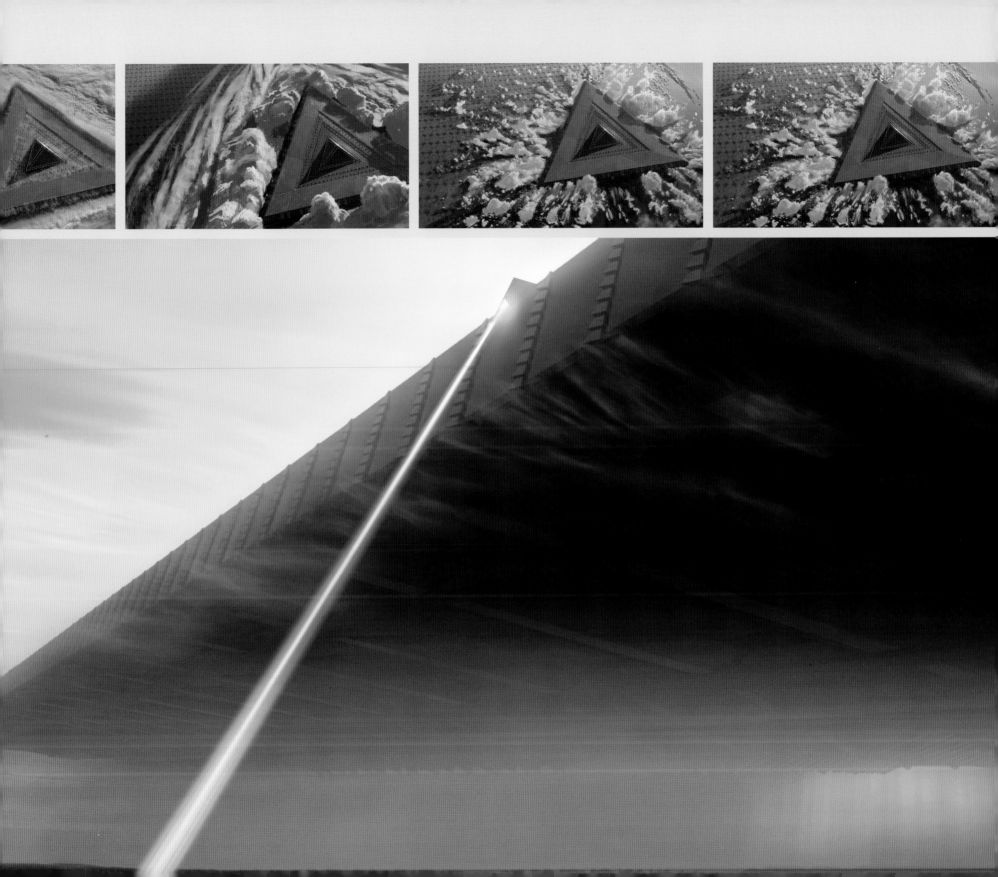

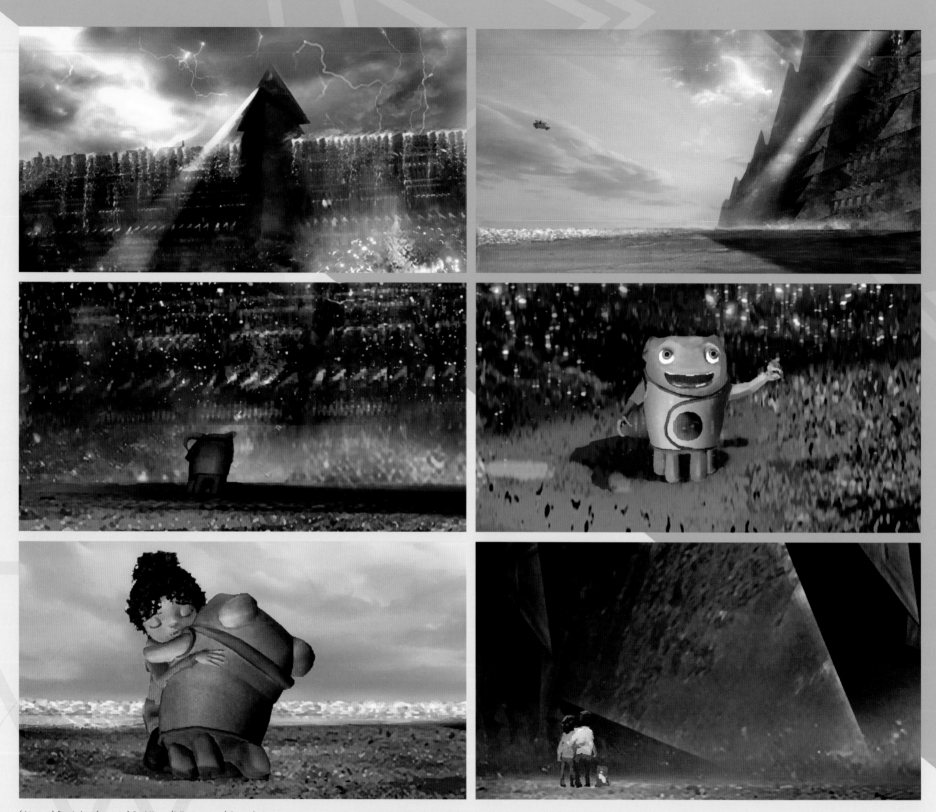

(this page) Ron Lukas, (opposite) Emil Mitev, (following pages) Simon Rodgers

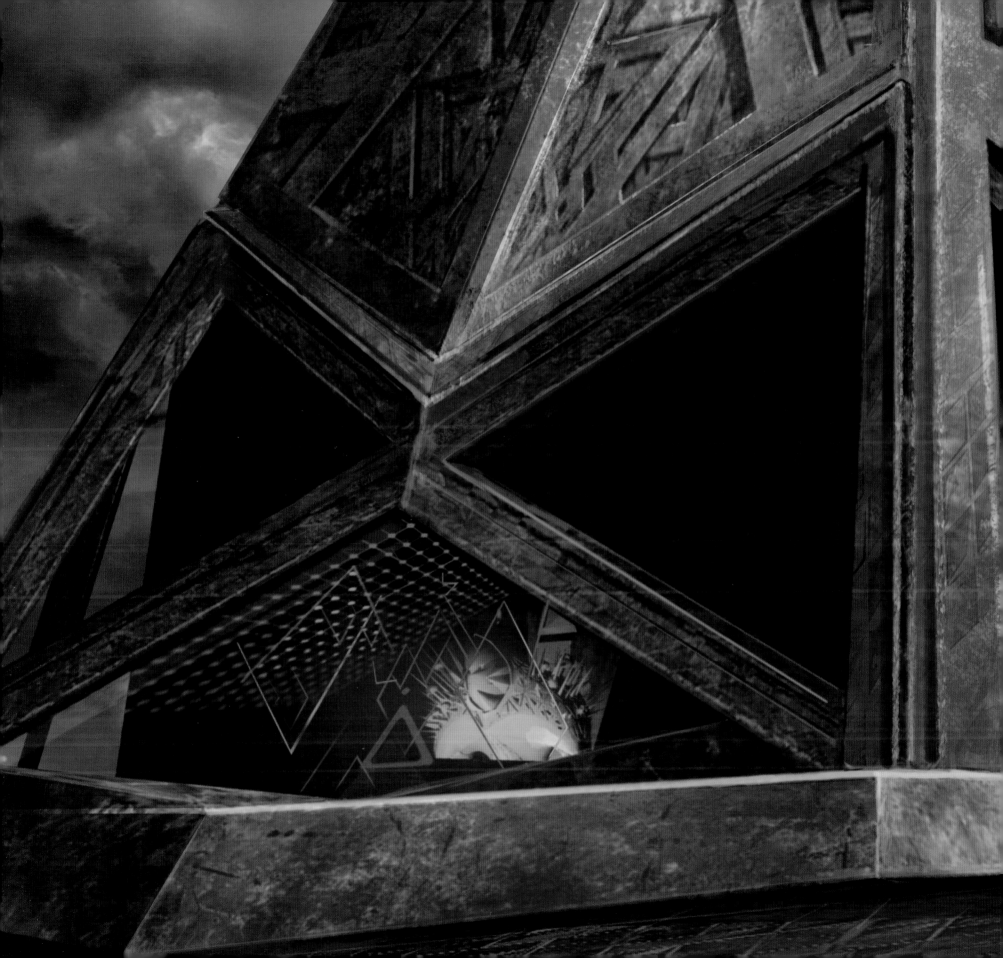

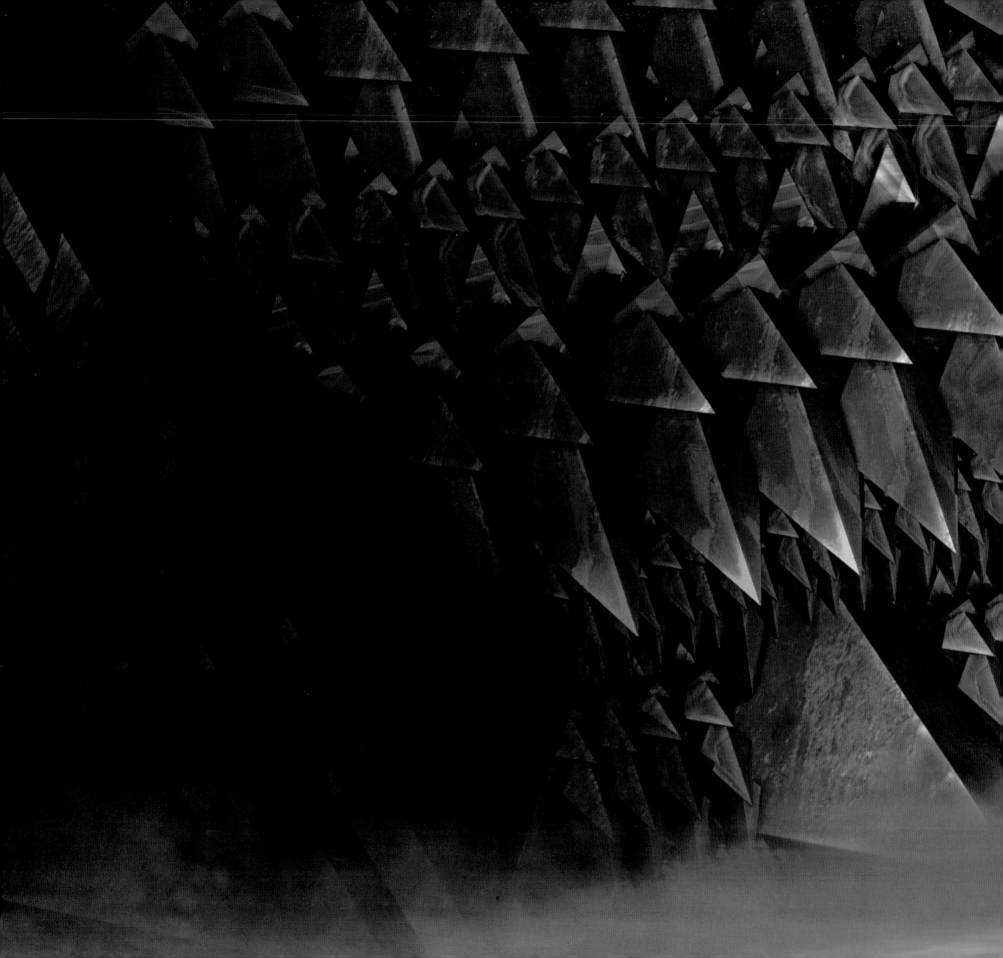

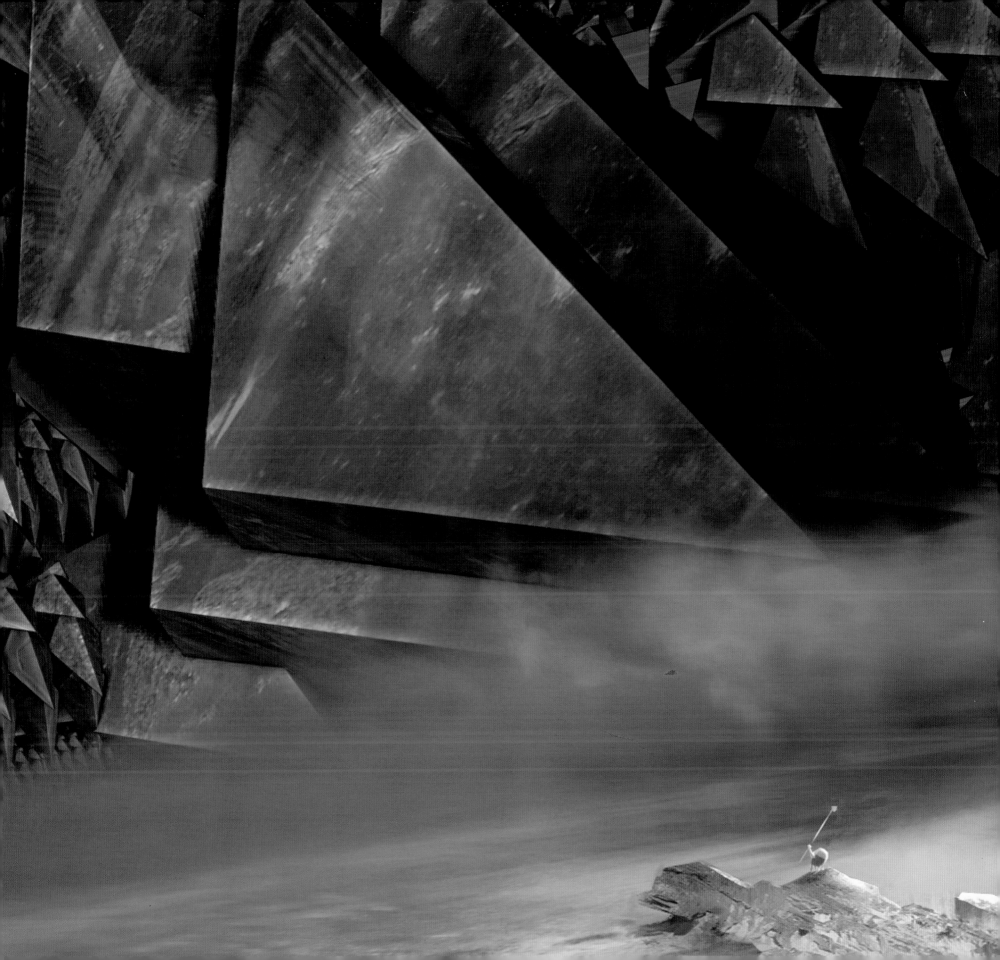

THE ALMOST HOME SHORT

THE BOOV'S ADVENTURES BEFORE EARTH

SUPPORTING CHARACTERS IN animated movies often take on lives of their own and beg for more storylines and screen time. In the case of *Home*, it was Captain Smek who demanded his own special short. Head of story Todd Wilderman says, "We wanted to do something to raise awareness about the movie and invite people to fall in love with these aliens before the movie's opening."

Wilderman, who directed the short, recalls, "Our director Tim Johnson asked me to take this one, so we got together with the story crew and came up with the story beat and structure in a matter of hours."

The hilarious short, *Almost Home*, is set in the time just before the actions of the movie. It centers on the bombastic leader Captain Smek and his Boov team as they search the universe for a suitable new home world. Yet, each planet they encounter reveals itself to be either previously occupied by some dangerous creature or uninhabitable for a variety of ridiculous reasons. Finally, when what seems to be the perfect rainbow-ringed planet explodes in front of them, Captain Smek sets a course for Earth. While the many weird creatures and different locations the Boov visit have various one-off styles and approaches, Smek and the rest of the Boov are depicted exactly the same as they are in the movie. "We didn't want to introduce our two main characters from the movie," says Wilderman, "but we wanted to introduce the Boov and Captain Smek."

The project took about eleven weeks from start to finish. "After our brainstorming session, we pitched our beat board and drawings to [DreamWorks Animation's chief creative officer] Bill Damaschke and got the green light to deliver the short in three months," recalls Wilderman. "A lot of the lead people on the movie did double duty and worked late hours to make sure we would have the short ready to play with *Mr. Peabody & Sherman*."

"If the challenge seemed impossible at the beginning, no one voiced their doubts," says producer

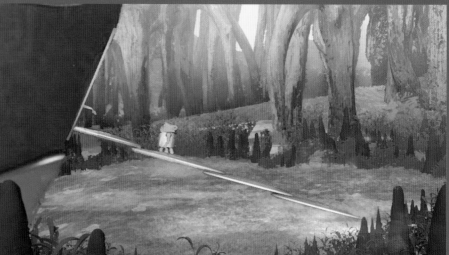

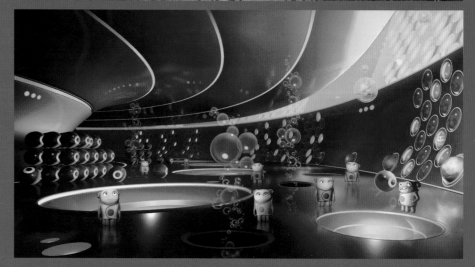

(left) Le Tang, (top & center) Ron Lukas, (above) Stan Seo

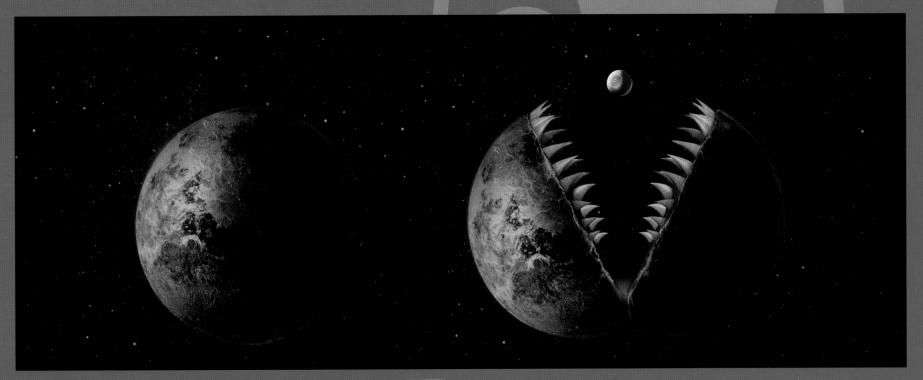

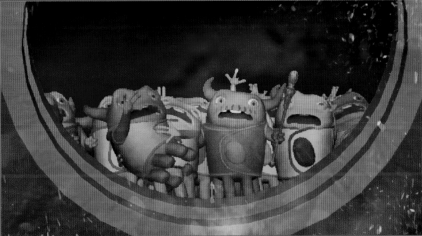

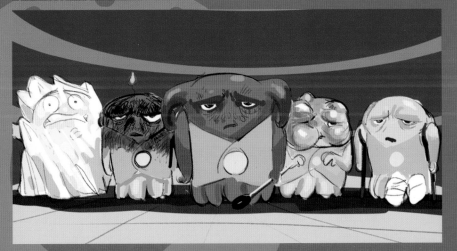

Chris Jenkins. "The crew came together to find a production plan where we used every trick in the book to break the land-speed record for producing three and a half minutes of animation."

Jenkins says he loves the way Steve Martin's comedy is sewn into every scene of the short. "It's a lovely sampler for what audiences see in the feature," he explains. "There are many ways in which it stands out—from its amazing art direction, to brilliant animation, right through to the sparkling lighting from our extraordinary lighting artists. It's as beautiful to look at as it is funny. The whole experience was a real joy. I loved working with this tremendously inventive and energetic crew led by the spectacular Todd Wilderman."

Wilderman enjoyed his entire experience of working on *Almost Home* as well: "Our main goal was to have fun, be entertaining, and make people laugh. Everyone across the board—including Bill and Jeffrey [Katzenberg, DreamWorks Animation CEO]—was pushing to make it sillier and more over the top. Nobody was telling us to hold anything back or reel it in. We didn't have to overthink it. We just wanted it to be really fun and entertaining."

Fans can also look for more shorts featuring the wild and crazy Boov characters. There are plans to produce more *Home* spin-off shorts to be released online. Of course, as we've seen with other DreamWorks Animation movies, there's a strong chance that the film's popular characters will star in their own small-screen series.

(top) Stan Seo, (center) Ron Lukas, (above) Le Tang

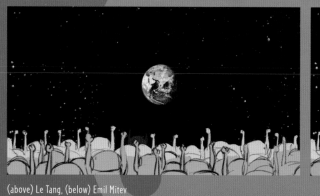

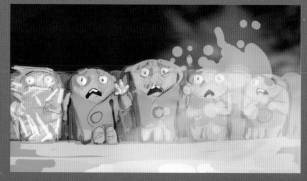

(above) Le Tang, (below) Emil Mitev

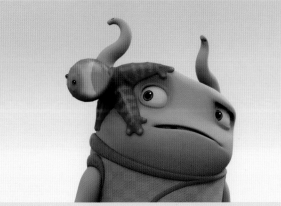
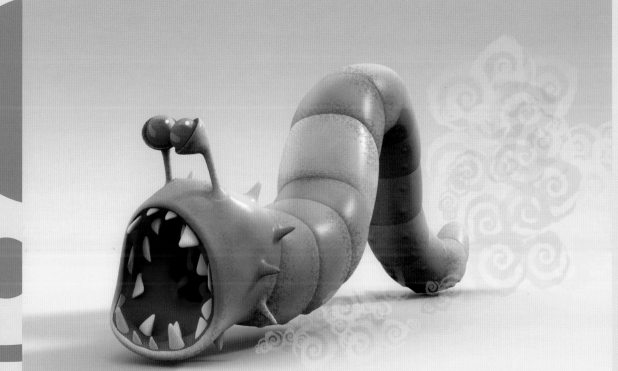
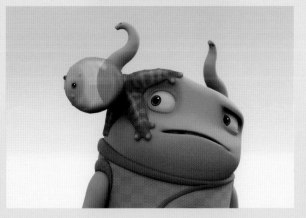

(this page) Takao Noguchi

MELODIES FROM EARTH

FROM THE DAYS of *Snow White and the Seven Dwarfs,* music has always played a crucial role in bringing animated features to life. And in *Home,* the songs and the soundtrack are woven seamlessly into the fabric of the movie in quite a unique way. The casting of pop superstar Rihanna as Tip helped the film's creative team up the ante by using the singer's impressive talents to echo the key themes of the story.

The idea to have Rihanna voice the film's spunky earthling came straight from the top: DreamWorks Animation CEO Jeffrey Katzenberg thought it would be a great idea to cast a star who shared Tip's own background. Producer Suzanne Buirgy recalls, "Jeffrey thought it would be a fantastic notion to have the person who voices Tip have the same immigrant background as the young character. When he came up with Rihanna, it really became this gift that kept unfolding."

Like Tip, Rihanna was born and raised in Barbados, and she had a deep affinity for music from an early age. As Buirgy points out, every new project seems to redefine the talented, chart-topping star as an artist. "Amazing things are happening in her career, and we are expecting this movie to really bring her into the next phase of her artistic path," she says. "We are right on the edge of that. The songs that she's working on for the movie are incredible and complex, and they show a lot of musical depth. They're definitely not a rehash of what she has done before. We're all very excited to be part of this special moment in her career."

In addition to other prominent artists, Rihanna is contributing original songs to the film's soundtrack based on themes from the movie. Although *Home*'s original songs were finalized in the last few months of production, the team screened early versions of the film to a team of songwriters and producers to involve them in the process organically. Among the film's top-notch list of producers and composers are Norwegian music powerhouse team Stargate (Tor Erik Hermansen and Mikkel Storleer Eriksen)— who has collaborated with Rihanna in the past—and composer Lorne Balfe, who was tasked with incorporating the melodies from the main songs into *Home*'s score.

One of the musical highlights of the film is the sequence in which Oh hears human music for the first time and is surprised by the way his body reacts to it. "Our director Tim Johnson's vision was to have the animators work with a song that was going to be used in the movie," explains Buirgy. "We were so fortunate because at first we weren't sure we were going to find that perfect song, but Stargate gave us a fantastic one. Then, we brought in our choreographer, Beau 'Casper' Smart, who did all kinds of amazing choreography to the music. So we ended up using Beau's original choreography as a great reference for the animators. It was a really special experience."

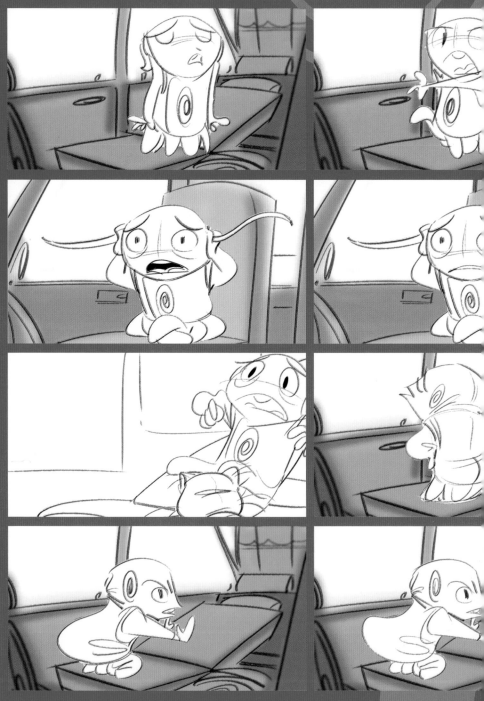

Michael Lester

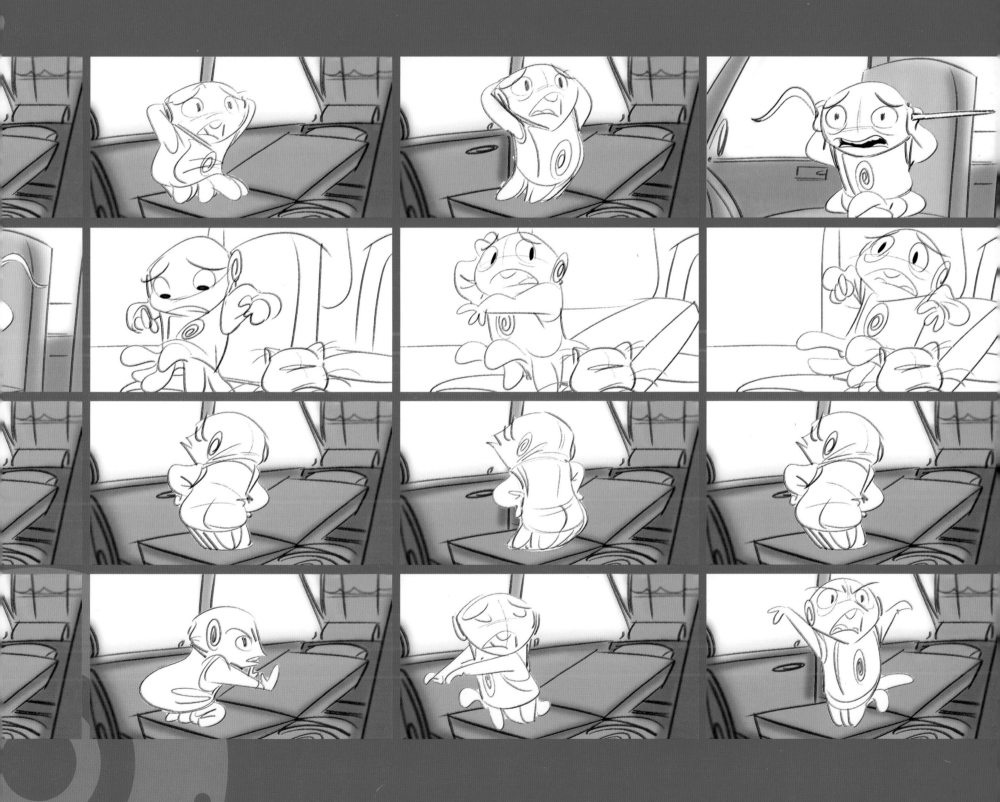

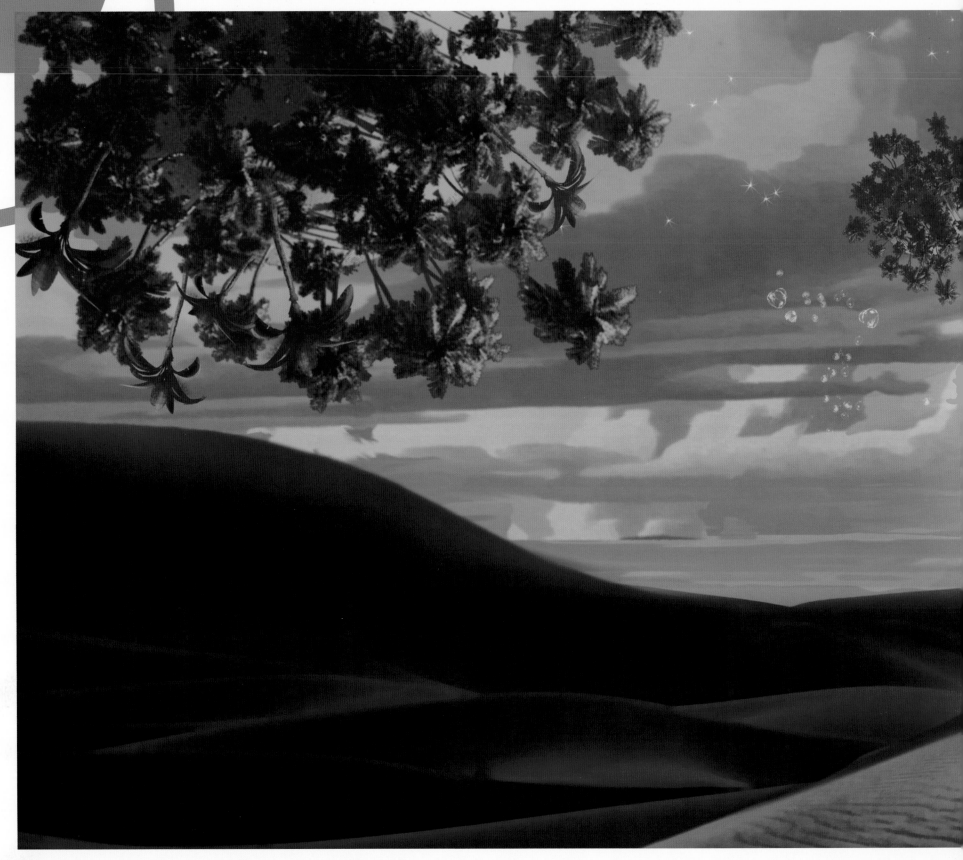

Emil Mitev

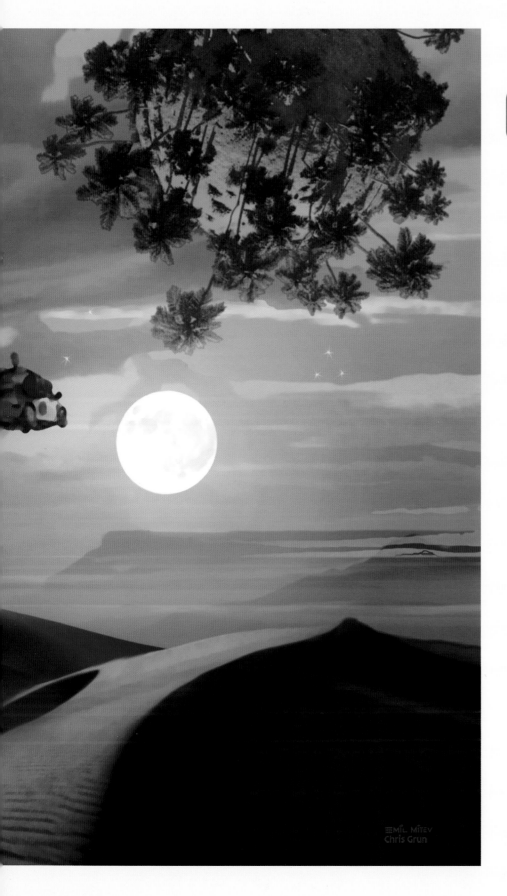

EMIL MITEV
Chris Grun

CONCLUSION

ADAPTING A POPULAR, whimsical children's book like Adam Rex's *The True Meaning of Smekday* is never an easy task. Yet the talented artists at DreamWorks Animation were able to successfully distill the essence of the book into a beautiful, CG-animated movie while putting a completely original spin on the classic alien invasion scenario.

This tale of a spirited twelve-year-old girl's friendship with a misfit alien and her quest to find her mother features memorable characters, unexpected twists, and unique artistic inspirations. Director Tim Johnson and producers Suzanne Buirgy, Mireille Soria, and Chris Jenkins and their crew have created a visually stunning adventure unlike any other science fiction epic we have seen on the big screen. *Home* is a musical journey that highlights the talents of Jim Parsons, Rihanna, Steve Martin, Jennifer Lopez, and Matt Jones even as it imparts a compelling message about the importance of family and friendship, as well as building bridges to other cultures.

With *Home*, DreamWorks has created a dazzling work of art that showcases the immense talent of the hundreds of artists who worked together on the film. All the different departments—from character design, editorial, and modeling to lighting, surfacing, and visual effects—came together to add a new chapter to the studio's rich legacy of quality family entertainment. This collaborative spirit of artistic exploration is precisely the kind of admirable human trait that impresses Oh throughout his road trip with Tip. If the little alien could see the process by which this movie was created, he would certainly scratch his funny, square-shaped head and declare, "Humans are definitely more complicated and talented than it said in the pamphlet!"

AFTERWORD

BY ADAM REX

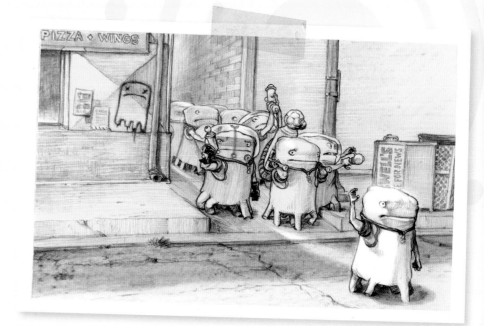

WHEN YOU WRITE A BOOK that's being turned into a movie, you find yourself on the receiving end of a lot of weird little condolences. Everyone gives you anxious looks and asks if the movie studio is taking care of you: if they're giving you any say in what happens; if you're worried they're going to ruin everything. People entering the Witness Protection Program probably get a lot of the same questions.

And, like in the Witness Protection Program, you're not allowed to really talk about it until it's all over. So, now that this whole business has been tried in the court of public opinion, I can finally say that *it has been so great. So* great. Yeah, some names got changed. People got new faces. It's Hollywood—everyone gets a little work done.

Okay. If I'm being completely honest, I have to admit that the first time I saw Oh, I thought, *That's not my character. That's not really a Boov, and this isn't really going to be my story.* I could only see the differences. But this was what I'd signed up for— no one had ever promised me perfect fidelity.

I was visiting DreamWorks for the day, and throughout that day I began to warm to their designs. They were so well thought out. So carefully considered. It didn't hurt that I just *liked* the DreamWorks team as much as I did: They're very genuine people, and they're obviously doing whatever's necessary to make the best films they can.

So I was already feeling a lot better about things when director Tim Johnson decided to show me some rejected designs—all the Boov that could have been. Glamor shots of a dozen aliens, any one of them charming enough to be a toy, but with no DNA at all in common with the protagonist of my story. Tim really should have started the day with those designs—they quickly put things in perspective. *There you are,* I thought as I glanced at the ¼ scale model of Oh sitting on Tim's desk. *I don't know why I didn't recognize you.*

I'm in debt to Cressida Cowell, author of the *How to Train Your Dragon* books, who referred to the movies of the same name as spiritual adaptations. That sounded about right, and it gave me something to tell all those people with their anxious looks. *Home* is a spiritual adaptation of my novel, *The True Meaning of Smekday.* They gave it a trim and a new name and moved it to Australia, but it's still the same earnest goofball on the inside.

I love our movie. I love the production team at DreamWorks and the talent that brought our characters to life. I also love you for bothering with this afterword. If we ever meet, say "Witness Protection Program" to me and I'll give you a hug or something.

Happy Smekday!

(top) Adam Rex, (opposite & following pages) Emil Mitev

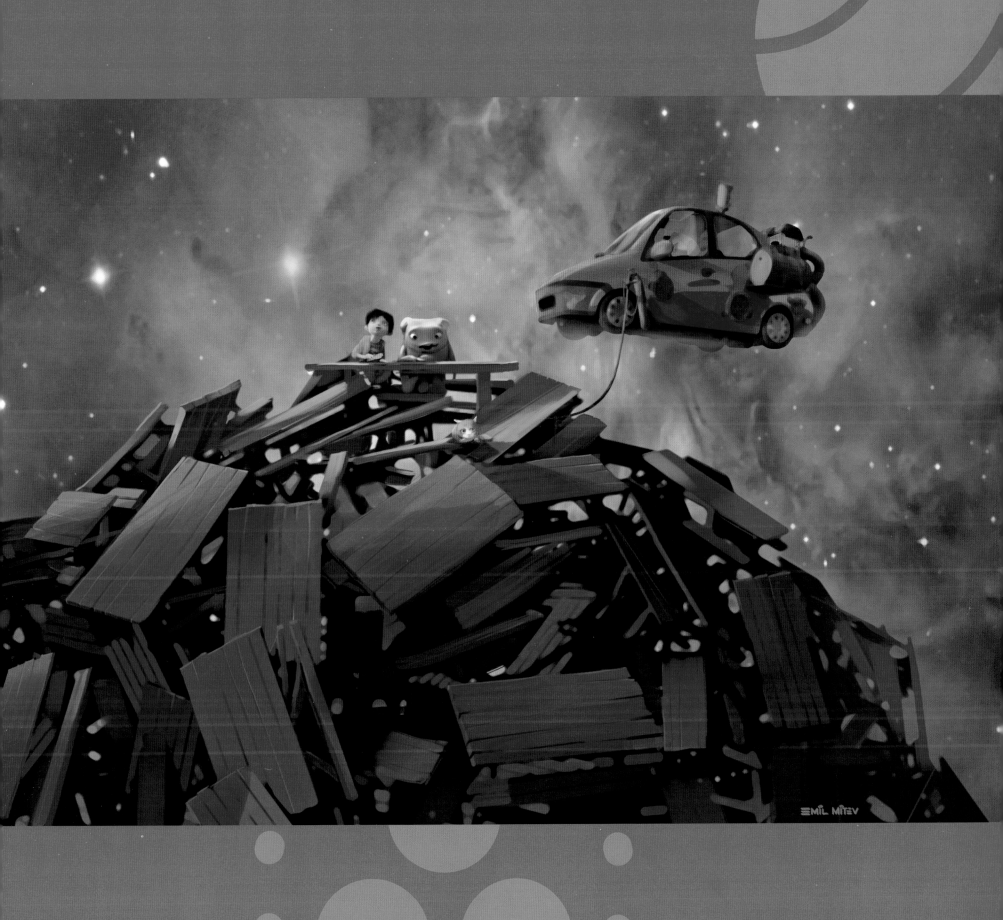

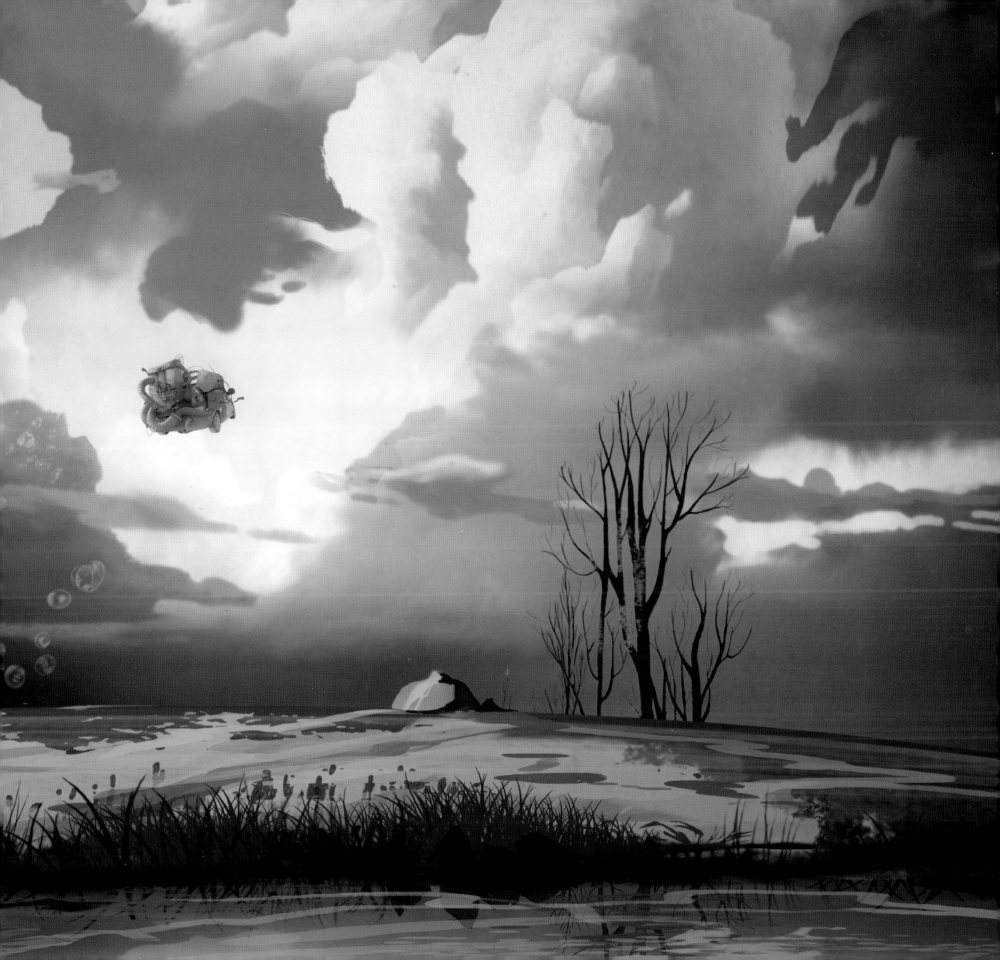

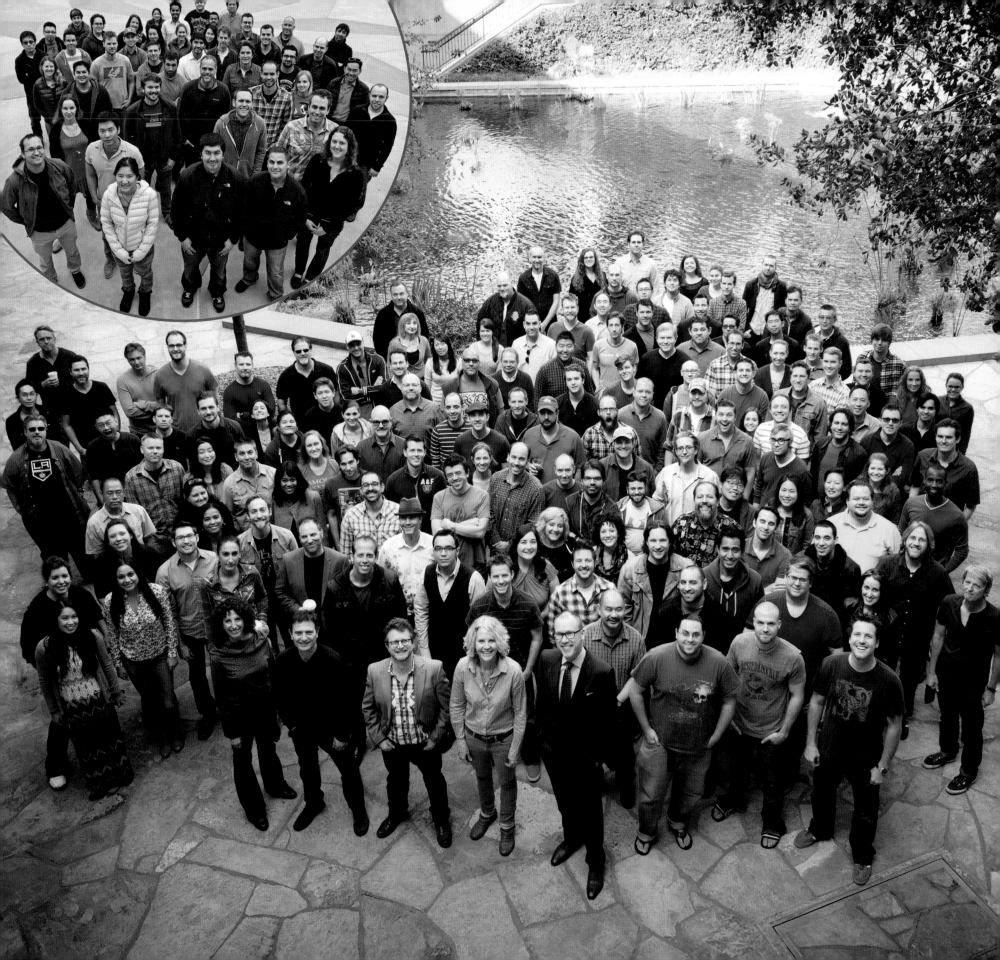

ACKNOWLEDGMENTS

MANY THANKS TO Jeffrey Katzenberg, Bill Damaschke, Allison Rawlings, Debbie Luner, and Art Bidwell at DreamWorks Animation for providing me with this great opportunity to learn all about the making of *Home*. I'm especially grateful to director Tim Johnson, producers Suzanne Buirgy, Chris Jenkins, and Mireille Soria, and production designer Kathy Altieri for being my brilliant guides on this special tour of the Boov invasion of our planet!

I am hugely indebted to all the talented artists on the *Home* front— Amaury Aubel, Damon Crowe, Jeremy Engleman, Sean Fennell, Nick Fletcher, Chris Grun, Jeff Hayes, Nathan Loofbourrow, Emil Mitev, Mark Mulgrew, Betsy Nofsinger, Takao Noguchi, Mahesh Ramasubramanian, Jason Reisig, Mike Trull, and Todd Wilderman—who were kind enough to chat with me about their work and inspirations.

Lots of kudos go out to the dynamic duo at Insight Editions, Elaine Ou and Jenelle Wagner, who guided this labor of love through its many stages.

Last but not least, I'd like to send out a very special thank you to the dynamic Jerry Schmitz, who kindly let me know about Tip and Oh's adventure. I'll be forever grateful for the front-seat view of this road trip picture.

—RAMIN ZAHED

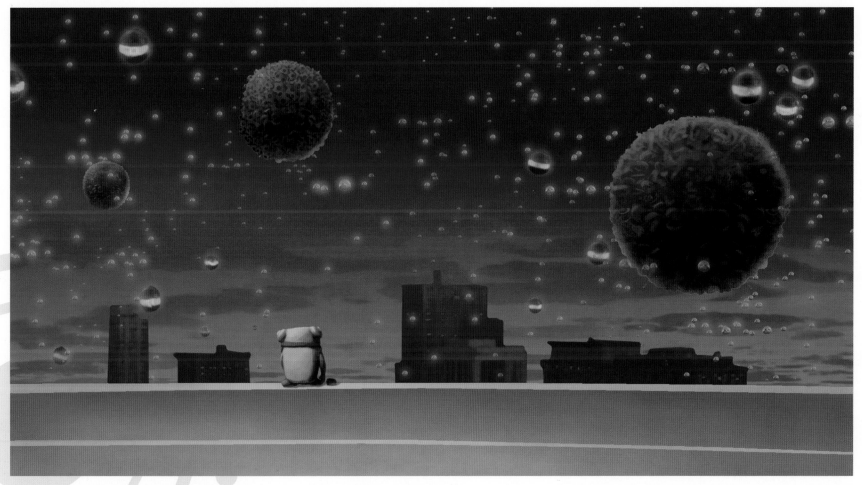

(opposite) Glendale Crew, (opposite inset) PDI Crew, (above) Bill Kaufmann

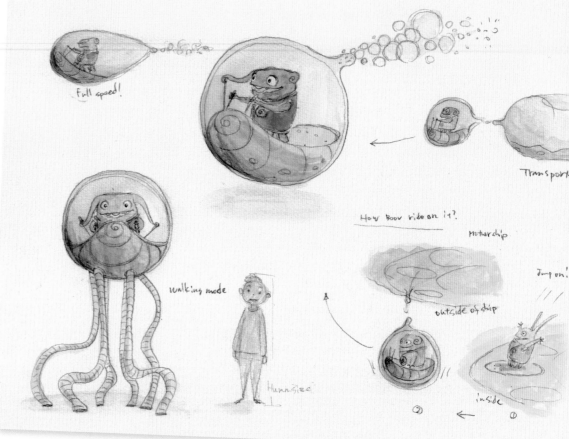

Boov vehicle concept.

Full speed!

Transporter

How Boov ride on it?

Mother chip

walking mode

outside of ship

Jump on!

Human size

inside

Takao Noguchi

I N S I G H T
E D I T I O N S

PO Box 3088
San Rafael, CA 94912
www.insighteditions.com

Find us on Facebook: www.facebook.com/InsightEditions
Follow us on Twitter: @insighteditions

Library of Congress Cataloging-in-Publication Data available.

ISBN: 978-1-60887-384-5

ROOTS of PEACE REPLANTED PAPER

Insight Editions, in association with Roots of Peace, will plant two trees for each tree
used in the manufacturing of this book. Roots of Peace is an internationally renowned
humanitarian organization dedicated to eradicating land mines worldwide and
converting war-torn lands into productive farms and wildlife habitats. Roots of Peace
will plant two million fruit and nut trees in Afghanistan and provide farmers there with
the skills and support necessary for sustainable land use.

Manufactured in China by Insight Editions

10 9 8 7 6 5 4 3 2 1

COLOPHON

PUBLISHER Raoul Goff

EXECUTIVE EDITOR Vanessa Lopez

PROJECT EDITOR Elaine Ou

ART DIRECTOR Chrissy Kwasnik

DESIGNER Jenelle Wagner

PRODUCTION EDITOR Rachel Anderson

PRODUCTION MANAGER Jane Chinn

INSIGHT EDITIONS would like to thank Debbie Luner,
Lisa Baldwin, Jessica Linares, Katie Kibbee, Brendan Thompson,
Suzanne Buirgy, Mireille Soria, Chris Jenkins, Tim Johnson,
Kathy Altieri, Emil Mitev, Helen Saric, Lynelle Saunders,
David Orecklin, Adam Nelson, Jeff Hare, Michael Garcia,
Cathleen Girdner, Jim Parsons, Adam Rex, Bill Damaschke,
Michael Francis, and Dawn Taubin.